DALE ELDRED: Sculpture into Environment

DALE ELDRED

Sculpture into Environment

by Ralph T. Coe

Photographs edited by
James L. Enyeart

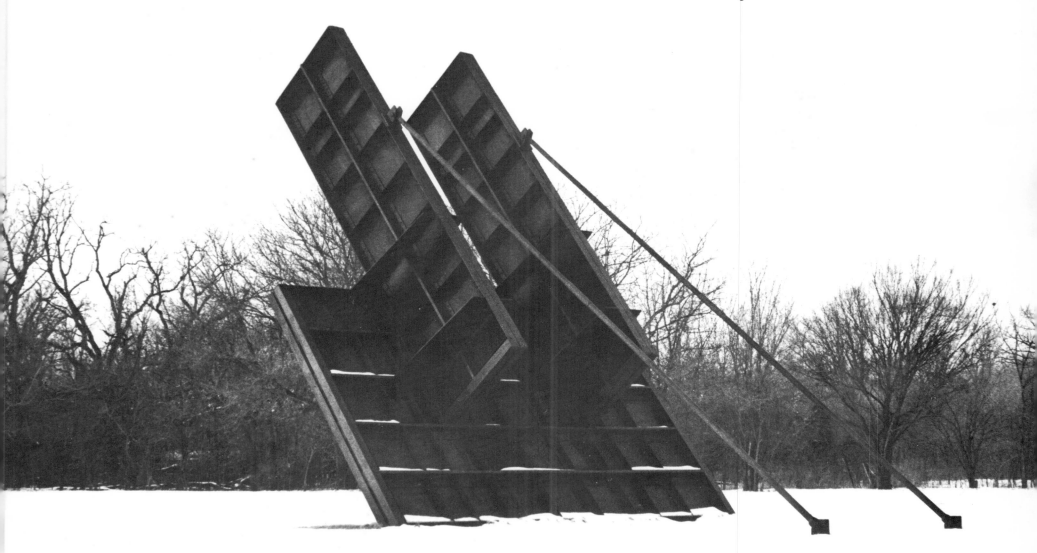

The Regents Press of Kansas
Lawrence

© Copyright 1978 by The Regents Press of Kansas

Printed in the United States of America

Designed by Fritz Reiber

Coe, Ralph T
 Dale Eldred : sculpture into environment.
 1. Eldred, Dale.
NB237.E43C63 730'.82'4 77-5896
ISBN 0-7006-0159-7

to
MARILYN STOKSTAD
scholar . . . friend

CONTENTS

PREFACE

This book has been written to explain the development of one of the most important of the American sculptors who have matured in the wake of David Smith. This sculptor is Dale Eldred, chairman of the department of sculpture at the Kansas City Art Institute. Smith's use of the formal cubist inheritance was conscious. Eldred's is not. It is built-in, inherent. David Smith welded, but Eldred has adopted the full factory-fabrication process, involving techniques that he fully understands. He has taken years to master them. He has carried the sculptural implications of the technological age much further than his illustrious predecessor.

One feels that Smith, for all his use of the welding torch, still made sculptures to be placed in a sculpture garden or in rooms. David Smith's sculptures belong to a series of styles. He worked in idioms. Eldred works in modes; he has no style. He wants no garden, no setting in the gallery-oriented sense for his work. His field is the environment. Even the scale models for his outdoor projects (many unexecuted) seem barely to tolerate their enclosed situation. They derive an impact from that tension. What Eldred seeks is "dimensionality," an integration of space, time, material, and nature, each element set against the other eternally—totality, in his view.

Eldred's work grows out of the twentieth-century constructivist tradition and is related to Brancusi, Pevsner, and Calder in a general way. "How I admire the way Calder thinks big," admits Eldred. But his own development as an artist has been remarkably independent. Along the way he has absorbed the capacities of architect, engineer, planner, and builder into his art to the point of making sculpture the product of technics. What he would like to do now is to keep several construction crews and engineering companies extremely busy. Metaphorically speaking, Eldred would like to run from Kansas City a world-wide sculpture construction and planning conglomerate. One wonders if it will not come to that in time!

His work was at least as important to the 1960s as Anthony Caro's, unless exposure be the criterion of judgment. Each artist worked directly with steel and matured at nearly the same time, Caro with *Midday* (1960) and *Early One Morning* (1962),

Eldred with *Standing Iron* and *Midwestern Land-scape* (1963) and *Penn Valley Park* (1962). Caro today is employing an increasingly aesthetic approach to his use of steel, while Eldred is expanding on a broad platform in many directions. A return to aesthetics is, for reasons I hope are apparent in this book, simply not in the stars for Dale Eldred. He remains an explorer and could never, as Caro recently did, work for an extensive period in Italy, to renew his contact with the Renaissance. Eldred would rather visit weavers in the Sudan or look at the Himalayas. Both of these men, one European, the other American, signify opposite ways of treating post-Cubist, similar forms in steel.

Eldred's work has a psychic thrust and an energy in its motivation that go beyond any schooling. Its relationship to time-honored forms of nature is too intense for such methodology. Much as he likes to teach, he has never cared to be associated with a set procedure or to create followers. In his view that would be too confining. His sculpture pertains to land masses, water flows, and air movements, even weather, across the world. He dreams of creating unfettered art for the steppes, the deserts, or the mountains, whether the wind blows off the Rockies or the Urals (the actual size of the latter would disappoint Eldred), but never for the living room, as Caro does. He is a natural outdoorsman, without overdoing the fact. If a woodsman or a steelworker became a technologist and had the benefit of a special education—that would be Eldred to the core. He still retains a certain conservatism, an overwhelming respect for the traditionalism of old-time agrarian craft, that betrays his Midwestern origins and affiliations.

Eldred's development recalls the history of modern building technology from its cast-iron inception, through the age of steel, to projects feasible only by using the newest up-to-date technology. However, wooden planks can go with steel, or grass can be near mirrors, and mylar provides a fitting surface for an ages-old Irish or American landscape. Cables cross-connect above prairie's undulations, a little like high-tension wires that march onward as they civilize the rough plains. Many people have missed the point that a large proportion of modern technology is spawned by agriculture. Eldred grew up with

that fact ready to mind and has always rested easily with it.

To add here the term "unhurried" is a clue to Midwesternism. It does not imply sloth or lack of energy, but rather a certain comfortableness in coming to terms with outlook and techniques. There is an irrevocable and unalterable commodiousness to an Eldred sculptural project. One can feel the deliberateness of the carpenter placing the level on a beam and can imagine the technician at home with a highly mental theory of calculation. On the other hand, occasional but telling use of moving water, jets, channels, and discharge pipes links a Baroque interest to the stolidity of environmentalism, so that all is not solidly of a piece in the constructed world of Dale Eldred. His latest work is meant to gyrate above the earth.

An appraisal of any vigorous artist caught in mid-career can be only tentative. A refreshed approach is inevitable as Eldred goes ahead with his work. He has intense regenerative powers and a gargantuan ability to absorb technological-constructionist ideas. He cuts right down through "art" and learns almost exclusively from the "doers." In comparison to many admired contemporary artists, he has worked alone, often in seeming isolation. His works are located off the beaten path. He flourishes by going against the grain without any qualms, but this independence has not in any way removed him from sculptural solutions that are central to our times, nor has it curbed his boundless energies. For these reasons, Eldred's work has remained too little known; it is time for him to be recognized as more than a sculptor's sculptor.

His environmental work includes one of the earliest earth-work sculpture projects undertaken anywhere, the Penn Valley Park of 1962, now destroyed but well worth remembering. As an accomplishment his environmental works and projects are already significant enough to warrant careful recording, visual and documentary. Since some of these designs have yet to be executed, they are treated here as projects necessary to understanding Eldred's vision. After all, they belong to the world at large—in the environmental and elemental construction of those words. He is one of the few sculptors who make significant prints. These have the virtue of

being integrated extensions of his work and greatly add to it and to our understanding of it. Eldred's images are too profligate for all to be realized as actual sculptures, so he envisages how they would look by environmental print-outs which quickly place any part of the physical world—any type of landscape—at the disposal of his vision.

Eldred is a dynamic subject to evaluate because of his highly discursive conversation, indicative of his desire to interrelate the most disparate and diversified energies in art and life. He is also an expansive man both physically and mentally, and, as a friend declared, "I have never known anyone else who occupies such space!" To state it simply, his type of work could not be undertaken without great positivism. His forthrightness, integrity, and fairness inspire his friends and acquaintances to believe in his work. "Be sure that the magnitude of his sculpture equals his size!" admonished a student.

One personal characteristic is worth citing, for it reflects light upon Eldred's approach, which is open and freehanded. He has little regard for chronological time or interest in dates. He is always slowly saying with emphasis "now let me think . . . or was it? . . . I think it was . . . It doesn't mean that much to me." One senses the past always, but too much reflection might stanch the flow of positivism. He also has little interest in recalling specific biographical details, and sometimes it was impossible to pin down accurately academic measurements when interviewing him (exact times of occurrence, details of precedence). Yet, how he loves to converse, covering huge stretches of the verbal landscape with factual feeling. Ideas confuse and confound one another like the rich patterns and colors of the Turkish Kelim rugs which Eldred collects and with which he surrounds himself. He is familiar with quantities of the world's folk art and knows the subject well.

An individual artist's viewpoint is asserted in these pages, perhaps at the expense of historical perspective. In the end, Eldred's work may not be better, only different from that of his contemporaries; unsuspected interconnections with other artists may be found by historians of the next century. While distance lends insight, immediacy is lost. Something of the initial freshness of approach, the excitement

of watching an individual style mature, is diminished with each reinterpretation. At some time the student must go back and refresh himself at the primary sources, however simple this material may seem in retrospect.

The interviewing process proceeded from all angles at once, and accuracy was obtained by cross reference. Even this system sometimes frustrated my search for exact information. Something of Eldred's discursiveness has found its way into this book. There was no reason to hide its presence. Unless otherwise indicated, quotations are from numerous interviews with the artist, edited and sometimes adjusted or recast for clarity of content and meaning. In these cases meaning was checked again with the artist. Since relatively little has been written on him, there is no bibliography, but sources are documented.

I have carefully coordinated the text and captions with the photo editing process jointly undertaken with the artist and James L. Enyeart, former curator of graphic arts at the Museum of Art, University of Kansas. The idea was to obtain, whenever possible, unity of presentation, invoking the artist himself, since he encourages team production of his ideas and designs. Many of the photographs were taken by Mr. Enyeart, who has kept a photo record of the artist's work for a number of years, and many of the illustrations were developed in his laboratory. The majority were reprinted from hundreds of record shots, negative strips, or finished photographs originally taken by the artist or occasionally his collaborators. We may be grateful that Mr. Enyeart "spirited" many of these away from the artist. A University of Kansas General Research Fund grant enabled me to observe some of Eldred's pieces *in situ* and aided Mr. Enyeart in his laboratory work. John Lowrey, former gallery designer for the Nelson Gallery of Art, contributed several additional illustrations, at my request. Credits for the illustrations are shown in italics in the captions.

A welcome grant-in-aid from the Jacob L. Loose Million Dollar Charity Fund of the Kansas City Association of Trusts and Foundations to the Kansas City Art Institute made possible many more color illustrations than were initially planned, which add a necessary dimension to the presentation of

Eldred's work. Charles F. Curran, President of the Association, and Barret S. Heddens, Jr., President of the Fund, are to be thanked for their positive consideration of our publication needs, and John Lottes, President of the Kansas City Art Institute, for advice concerning these problems. Donald Hall, President of Hallmark, Inc., also gave assistance.

Color separations were donated by Bernard J. Ruysser, President of the Commercial National Bank of Kansas City, Kansas; Senator and Mrs. John M. Simpson, Salina, Kansas; and a donor who has asked to remain anonymous. Carl Migliazzo, President, Missouri Photo Engravers, Inc., showed the way to achieve the best quality color separations.

Ralph T. Coe
Kansas City, Missouri
1976

1
DALE ELDRED
AND
GIGANTISM

A Los Angeles art dealer said to me, apropos a rival of Eldred's: "But he doesn't do enough with sculpture; he only 'sees' painting." It could as easily be said that the dealer-antagonist "saw" only sculpture. Either way it is a dilemma: in an art world increasingly dependent upon technological standards and technocratic responses, it is not the traditional orientation (sculpture; painting; prints) with which an artist begins that is any longer of primary importance. To what set of conceptions does he apply that orientation? How does he bridge the gap between his expression and expanding technology? What role does he play in the creation of new identities in which art joins related disciplines, such as engineering, science, or environmental study? Today's artist should be aware that he does not have to work for a given dealer or museum-oriented audience. He can create for people by working on public commission: i.e., designing parks or urban projects or an open-air museum. A few artists in America recently have chosen to eschew the dealer and strike out for themselves. Prominent among them is Dale Eldred, who says:

> The way I see myself basically: I am a sculptor who is a total artist. I can function in concept and idea, but can also build a many-dimensional thing. The entire operation is my thing, from the concept to the drafting table, to costing [up to hundreds of thousands of dollars], hiring, jobbing out, and supervision. I like to feel that I can surround the whole operation. I'm realistic enough to know that I love physical work, but through the drafting board I can implement larger ideas, huge dimensions, and put together so much more. When I step up to the board, everything becomes logical like a knife edge. The drafting discipline hasn't escaped me, no matter how random my interests. Today I'd have difficulty going back to single sculptures. The *Salina Piece* bridged out of the single sculpture concept. I don't think I'll return. Using cranes to lift its components and transportation to get them to the site involved more than one level in sculpture anyway. In fact, in Salina it wasn't sculpting, but building, in technological complexity a multi-dimensional project.

Eldred's point of departure may be as old as man's sculptural feeling for things, but the application is less traditional in that it is not directed at a studio audience. In 1969 Allen Weller said: "In building his huge outdoor environmental earthworks (which can hardly be included in museum exhibitions) the Kansas City sculptor Dale Eldred employs his own crane with backhoe (cost, new, about fifty thousand dollars), and on exceptionally large commissions must also contract for the services of bulldozers, power shovels, and other heavy industrial earth-moving equipment. The use of such equipment on a regular basis, whether owned by the artist or rented, obviously requires substantial capitalization."[*] The individual art piece might be a children's park with an ethnic neighborhood as audience, or an outdoor museum of American ceramics at a city's center meant to attract the general passerby.

The program may be social or even sociological, but not political, except for the complicated politics of getting things built or done. In dealing with government agencies, both national and local, city department chiefs and their employees, and collaborators with varied talents, Eldred has become something of a master. These are the areas of special kinship. After all, the execution of his work has come to depend more and more on mastery of the intricacies of interdisciplinary communication. In turn, a lot of people have been touched by Dale Eldred in ways for which their own discipline had not prepared them. In the case of Eldred's Washington Square open-air museum project, one artistic discipline (sculpture) services another (collecting; curating; documentation) by becoming a format (park) for its presentation, taking advantage of the various points where art, technology (display), and practical function meet. A shopping center can provide such an event, almost like a theater. Like land, it is also a piece of real estate—space.

Dale Eldred's talent is stimulated by the ten-

sions between media, as time has confirmed their division into separate branches of artistic endeavor. He sees his role as an actor working in the gap between architecture, design, and construction, and feels the artist is best fitted for this role. Acting in a non-studio, non-museum–oriented way, he is stimulated to use the physical world as a laboratory. At this point the dramatist gives way to the practical builder in his workroom or office. Working with land, he returns sculpture to the matrix "out of which it was formed in the first place." Even urban projects are considered to be landed, a very Midwestern point of view. "Everything comes out of history, for the sculpture is the land on which civilization stands, like a catalogue," Eldred says. Nature literally becomes the amphitheater for art; art becomes the stage as in outdoor ancient theater. Human perception and activity activate it. The artist thinks in comprehensive terms as he relates his thinking to the outdoors. This approach does away with the museum object in its "hothouse setting." It moves art out into real space in order that it not be boxed in by conjectural (limited) space. Such an orientation provides cold comfort for those critics who formulate criticism from a two-dimensional canvas. Eldred is hardly an artist who would interest an art critic of Clement Greenberg's stripe. "To be a sculptor means I occupy all the spaces between an architect, a painter, fabricator, agronomist, contractor, nurseryman, and environmentalist," Eldred explains. He works with grass as well as concrete, earth as well as steel. He coordinates his role with the environment the way an architect or planner might. Any show of his work in a museum would bear the same resemblance that a show of architecture would bear to the real thing, except that the artist, acting as *individual*, through his models, blueprints, drawings, or small pieces, would control all his data. His data therefore functions as art.

"Open spaces have great value for me. Function of value separates sculpture from those things that appear to be sculpture today. Sculpture 'posing' today isn't necessarily sculpture today," Eldred says. Sculpture "caught in poses" doesn't go beyond the confines of the life class, even when abstracted. It's a question of time and the earth. Such an approach could come near Louis Sullivan's

[*] *Contemporary American Painting and Sculpture 1969* (introduction, *The New Artist,* by James R. Shipley and Allen S. Weller). Catalogue to the 14th exhibition, Krannert Museum, Champaign, Illinois. University of Illinois Press, Urbana, 1969.

ideal of "a demonstration so broad as to admit of no exception." Why not search for a sculptural mode to set out in those vast spaces (Midwest) beyond figural posturing? Why stay with sculpture on a pedestal when one can echo the undulations of the land, follow its space divisions, and punctuate its topography empathically through a union of sculpture and architecturelike design? Sculpture on a base is topical; baseless earth sculpture is timeless; natural forms such as mounds, berms, arroyos, and outcroppings, when reformed as sculpture and distilled into concentrated design, evade category. They evade naming in the ordinary sense. They become generalized as terms, like shades, hues, and value in art.

Eldred designs in the present tense. A work concludes abruptly. It is planned all of a piece. Gone is the traditional, time-honored beginning-middle-ending. Walk around the corner of a project of his, and one comes across the same angles or curves, however differently used. There is a peculiar blanket similarity to different portions of an Eldred undertaking, hence the similar joinings and connections of elements one experiences through widely separate sections of the same sculpture program. One is reminded of an experienced steam fitter who reforms over and over again various angles with given industrial parts in different places according to differing needs. This concordance explains the inner constancy of his work as contrasted with its expansive outward reach.

Eldred seeks to set these shapes against duration, so that they will stand before us and after us. To a timekeeper, he would indeed be an iconoclast. "No piece will be allowed to weather in its relationship to what we know; winter, summer, and change exist apart from us or my pieces, and the seasons don't bear in on them. Weather is deliberately meant to affect but not change them. I try to build things that stand with their own rhythm, like equals and durations." Eldred's mature sculptural projects, whether constructed pieces, neighborhood parks, or open-air museums, all act in scale with acreage. As art they are stationary. Since they are not easily shipped and sometimes not marketable, they are beyond being handled or considered as a commodity. They proclaim durability. They are really huge

in concept, even more than physical dimensions. Only the indoor models, drawings, and graphics are easy to handle or exhibit. These latter become an extension of style into documentation, as a blueprint is to a building, or an aerial photograph is to a city. By definition, such works, especially the realized projects, are not to be found in places frequented by that crowd who prefers the cloistered art gallery or crowded museum enclosure opening to the Kansas plains.

There is no attack intended here on museums. Eldred recognizes the art museum's natural role in culture as conserving centers for the vital evidence of man's creative visual past and contemporary interpretation of it: "After all, Ted, I've shown in art museums. But it's a fact that my full-scale work generally won't fit in them like the Kelim rugs I've collected in Turkey and displayed in the Nelson Gallery's Sales and Rental Gallery. Seeing them there confirmed the excitement I saw in these textiles all over again. Museums are awfully good at that sort of confirmation. Where else can it be done better? But there is a great deal to see and absorb that is not in museums, can never be, and why not be aware of that fact?" Eldred has in mind here all those externals out in the environment that act upon us in determining our relationship to landmarks and sites: "Considering all the technological and geographical sources we can command today in getting to know the world, where would artists be if they ignored them? We'd be back in the boudoir, and we took a long time getting out of there." Eldred is not only against a boudoir stance, he is dismayed at artists who use their studios in boudoir fashion to decorate small ideas: "My studios are documentation centers for the engineering, planning, detailing, and building of art. An engineer and architect would not feel strange there; you see drafting tables, drafting tools, Ozalid machines, metal samples, and mylar, but no easel. There are plants, folk art, Tantric drawings, and filming cabinets, but there is *no* easel."

No Park Avenue apartment can hold a collection of Dale Eldred's realized projects, any more than it could enclose the Ohio Serpentine Mound or the immense, astronomical outdoor clocks of Jaipur. Nor are the patrons of Dale Eldred's sculptures the usual type of art collector. They are ranchers, in-

3

dustrialists, or individuals who will commission directly by allocating a vacant field or yard for Eldred's use and who willingly adjust to the presence of a team system of art production, complete with crane and earthmovers. They are park officials who sit at city hall and rarely come near an art museum. These commissioners of art often do not seem to meet the accustomed criteria for an enlightened patron.

Why construct art in bottles, Eldred seems to ask, when there is the whole, vast, wide world in which to operate, by extension and metaphor, if not always in reality? After all, "Turkish rug bazaars are only a day and a half from Kansas City by plane. In four days by truck from here I can be at Lake Atitlan in Central America buying folk art right and left." Sculpture is aligned with constants, however extended in design and intent.

Eldred's sculpture is, however, connected historically to the strain of romantic gigantism that often crops up in American art, most noticeably perhaps in the useful arts of engineering, architecture, or park planning, but also in painting: its syntax is the outsized painted landscape of Thomas Cole's huge cycle *The Voyage of Life*. Gigantism is part of the vision of Bierstadt's panorama of the American West, Church's olympian dioramic pictures of the Andes, or even Ryder's limitless seas. In engineering, its implementation is Eads's steel-trussed bridge spanning the Mississippi, or the physical tautness of a Chicago School skyscraper. It breaks ground in our barns, silos, covered bridges, and water towers. It can pertain to the vernacular or the sophisticated. What is massive is more direct, more redolent of strength and fortitude; sheer forcefulness bores to the center of things, relating us to phenomena, to history (perceived by Eldred only in terms of its most vigorous moments), and to our situation in a world so easily spanned that we have no right to be glued fast in self-centered relationship to it. By this is meant that Eldred's work may exist outside our reach, parallel to, rather than contingent upon, our own scale. To be successful, gigantically conceived art should have independent scale so that one reacts positively to its own conceptual impact. This impact is another aspect of "dimension," as Dale Eldred terms it.

4

Large-dimensional thinking should avoid niggling details that can have little direct impact upon us. So much detail in art, Eldred feels, is esoteric. Let's learn by the example of folk-expression, beautifully elemental and direct. Why waste time on lacy patterns or soft textures? Sculptural detailing should come out of structural necessity (from components put together in a fabricating plant before being assembled at the work site). In using concrete or stone forms the detailing should be submerged in the design so that they are organically one. They should clearly sit upon the earth, as a sort of sculptural parallelism to terrain. The refinements should exist in the same sense that a builder (not a painter) "details" integrally.

Art has too often been concerned with "taste," with superficial decorum. It has existed, isolated like a tender plant, and protected by aesthetics. Why not "get it out in the open," away from artificial situations, where it has to be built from the ground up, so that it really becomes a living entity, part of the environment, not the realization of an aesthetic theory? Hence Eldred's huge idea of an out-of-doors museum for American folk art and ceramics, combining primarily sculpture, park play, landscape architecture with display, conservation, and history. Perhaps the Chicago architect Daniel Burnham, at his weakest when occupied with "taste," spoke up once and for all in support of the power of brutalist thinking in American art with his pragmatic advice, "Make no little plans, they have no magic to stir men's minds."* Neither should a sculptor be tied down to little plans.

When Eldred works out the construction schedule for a sculpture park with the Kansas City Park Department staff and supervises the job as foreman, he is not working with artists but with workmen of the ilk that Burnham's contractors would have understood. Eldred says, "I don't like to work with artists. I like to work with men who will get the job done. Less and less do I like the art world." He feels no peer pressure.

In Eldred's hands the combining of heavy-duty materials leads to an elemental intercession of three-

* Carl W. Condit, *The Chicago School of Architecture* (Chicago: The University of Chicago Press, 1964), page 112.

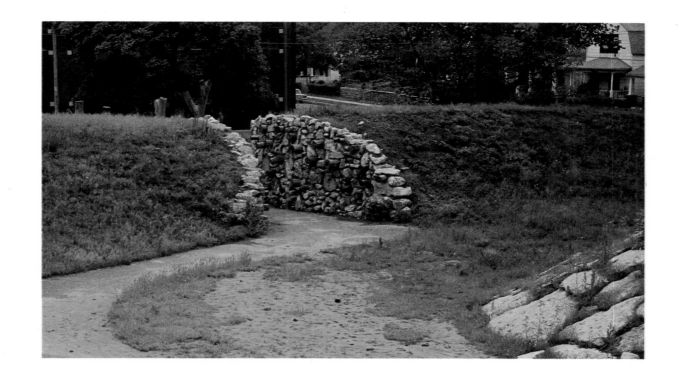

Dale Eldred, Penn Valley Park,
enclosing berms, entrance,
and corner of stone-clad mound,
1962. *Dale Eldred*.

Dale Eldred, Penn Valley Park, stone work and logs at entrance,
1962. *Dale Eldred*.

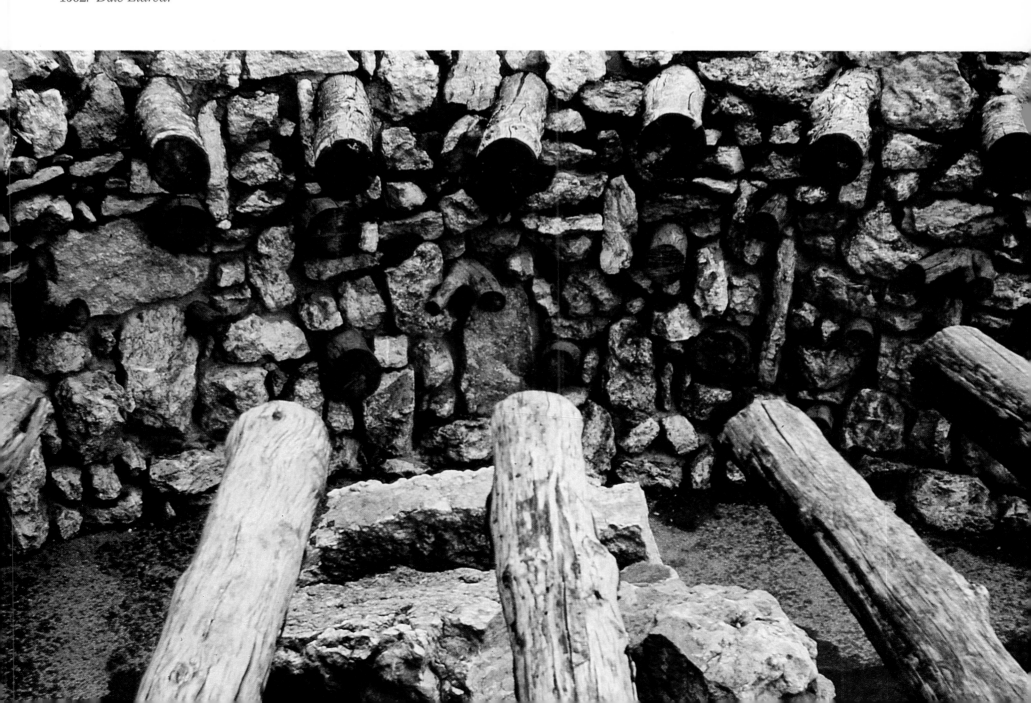

Dale Eldred, detail of *Sisu* at the Kansas City Art
Institute, 1964. *Dale Eldred.*

Dale Eldred, *Kansas Landmark*
(*Drum Piece*), in Harrison Jedel's
yard, 1965. *James Enyeart.*

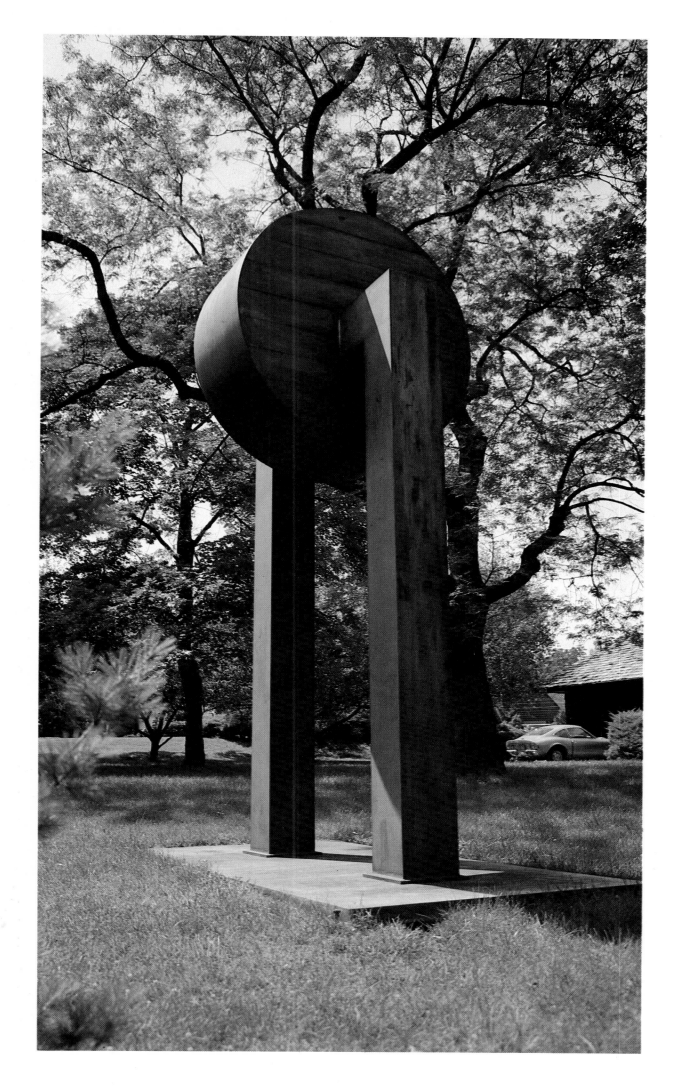

Dale Eldred, *Big Orange*, detail.
Dale Eldred.

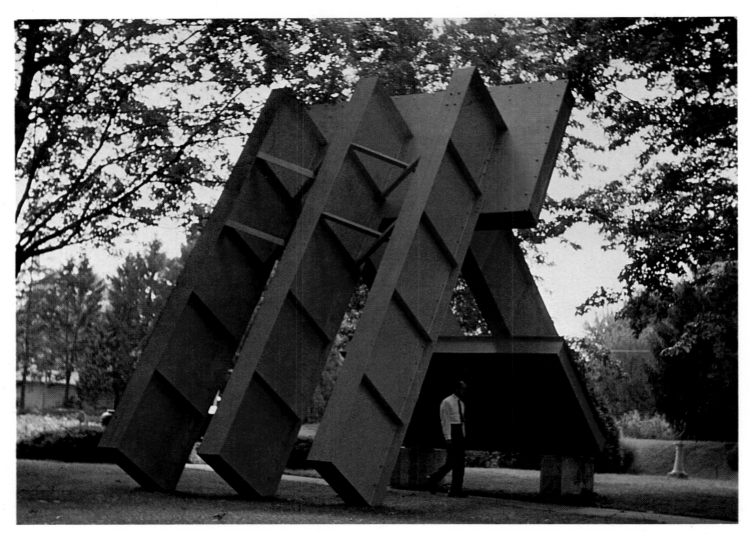

Dale Eldred, *Big Orange*, as assembled at the Albrecht
Art Gallery, St. Joseph, Missouri (Eldred exhibition, 1968).
Dale Eldred.

Dale Eldred, *Mankato Piece,* Mankato, Minnesota, 1968.
James Enyeart.

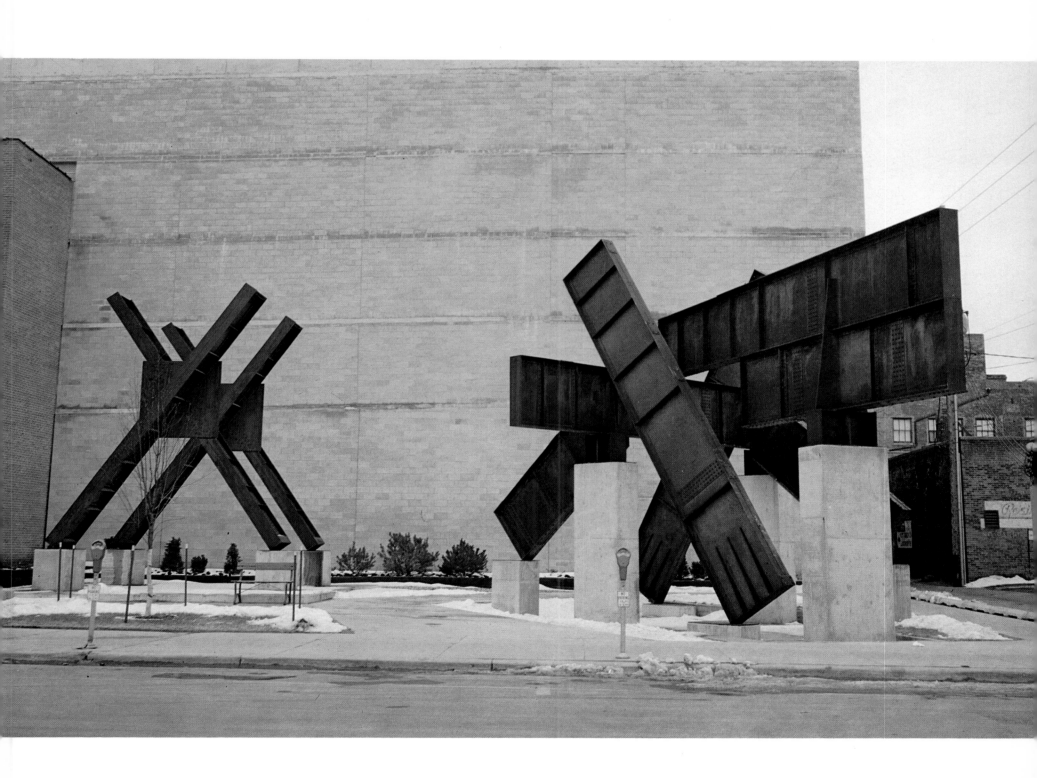

Dale Eldred, *Mankato Piece,* collaged against the city.
Dale Eldred.

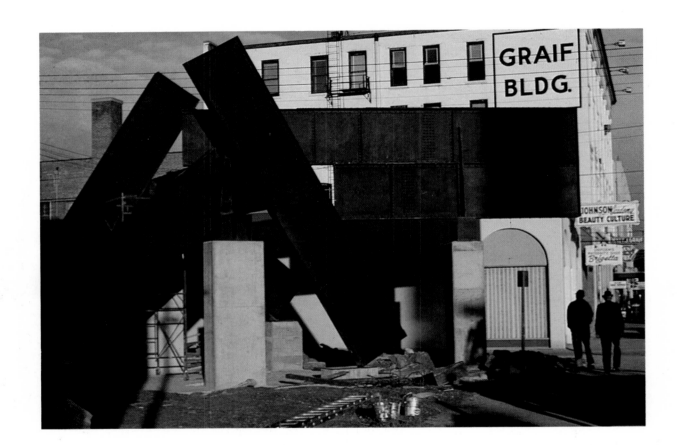

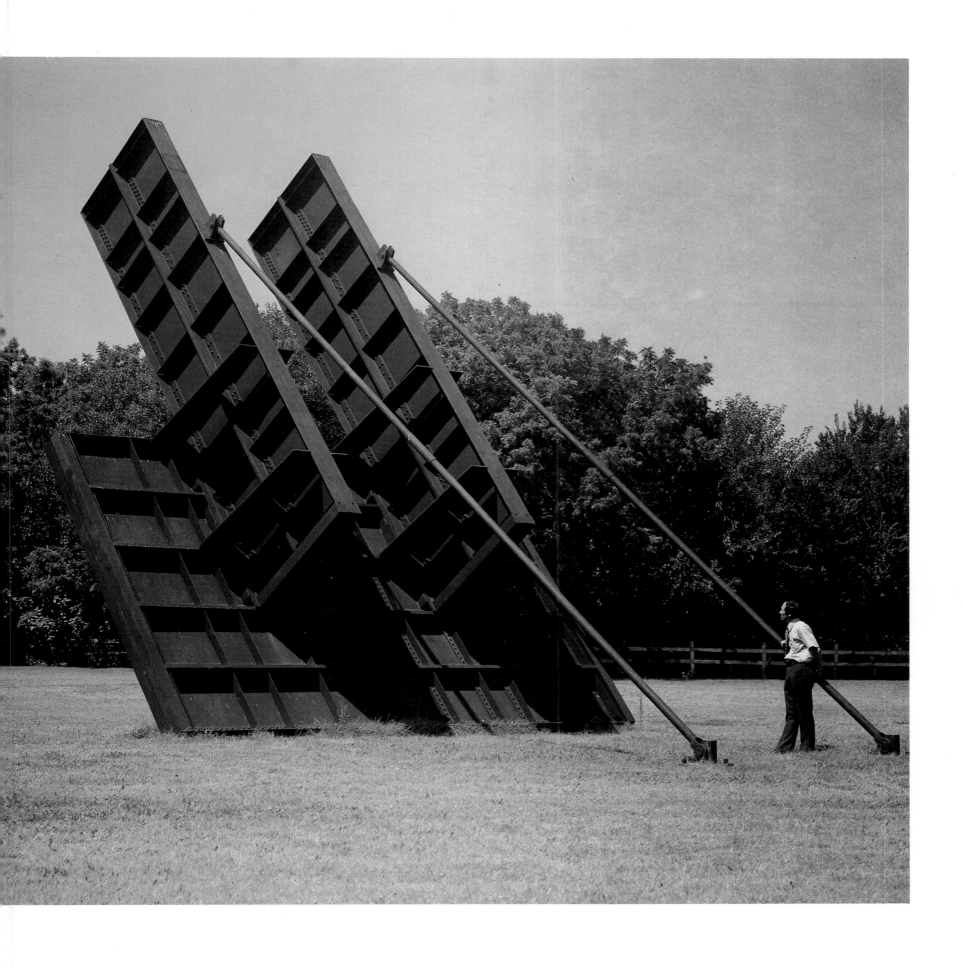

Dale Eldred, *Salina Piece,* Salina, Kansas, 1969.
James Enyeart.

Dale Eldred, designer, City Center
Mall, Kansas City, Kansas (urban
renewal project), 1970– . View of
the beginning of waterworks
system. *Dale Eldred*.

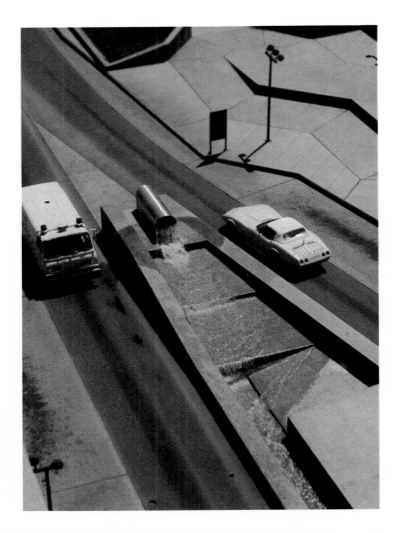

Dale Eldred, designer, City Center Mall, Kansas City,
Kansas (urban renewal project), 1970–
Detail of watersheds. *Dale Eldred*.

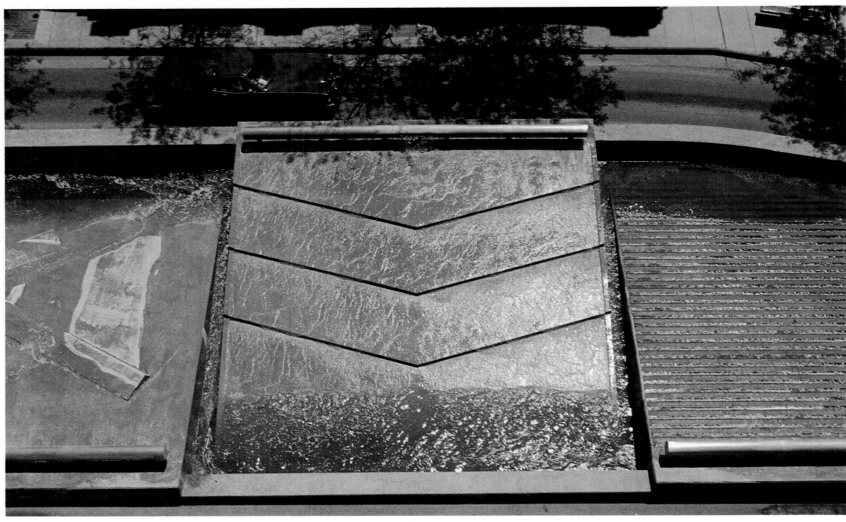

Dale Eldred, *Grand Rapids Pendulum,* as
finally installed at Grand Valley State College,
1973. *Shirley Doebel.*

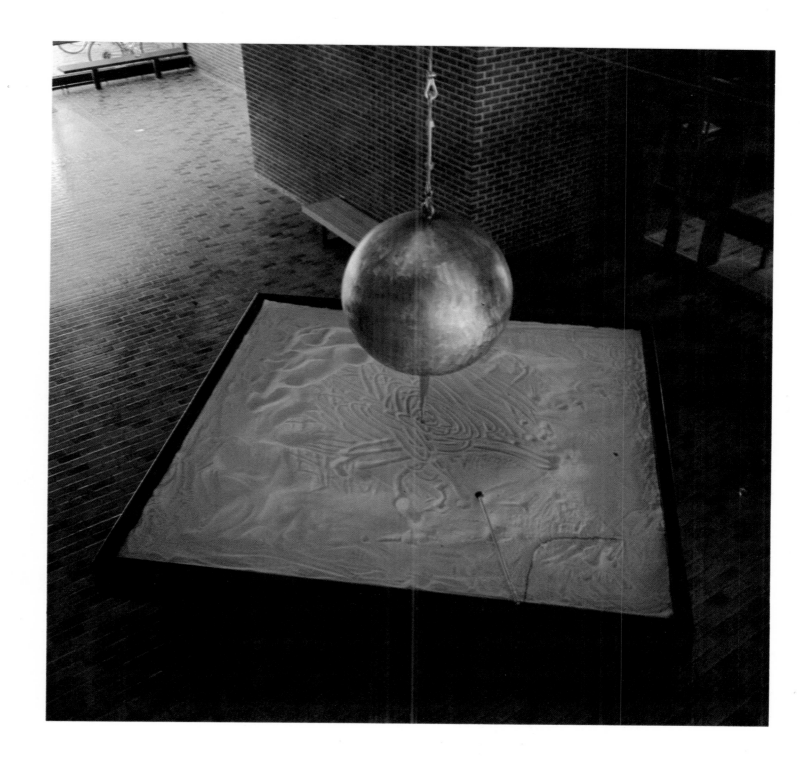

Dale Eldred, Cypress and Thirtieth Street
Park, Kansas City, Missouri, 1971-1974.
Dale Eldred

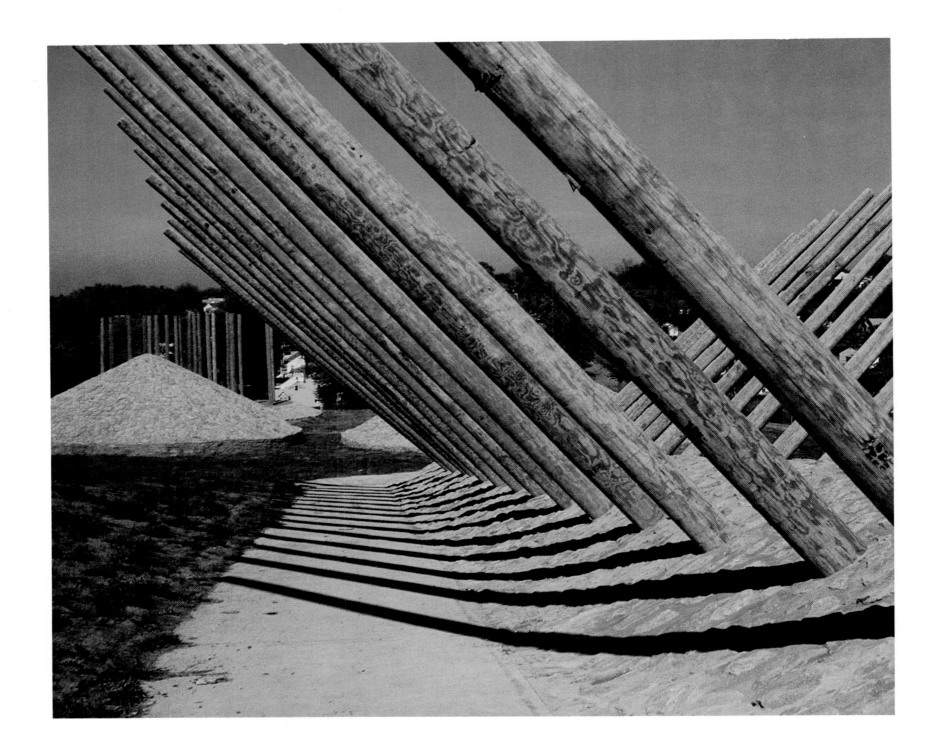

Dale Eldred, sculpture for Southgate Mall (pendulums and suspended tubes), Atlanta, 1976. *John Lowrey.*

Dale Eldred, sculpture for Southgate Mall (suspended tubes in movement). *John Lowrey.*

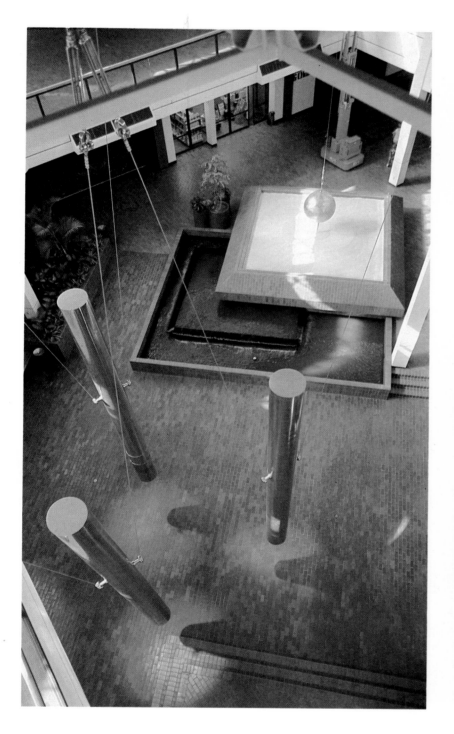

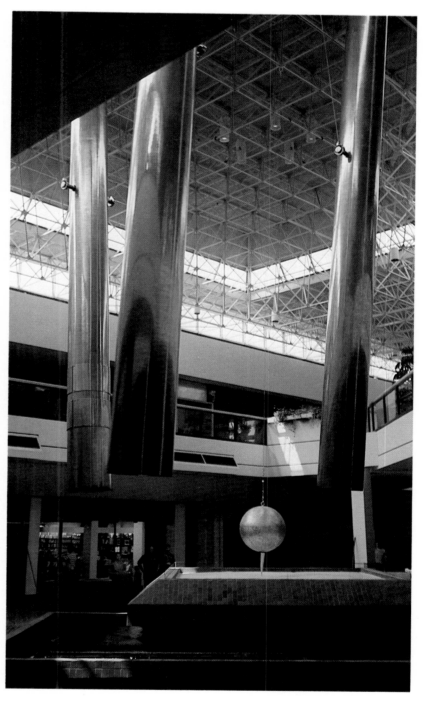

Dale Eldred, original collage for Ozalid print, *Desert,*
1969. *James Enyeart.*

Dale Eldred, original collage for
Ozalid print, *Rocky Mountain
View,* 1969. *James Enyeart.*

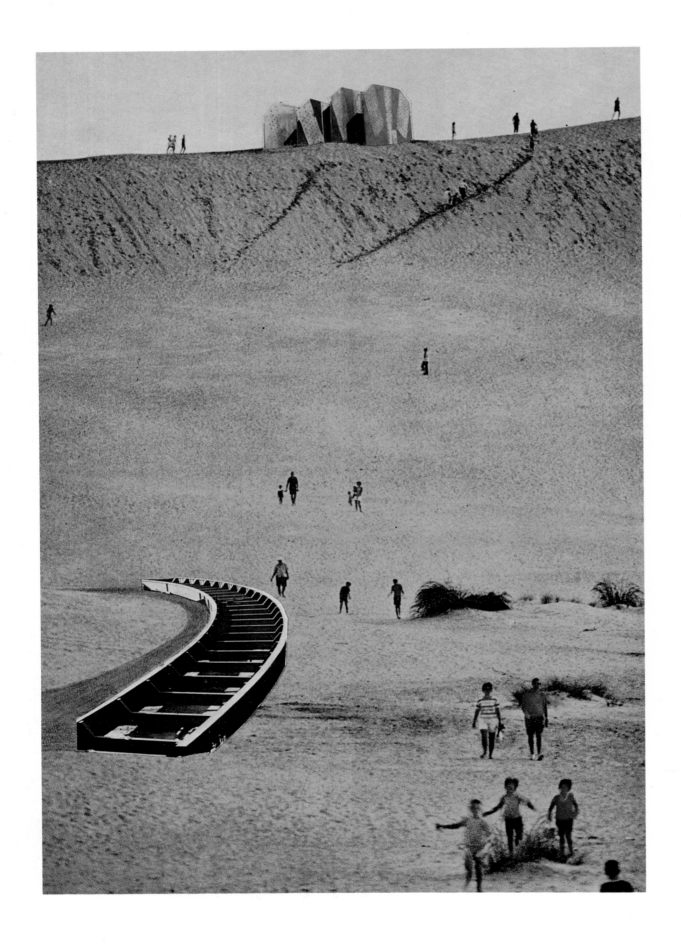

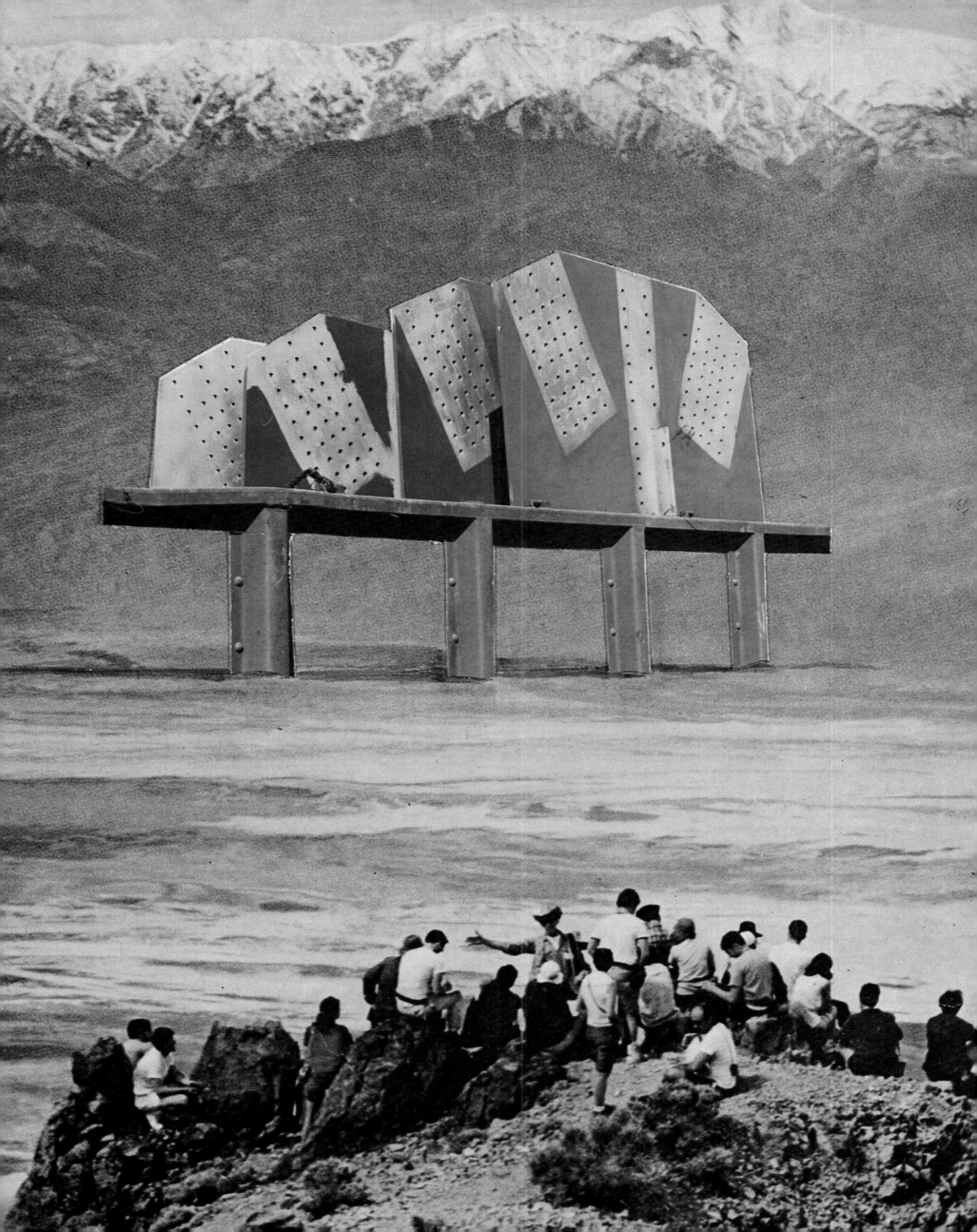

Dale Eldred, original collage for
Ozalid print, *Portuguese Salt Flats*,
1969. *James Enyeart.*

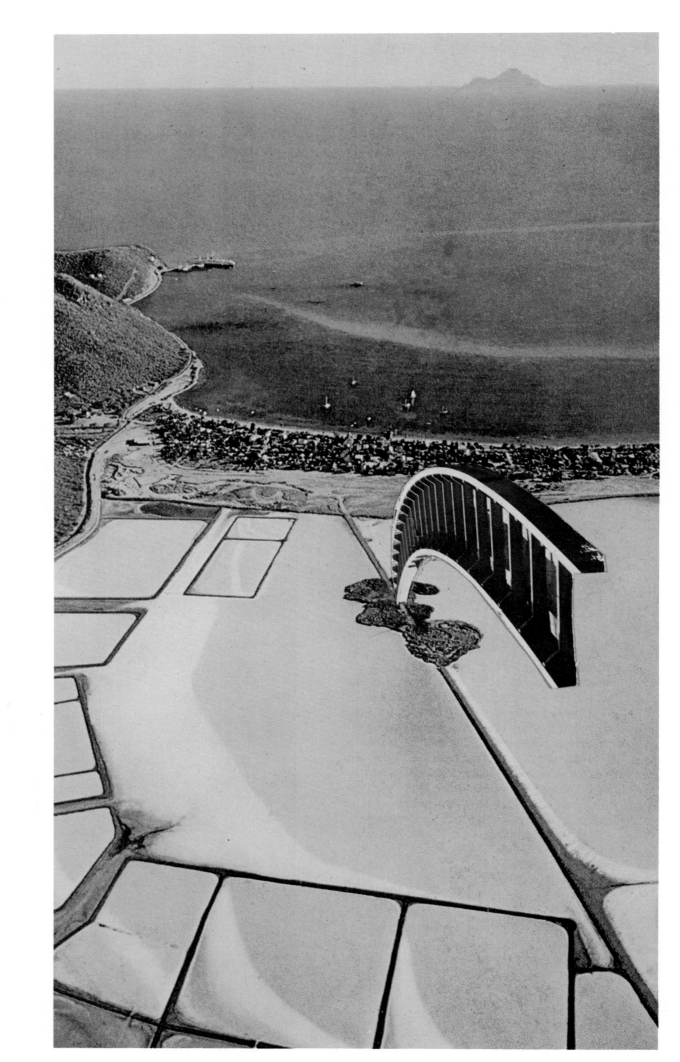

Dale Eldred, original collage for Ozalid
print, *Funeral in Greece*, 1969.
James Enyeart.

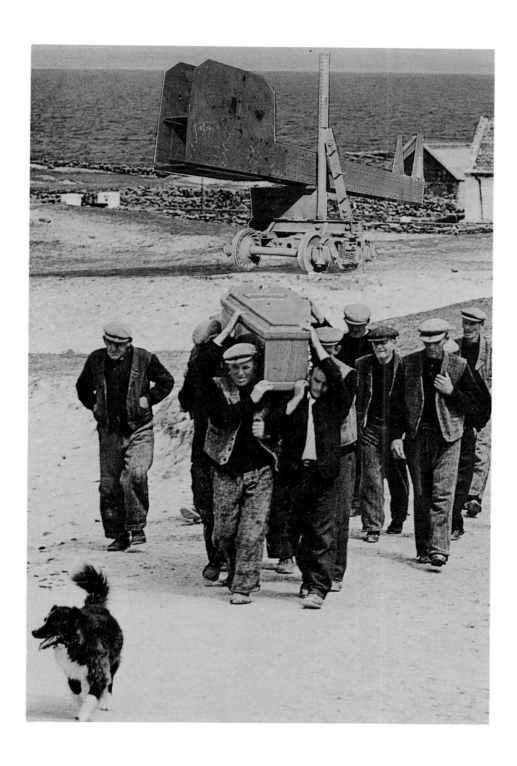

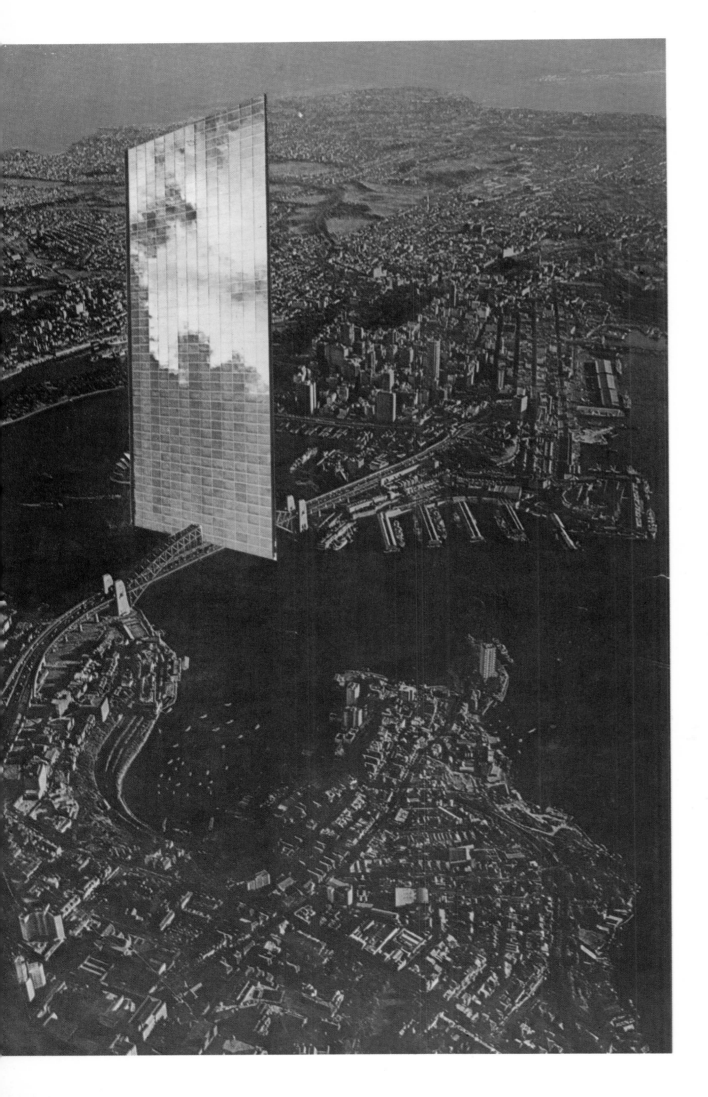

Dale Eldred, original collage for Ozalid print, *Sydney, Australia, Mirror,* 1975.

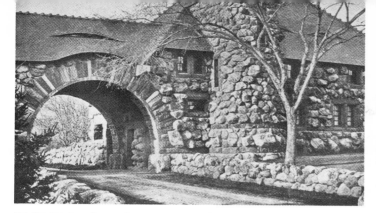

H. H. Richardson, Ames Gate Lodge, North Easton, Massachusetts, 1888. The road shows Cyclopean stonework, 1880–1881, after H. R. Hitchcock. *M.I.T. Press, Cambridge, Mass.*

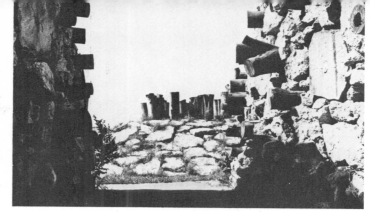

Dale Eldred, Penn Valley Park, north entrance, Kansas City, 1962. *Dale Eldred.*

dimensional form against a fourth-dimensional format of space and time. While present-day technological artists like Boyd Mefferd, James Seawright, or Howard Jones accommodate their art to time sequences through circuitry, Eldred raises his structures and earthworks *against* time, which he has equated with environment. Like the American Indian, he is preoccupied with space rather than time, land rather than sequence. He reverses in effect Bergson's theory of duration. One recalls the Near Eastern addage: "Man fears time, and time fears the pyramid."

His moundlike forms hold eternally against the sun. An Eldred piece takes a sight on the sky. Kinetic sculpture rotates metaphysically around the world; the world rotates around the fixed station of an Eldred piece like the sun against a sundial. "It isn't just the physical sense of the sun; I aim at the stability that precedes us and succeeds us," he says. "Now in Atlanta and St. Lawrence University, I even let movement and changing parts in the act. But in the end everything is fixed." His *Salina Piece* recalls a sundial set in a field, casting its shadow according to light conditions, ever constant against all the solar change it helps record: earth rotation, temperature change. The *Salina Piece* holds moisture on its shaded side, then loses it by heat-light refractions as the sun rises. The Atlanta freon mirror achieves the same thing mechanically. Cold temperatures make both pieces feel colder to the eye and senses. What Eldred seeks here is a permanent measure, separate but equal, which helps describe the identity of natural forces for us. He is "trying to compete with nature to find the right size that best relates to whatever the problem is in paralleling the elements at hand, the prairie, the sky, the horizon scope."

Setting shape *against* the elements involves more than a salient eye for sculptural form; the shapes selected must become timeless. Eldred says, "We talk in terms of years (our lives), but the pieces should erase man's steps, hours, and days." Stone-clad cones (at the Cypress and Thirtieth Street Park in Kansas City) "do not declare themselves in favor of anything, but exist in a self-contained continuum. I have a feeling for surface that resists manipulation and discloses not its appearance but what it is."

Large-scale vision implies size; gigantism involves us with the *feel* of being large, of concept, not just size. After all, a practicing sculptor cannot compete with builders of bridges or hangars in this respect. That goes without saying. Gigantism as meant here is qualitative, not quantitative measure. Swallowing the tape measure is not the point. "I think bigger than I am." Eldred dwells on the problem of expressing energy and vitality rather than the state of hugeness: "Athletes can't function when they're overweight."

American gigantism is imbedded in the massive architecture of Henry Hobson Richardson. Consider for a moment the water-worn boulder construction of his Ames Gate Lodge. In this building Richardson led the way from Victorian elaboration to geological simplification, composing walls of rough local stone over which the roof planes slide like giant sheltering wings. Like Richardson, Eldred, who had architectural exposure in Eero Saarinen's office and who has also made use of boulder-walls and rock-strewn formations in several projects (the 1962 Penn Valley Park, the bedroom vestibules of his own house), has nothing against architecture except that: "I didn't want to spend all the days of my life at a drawing board. . . . I'm just swallowed up by the idea of sculpture. But I can't think of any skyscraper I'd want to do a commission for: my thinking isn't that confined." If Richardson had been liberated from the professional limitations of architecture or if the nineteenth-century park planner Frederick Law Olmsted had leaned more toward them, both might presage more directly the aims of a sculptor like Eldred in this century. Eldred says, "I've got to put together a package design for pieces of land on which there will be no commerce. The Cypress Park land and Pershing Park are far larger in extent than anything I will put on them. I need a vast format to bring off my ideas. Indoors, I need a hangarlike place. I like to work with water systems (the Kansas City, Kansas, mall) and river systems (recent sculptural models), water moving over concrete landlike undulations that sweep." In the open-air ceramic museum, he intends to meld all these elements expressively. "How do you manipulate water and guide people from here to there, all the people and 'land' formations that don't exist in

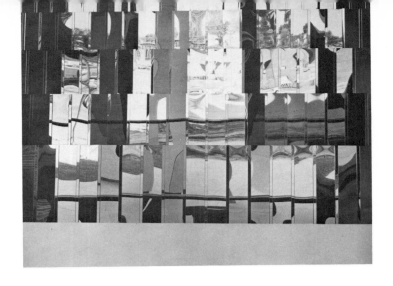

Dale Eldred, Olathe Court House
Mirror Project, Olathe, Kansas, 1973.
Jim Enyeart.

correspondence to architecture but which do exist in my designs?"

A leading criterion for Eldred's environmental approach is: does it definitively reinforce our position with regard to those fundamentals, the planes of earth, and sky? "I think in projections, as in the solar glass for the Olathe mirror embankment. With its wide-open penetration into and reflection of the sun's rays the piece will work like a fixed astrolabe, defining the interaction of meridian and horizon." Why shouldn't sculpture cut the sun's rays and return them with high reflection in a piece also adjusted to the high physicality conveyed by surrounding environment? At one time it was planned for this project in Olathe, Kansas, to elaborate on natural effect by controlling it: invisible behind those solar glass-mirror systems, heating coils were to radiate warmth in winter and freon tubes were to produce a frost on the glass in summer. "You never see the systems, but you will feel the contradicting presence, despite the fact that you're looking at a perfect mirror." This idea has not been cast aside, only postponed, according to Eldred. "I have revived it for Atlanta—a freon plate mirror cutting across a huge interior building court, set in a water-filled base"—like an indoor glacier.

In an Eldred project it is not the human image we concentrate upon, as for example with Rodin's *Balzac,* but the vast space beyond. The objective correlative of Eldred is always natural space, be it a ten-acre field at Salina, Kansas, or eight blocks of a densely populated street in Kansas City, Kansas, or a suburban hilltop. His sculptured formations are highly affected by natural phenomena, and his sculpture designs are meant as barometers of that effect.

Americans "thinking large" have held deep converse with nature. This dialogue stems from the conflict between the Yankee tradition of building and the untamed land: while the aboriginal Americans coexisted with nature, the newcomers subdued it. Why not link this unsparing directness, seen in the span of the Brooklyn Bridge or in the practical hard-edged design of William Le Baron Jenney's second Leiter Building in Chicago, to a purely sculptural concept? Such a process would turn our traditional need for solutions to problems of shelter and settlement toward the purposes of art, narrowing the gap between the real and philosophical aspects of American life. However, Eldred's "man-made landscapes" are created in sympathy with the aboriginal point of view. Again and again his land-projects remind one of the ball courts of the ancient Mayas, a number of which Eldred has visited, particularly Copan. Or is the image that of the Ohio mound-builders? Eldred explains, "With regard to the big mall and park plans, those two trips to Yucatan and Guatemala were timely; it all worked out in time."

Eldred's constructed steel sculptures seem always to "look west" but are landlocked. They are eminently fitted to be set into fragments of the vastness and spatiality of what was once the American wilderness. In our dreams and his it is still there, only much updated. His sculptures are Midwestern, centered as they are on the crossroads to everywhere. They could be lost in the protective umbrella of the Eastern landscape; they metamorphically point to the West (without ever reaching the coast), where by collage they do seem to exist in some of the artist's graphic dreams.

In populating the American wilderness, how little time there was for details of nicety. Eldred doesn't have the time either. Pragmatism and practicality—getting the thing done right—exude their own nicety, as in the case of a Kansas soddy or a covered bridge, or an Eldred drawbridgelike sculpture. All have the fitness of energy. Eldred's energy is of the type that does not tolerate self-indulgence or endless, minuscule adjustment. "Get it in there with accuracy and hang it right." The fact remains that artists or architects who become preoccupied with detail often become muddled in their thinking as well as their aesthetics, a prime case being the academic architects who stifled the lean functional beauty of the skeletal office buildings with academic decor devised by their firms. Beware tedious quotes from civilization's copybook. When Americans confront the specter of being over-civilized, the old need of "primitive" solutions returns. Dale Eldred's work to date is proof that being primitive ("there is something primitive about me") does not mean that one is uncultured, but simply strong. "Decorator sculpture is for the birds."

6

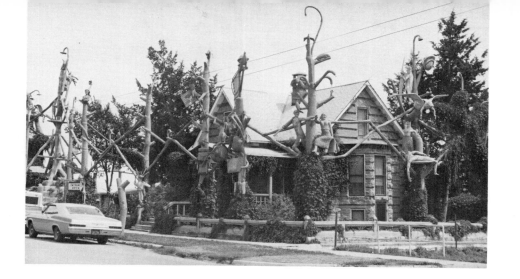

S. P. Dinsmoor, The Garden of Eden, Lucas, Kansas, 1900–1930. *James Enyeart.*

Eldred's shapes are masculine and bold, expressive of a certain toughness and Nordic competence in his own character, always tempered by sensibility. One is reminded of the phrase "tough but oh so gentle." In his hands "primitiveness" also means building competence, emulation of the way of old builders like his Finnish grandfather: "My associations have to do with contractors, builders of society, not artists: they often take more chances than artists I know; the strength of America was expressed in self-formulating ideas behind our barns, tools, and bridges." Because art is engaged to forces of nature, "don't tenderize your feelings. In some ways design has nothing to do with art. I don't regret delicacy (I'm working with grasses now), but I like the blacksmith's attitude. I'm not one of these naïve builders, but I understand the soul that stands behind them."

In a technological society, however, one cannot enter into naïve attitudes that are passé; there is no need for that. To do so would be indulging in fruitless romanticism contrary to fact. Use today's technology openly and assertively, with great physical warmth. Eldred's view is that many painters have been diminished by modern society, forced to assume a precarious role in the art world, and pushed into a corner. "I have absolutely no intention of participating in that role or dimension. I think there are artists who are victims of their environment; I want to contribute to mine through technological means."

In this case a Midwestern charisma does not mean provincialism, or "digging in." Regionalism has gone with the wind. Kansas City provides a good position for the ecologically-minded artist to look out over the world while keeping his balance. It is at the geographical center of the United States, pointing three hundred and sixty degrees to distances far, near, and wide, tropical and wintry. Kansas City each year exhibits every kind of weather, from heat lightning to blizzards. Eldred needs romantic, native-oriented inspiration combined with the sense of cultural experience that comes from contrasting cultures world-wide. He returns to build close to his land: the land. Always put your feet on the ground; respect those who have done so. That is why Eldred takes his students on field trips

first to grass-roots sculptor S. P. Dinsmoor's eccentric Garden of Eden in Lucas, Kansas, rather than the Prado. But he enjoys tremendous freedom of the spirit and is often on the move. That is why he may appear on a motorcycle in the midst of an Oaxacan village during a masked dance or participate in an island-hopping expedition in the Greek islands with Zorba-like fishermen. He never knows where his consuming, expansive interests may take him. He may say, "Ted, I'm leaving for Guatemala in a few days to put together an exhibition of folk art for the Institute. See you at the end of the month."

He loves studying Arabic ways, whether in the Valley of the Kings or Mecca, Indian temple sculpture, any fantastic folk art *in situ,* and English civilization as well, always giving due credit to the residuary strength of people. "You end up on the rockiest coast of Cornwall and go in the most remote, roughcast house, and then inside it's all English china, the tea service, and hominess. That's English civilization and why it's survived!"

Eldred believes that some of the greatest monuments of man across the globe are related to one another by a basic identity of form and energy. There is a psychic progression of monuments that includes Stonehenge, Jaipur, the Temple of the Sun at Konarak (Puri), Mathura, the Mayan sites of Palenque and Copan, and the Gaudi architecture in Barcelona, among others, all of which he has visited as part of a global tour made possible by a Guggenheim grant in 1969 and 1970. He has returned to some of these places since then. With these far-scattered monuments Eldred feels immediate kinship, noting that, for him, in Europe only a few marvels by Gaudi and Brancusi provide "sufficient measure." He would like to contribute to this chain of residuary monuments in North America. He never runs out of root-sources of inspiration or new discoveries among the arts, building, textiles, and pottery of the "fundamental" peoples of the world, which, aside from known monuments, make up a neglected "third world." His enthusiasm for weaving, masking, and pottery is itself an inspiration to watch and is boundless, especially when he is collecting folk art in the field with evident gusto: "Greek costumes and Kelim rugs really have it!"

Man is part of the whole cycle of change, but

7

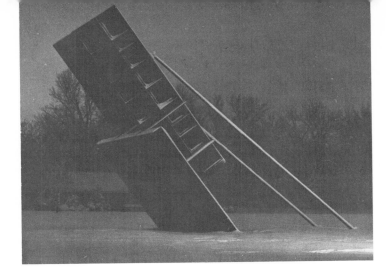

Dale Eldred, *Salina Piece*, Salina, Kansas, 1969. *Roger Morrison.*

the monuments do not change—like Eldred's sculptures, they are constant. Many temporary structures are really very changeable, but the shapes of Eldred's favorite monuments are not. They are related to earth forms, anchored, so to speak, "underneath." Their sense of energy is elemental. Sculpture should be as elemental. "It takes thinking to arrive at a simple conclusion. We can use simple or traditional elements (mounds, peaks, troughs, terraces, suspension cables, trusses) because they are factual," Eldred explains. Facts should never be toyed with. Directness and firmness are the measure. During construction of the Kansas City, Kansas, City Center mall a planning consultant wanted the mound "halves" to be set separated off-axis, not symetrically opposite as Eldred insisted. "I didn't mean this feature to be designed 'à la drafting board,' but to be set implacably on its plateau line, as a tumulous form without any slipping or 'curving' of alignment." There was no question of a double ellipse, only a plain circle. "I didn't want the automobiles passing by or the pedestrians to have an easy time of it because of designer 'cuteness.' I wanted an abrupt taking of heed, a definitive encounter, like hitting an Arizona mesa dead on." Because it has no function, Eldred's "mound" remains sculpture, gives way to nothing, and will remain pristine after the automobile passes by or the pedestrian walks through the cut between the mound segments.

Eldred's Kansas City open-air folk art museum, when in the design stage, gave evidence of his creative process: "We started with slides showing the traffic patterns of the area, learning about developments nearby, such as the purchase of air rights over the nearby railroad tracks. The land plot I've laid out: I've no idea yet of concrete shapes, except that we'll have to go down below the terrain line, especially at the back, and maybe only the two bus stops will be sheltered. The model will be of Plasticine because the architects in the Park Department, if they see a model of rigid materials, will go rigid too, and do anything to keep the model unchanged, when, to my mind, the model is the most sacrificial thing of all." The *modus operandi* can always be flexible. "I change the model by cutting on the Plasticine." Eldred is particularly pleased that one of the Park Department staff working on the ceramic

8

museum with him has designed golf courses which make him "more susceptible to terrain shapes. There is a relationship of trees or sand traps to my man-made landscapes." But the end product must "ignore all my frailties, spring independent of the times." Bulk, resistance, forces, and energy put together produce a design constant, as clarified as an equilateral triangle.

Once this sculptural time dimension is made constant, effects of light and shadow, water, ice, sunshine, snow become the sole element of change. Take the *Salina Piece*, for example: when its giant grid absorbs the temperature of night, a wash (dew) accumulates on its cold surface. Then the same surface picks up morning sun like a solar cell: by noon it is dry in texture, rasplike on the south face, while the north face still has dampness retained by waffle-like spandrels facing away from the sun. In the heat of high day all surfaces are dry and placid. In winter this "waffle grid" is vigorously etched with snow, and in the dark the *Salina Piece* seems to lose visible means of support, as if it were a giant animal trap. "You feel like a rabbit when you're under it."

Eldred continues: "I am very direction-oriented in my work, and directions often are indicated on drawings." What is more inclusive, more universal, and less tainted with preconception than the four directions? Directional alignment is not only a mystical matter, but a practical one. "Wind direction can be an important factor, as in the case of the wooden poles projecting upward from the cone interior at Cypress Park. They must be wind resistant." His design is related to the process of surveying. "All my pieces are sited; you can hit them with a dead level." His designing process is a little like navigation by degrees, or measuring in minutes. A number of construction drawings are measured off in this way. Surveying is increasingly a part of the sculptural process, to the point where there are graphics, drawings, and sculpture table pieces based on "created" land elevations, the pieces being like three-dimensional geological survey maps.

Directionality is part of Eldred's aplomb. If a sculptor no longer believes in sculpture created on axis in imitation of the human body, but believes in sculptural landscape, the compass becomes the way of orientation. Eldred stops short of designed in-

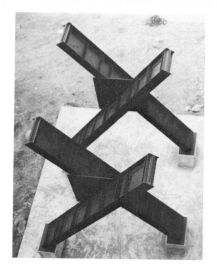

Dale Eldred, *Mankato Piece*, Mankato, Minnesota, 1968. *Dale Eldred.*

finity because of his constructual bias: "the infinity" is out beyond what he makes. His work relates to but is not of it. It is finite, like building. But the tensions work toward the horizon or endlessness, as does the compass needle. One has the feeling that his expanding aesthetic will take on increasing multidirectionality. "My brother, who is a pilot, has exposed me to celestial navigation," Eldred says. One of his outdoor pieces is in effect an instrument of measure: *Grand Rapids Pendulum* moves across sand, sands of time, to create lines that are always subject to erasure. "There is in my work an elemental relationship to ratios, as with Mayan terraces. It is full of the implications of optical measurement." Working with it (often this means walking through it or around it), one is continually seeking broad optical levels. In fact, the X-girders of his *Mankato Piece* resemble an elephantine outdoor sextant: "I'm still fascinated by the idea of bombardment by television waves realized in a very definite way like energy or rain that becomes a part of my outdoor pieces. In effect the elements run through transit points in my pieces."

There is often in the American conscience a bit of the Paul Bunyan myth where land is concerned. Didn't Babe, the blue ox, create a lake with each footprint? Eldred, a true son of the Bunyan country, is infected with this love of gigantism. He has been accused of exaggeration in his verbosity, but the accusation is not fair: he simply slides back and forth between material largess on one side and conceptualism on the other. Like Bunyan and his ox, his work "strides" over the landscape, improving without destroying, recrudescing the terrain in the midst of cities, both in reality and as an idea. His giant wooden pull toys for adults are a Bunyanesque spinoff. So was his off-the-cuff spate of decorating rough Ozark pottery blanks. These, however, are side issues.

With regard to his major projects, no Bunyan ever traveled so widely or commanded such technology, and one must not overdraw such analogies. "My mind does indulge in all the mysteries; but when I make a choice, it has to be with things you can feel and be with and walk through. I am fascinated with the presence of things rather than just the thought and transparent ideas. Something has

to be in the end, it keeps coming back to that in the end. Otherwise, you end up playing sculptural games," explains Eldred. No matter how esoterically his *Grand Rapids Pendulum* writes upon the sands of time, suspended high in time and space, it is sculpturally materialistic.

Considering Eldred's "giants in the earth" stance, it is surprising how recently his mother's parents emigrated from Finland: 1928. He was born in Minneapolis six years later. Nonetheless, his family origin pertains to the nineteenth-century Scandinavian settling of the north Midwest romanticized in Ole E. Rolvaag's novel. His Finnish grandfather built boats in both countries, having brought the Old World sense of craft with him. "They came to Minneapolis in search of a piece of land similar to that they had always known," Eldred says. There was poetry as well as carpentry in the family inheritance. "One of the better known Finnish poets was one of my grandfathers, Ilo Robinson." Although his father was Irish-English, the influence on the son was always from the Finnish side, as he never knew any relative of his father's. "Everyone spoke Finnish before English; going to Lutheran church, I remember singing Finnish."

He came from an athletic, poetic, building strain, and to all these characteristics he has remained faithful in his work. In Eldred's environment there was special respect for constructional achievement: "I remember when my grandfather was eighty-eight, he started building a house with my father. He loved to make pianos. He died when I was a kid, but I revered the image he created—a world of tools." Ever since, he has been at home in that "world of tools" and amidst things crafted or fabricated with them.

Eldred's father, also a carpenter, used to take his son to the Walker Art Center, the Museum of Modern Art for Minneapolis, to see "how things were made," a quite liberal attitude, part and parcel of the agragian liberalism of the place and period; "He never had a derogatory or snide thing to say about the experimental things that were exhibited there, because he understood the role of people who make things." Modern art never was raised as an issue; rather, it was not intellectualism, but a real respect for the arts and crafts that was stressed.

9

From the first exposure there was no antipathy allowed to grow between art and practicality, and no hang-ups were induced of the more aesthetic variety. Robustious Nordics do not allow intellectual weeds to grow! This background instilled in Eldred a sense of direct action, ease with machinery and workers, positivism, and also a concern with community betterment: "My mother is in her late seventies but still serves on the mayor's welfare council. We lived modestly but were always community-minded." There was always a warm sense of what would suffice, what Eldred calls "enough."

"Looking back, I was lucky to have been raised with such basic people. It was a really ethnic area of the city, Finnish, Jewish, black, so much so that the old Jewish men walked to the synagogue together. It drew things in sharp perspectives right away." Perhaps some of Eldred's interest in people came from this early feeling of ethnic comfortableness. "Lots of politically active, bright people came out of that neighborhood. Do you know Bob Vaughan [TV's Man from U.N.C.L.E.]? He's a good friend of mine, raised down the block. Used one of my pieces on a TV show once. The guy who wrote *Marzie Doates* kicked around there, too."

There was never any sort of hardship, but there was no automobile either. "If you didn't walk, you ran, for athletics were held high, especially track. Our community hero was the Finnish miler Paavo Nurmi; when he came to town, my grandfather got seats at the finish line with the Finnish ambassador, yelling all the time: 'Go Paavo!'" Much later, in college, Eldred posed for illustrations of discus throwing for a track association brochure. "I still throw the discus often; I've got one out at the house right now."

In 1952 he won a football-track scholarship to Hamline University in St. Paul. The next year he switched to the University of Michigan. "By the time I went to Michigan I knew I wanted to be an artist, but never related to the word 'artist.' I obtained a B.A. in science and architecture in 1956, but I felt I didn't want to go into an architect's office: more and more the closed studio or office was contrary to my nature."

Early on, Eldred became dissatisfied with rigid disciplines, choosing to interview an art anti-hero,

the first of many who have claimed his interest at one time or another. In New York he called on theorist-architect Frederick Kiseler three times. "He struck me as an individual with a multiple background, an architect-engineer who also did things with cable and timbers (sculptures only to be seen in his shop). One of the things that came through to me was his stretched-out vision; his 'endless house' came out of more perverse schools of thought. But he was a misfit." Why? Perhaps because Eldred never could relate to Kiesler, to the things he made: "He always wore a sport coat. . . . never saw him make anything, a puzzle to me." In Eldred's view, if you don't make things you don't exist.

In 1954 Eldred spent a semester at the University of Minnesota, without severing his University of Michigan connection. In Minneapolis he spent part of that year at sculpture. But of course he tired of the studio. Zorach came and said, "The road to sculpture is paved with stone," a road he did not at all choose to take. Saul Baizerman, "the last of the bang-bang school of sculptors," chased him out of a one-man show in preparation at the Walker Art Center, yelling between hammerings: "Okay, kid, get out of here!" He recalls Lipchitz and David Smith lecturing to students, the latter opening his lecture by breaking wind, followed by the fanning of his coat. "So much for art," Smith said. "Now let's get down to business." It was always a hardy school of art and thought.

After his B.A. from Michigan, Eldred stayed on for a graduate degree in science and architecture (awarded in 1959). At the School of Architecture Eero Saarinen, a celebrated fellow Finn, was an adjunct professor. Saarinen invited graduate student Eldred to join his design staff part time. "I'd go into Saarinen's studio behind Cranbrook school and see the model for the St. Louis arch hung above the drafting area. 'What's that?' I asked. I don't think anyone there thought it would ever be built."

Though closeted magnificently, Saarinen's design staff was also removed from the builder's world. This made Eldred miserable, but he can remember the projects at the time: Saarinen's M.I.T. chapel and Kresge auditorium. "The one thing that came through to me was Saarinen's fantastic ability to

deal with the complexities of his discipline. I learned something there. He let you know what competency in architecture was, what you had to be. It was useful, but it wasn't me." Eldred told Saarinen that he "had no desire to be a draftsman out of touch with 'things.' Saarinen replied that he would finance me to finish up while I decided if I wanted to be an architect. Or did I want to be a sculptor? I had three free months to make up my mind: 'Look, go ahead and find out what you're about.'"

Eldred continues: "After the M.A. degree, I was living on and working a farm outside Ann Arbor, and had a studio there. I married in 1955." The Saarinen reprieve gave him a chance to think matters over a little longer. It was getting down to the wire. "If I was to be an architect, I had to 'center things that way,' as Saarinen put it. Instead, obeying my family trait in making things, I tried out casting in an iron foundry, making my own things." That factory experience did it. It rang a familiar bell. For him, it was reality, a chance to deal again with *things* like his family had always done. Here was a hint on how one could become an artist yet operate outside the cloying studio or office. "There was some guts to the operation—like my grandfather's approach." At Fell Foundry he also met Julius Schmidt, "about the only sculptor at the time working in cast iron as I was attempting to do, rather than bronze." Schmidt told him he was leaving the Kansas City Art Institute sculpture department and moving to Cranbrook. Did he want the position? There were foundry facilities there. "I had turned into a sculptor on my own terms. I no longer had to ask."

2

PENN VALLEY PARK

What attracted Dale Eldred to Kansas City was the casting equipment, which the University of Michigan lacked and which Julius Schmidt had just left in his wake: cupolas for melting iron, a foundrylike studio in which to cast. But very soon he acquired space of his own at the Haypress Foundry and did his own casting there: aluminum and iron motorblocks, tractor parts, and crankshafts were on his mind. "I began to think of humanized machinery, like American cast-iron stoves, but I balked at their decorative patterns which were only a surface thing. I wanted to go deep into iron, into its constituent being."

He preferred iron (or aluminum looking tough as iron), he remembers, because of its intensely masculine character and feeling: "It melts high and solidifies quickly, is intensely male in its definite way of responding, not sensual and delicate like bronze, for instance, no highlights or luster. Iron has a beautiful gray color, not seductive, but factual."

As in Michigan, Eldred found a farm to work, this time at the south end of Kansas City, just over the Kansas border. He lived there "amidst machinery. I put a lot of my first castings out there in a woods: a good end for them." Eldred cast a series of wall plaques and boxlike or headlike pieces (iron; aluminum), often with gonadlike projections, "architectural pieces." In them he used cheesecloth and burlap as mold linings to "get rid of prettiness, softness, or highlighting." There was no modeling, despite textural reference; they were cast like a stove. "The molds were directly built of ready-made materials mounted on rigid boards of styrofoam, with exposed nail connections." These pieces staked out one of Eldred's sculptural tenets: strength without modeling. They constituted a self-made kindergarten of technical experience, in need of positive application. But that was all.

A number of these pieces were exhibited at the Nelson Gallery Eldred exhibition in April 1962. Because his talent was too tentative for a major exhibit, his was informally held in the Nelson Sales and Rental area. There were only two buyers, one of whom was the architect Elpidio Rocha, who would shortly play a catalytic part in Eldred's first outdoor project, Penn Valley Park. The other was

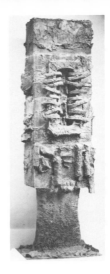

Dale Eldred, *Sculpture II*, Nelson
Gallery of Art–Atkins Museum of Fine
Arts, Kansas City, Missouri, 1962.
Nelson-Atkins.

Karen Dean Bunting, head of the Sales and Rental Gallery, whom Julius Schmidt had told: "Don't worry. There's a young man coming who is really going to develop and, in the meantime, make a fine teacher."

A catalogue of his free-wheeling teaching projects at the Kansas City Art Institute from 1962 to 1965, where he instructed beginning students, gives an idea of Eldred's expansive reach, feeling for activity and experimentalism that would eventually extrude into his own work. "I never had students working at what I was doing," explains Eldred. From the first they were project oriented rather than piece oriented, and were given materials "you couldn't render but had to put together, like plastics." There were built landscape pieces with sails, floatables (transparent, inflatable structures in which people could be seen walking as they floated along the Kaw River from Bonner Springs to its confluence with the Missouri River), and inflatables strung through buildings, and "sometimes a piece of work passed through the mind from student to student, until the thirtieth had to draw it." The media were indeed mixed: Eldred remembers with a certain glee "collective 'drawing' in the snow, thirty male students on the Nelson Gallery lawn using only one resource." In comparison, Eldred's own work seemed less free, held to his constructional obsession.

Sculpture II, a seven-foot-high cast-aluminum piece, was included in the Sales and Rental show, though it had been in the previous year's Nelson Gallery Mid-America juried exhibition, at which time it was given to the museum. The Nelson Gallery accession-card description pinpoints the inchoate vigor of Eldred's approach at the time, leaving out only the obvious libidinal overtones: "Above flat plinth slender pedestal form supports irregularly surfaced parallelepiped decorated at random with bars, bosses, and free-form accretions in relief, impressions of burlap, etc. In front, raised oblong frames hollow from whose sides curved bars protrude."

This vocabulary of wild sexual machinery Eldred balanced by a 1963 piece called *Standing Iron*, the first in which his casting ideas came of age. *Standing Iron* was not inchoate, since the cast framework is cagelike, rational like an office building

frame. No longer conceived solidly, the iron planes open up into "something you can see through." For the most part, the material is handled smoothly, free of accretions, with a builder's respect for its elemental, integral character. If one could remove the cage and project the hydrantlike interior elements into giant scale with far greater power, the fabricated sculpture to come would emerge from the chrysalis. Sam Francis, Richard Diebenkorn, and James Speyer, who juried the 1963 Mid-America exhibition, thought well enough of *Standing Iron* to award it a first prize.

These potentials lay dormant while another direction was opened to Eldred. The Kansas City Penn Valley Park project was as much a surprise to him as to anyone else when it landed in his lap. In September 1962, the architect Elpidio Rocha, a Kansas Citian of Mexican descent, called Eldred: "Do you want to do some sculpture for a children's park I'm doing down on Twenty-Seventh Street?"

Eldred answered no, but Rocha brought along his plans anyway. Eldred remembers, "The one-half block plot in the inner city was just a hole in the ground where they'd taken the school out. What he had in mind was very corny, with a little house in the middle, unconnected to anything else. He wasn't that interested, really." Eldred repeated no, he did not work that way, but that he would design the whole park as a sculpture. He became excited by the size of the property, enough ground to relate to the suburban farm he lived on. Rocha "made it possible for the project to occur as it did. He took the risk in coming to me."

The design period was volcanic: in three days Eldred conceived and made a rough model in Plasticine on a board. "I took a string, framed with it a gridiron over the model, then dropped strings at the intersection points for corrections and depth and height (elevation) measurements." This, it should be pointed out, is the reverse of usual drawing-before-model, as an architect would think. Eldred did some presentation drawings, necessary to win approval for the project from the neighborhood. The blueprints were drawn in Elpidio's office. "I had no such facility for that sort of thing: it wasn't part of me at that time as it is now." Specifications were also prepared in Rocha's office, according to Eldred's

14

model-plan. But the specifications grew out of the ground and the imagination, never from the drafting board. The five design materials were earth, glass, logs, stone, and water. No casting here.

The presentation was to a hundred neighborhood residents at Guadalupe Center School. Only a priest spoke against the project, a certain Father Brown: "Children have to learn playground skills on swings and teeter-totters; besides, the people of this area don't understand this sort of thing." A young mother stood up: "You don't understand it, but we do. Our people have built pyramids, we had arts: I call for a hand vote." The result: ninety-eight for, two against. The Park Department head had considered the park as being too far out, but he presented it for neighborhood consideration impartially and democratically. Actually, the Welfare and Recreation Department had jurisdiction, and there was a certain amount of ethnic pressure, due to the solidarity of people of Mexican descent in the neighborhood.

There were three bids: the winning $38,000, and bids of $80,000 and $90,000. Earth was a major expense problem. "Hauled earth is expensive but hard to get rid of." The cost of earth was knocked down by obtaining it from the excavation for the downtown long-lines telephone building. The city prison was called upon to mill the logs and treat them with penta preservative. "Every morning at 5:00 a.m. I was out at the farm. From the prison I hauled them to my farm and reworked them on a hill: they were skinned on the hill top and rolled down into horse troughs and boiled in linseed oil to make their preservation sure. At this time a lot of the work was still conceived in home-made terms."

Eldred continues, "I spent a lot of energy seeing that the stones were placed correctly, didn't want to be goofed by the stone walls or center mound facing." When the north entrance inner walls did not splay enough, Elpidio Rocha simply issued a change work order; later the city sued him for the change: "You mean you pay $5,000 to an inspector who didn't catch this when there are only two of us?" The matter was dropped somehow.

Rocha's sense of wheeling and dealing, his adroit manipulation of the bureaucracy, opened to Eldred new possibilities on which an artist would have to dwell if he were to master the craft of environmental art: "I arrived there one day and saw the excitement of the earth. I knew the others involved weren't getting the same supportive jag that I was. I was building a total thing: it had little to do with parks as they exist; it was a space coordinate. All of a sudden I was out beyond them and something exciting was happening."

Eldred strode out to the enclosure where a bulldozer was shaping the center mound, but it did not look right. "The contractor had staked it out where I designed it, but it needed to be moved farther to the east. The mass of the work really caught me up; I feared that it was getting away from me." He stopped the man on the bulldozer, feeling that probably nothing could be done, that it was too late. "He showed me the stakes. It was simple. 'Put a stake where you want it.'" Such experiences showed Eldred that changes during heavy earthen construction could be made; it was a really flexible material if it could be watched closely. "I did have control if I acted in time." After that a telephone was mounted in Eldred's truck, so the construction foreman could get in immediate touch with him.

Inmates were released from prison chores to work on the rough stone walls, into some of which pole ends and treated wood were also imbedded or inserted. "They got good at it, quite dedicated. This was different in their experience. One day when the city put up ugly project signs, I took a chain saw and took them down." Neighborhood people began getting protective of "our park." When the city began to put in retaining walls that were not in the plans, Eldred was told by neighborhood informers. After the park was dedicated, "anytime the city fooled around with it—pretty benches or orange trash cans —the people in the neighborhood would call me." The children did their own exploring, using the mounds and logs as forts and the vestibules and crossed-log area for games of their own invention. They worked not with toys but with "the real thing," surpassing the missing playground gimmicks with their own activities.

Penn Valley Park did not intrude on their imagination by over-puerile suggestivity. It is simply not in Eldred's character for him to play down to human nature. As an artist he sought his own level

of expression to which he remained constant and steadfast: a piece of sculpture does not compromise when composed from nature. Rather, children were given the facts, not the content, with which to fabricate their own programs of usage: wading, tree-limb-climbing, log-jumping, scaling walls, stalking, hiding, staging play about whatever came to mind. Exact connotations of any sort were avoided. When empty, the park (it was really nameless and was sometimes designated the Twenty-Seventh Street Park) became massively formal, but at the same time ritualistic and archaic in mode, quiet, Druidical in feeling. Here in rudimentary form was set down Eldred's almost oxlike power in the handling of natural forms: logs, rocks, grasses, redesigned in a way a tiller of the soil or a hardy, animalistic pioneer could understand, or for that matter a Mexican-American, descended from the builders of pyramids.

During the winter of 1962 the soil compacted. In the spring of 1963 the two entrances were tunneled with bulldozers (Mycenae-like areas that "slowed your entry pace"). Poles were set upright at the north entrance to help shut the view from the street. The west entrance contained an interior vestibule or open cistern with log ends set out from the circular walls through which one had to pass; the west and south sides were closed. Prairie grass was planted all along the encircling seventeen-foot-high outer berm, to which rough stone revetment had been applied at the two entrances. Within the extensive interior "pocket" was the mound surmounted by twenty-five to thirty poles "like an elephant graveyard" and at a distance a natural sculpture of criss-crossed tree trunks and limbs, "a sort of driftwood conglomerate," and farther along a heavy rock set like a dolmen. The wood-pile sculpture and Zen-like rock were all that touched upon ideas attractive to popular avant-garde taste. Even these elements were played straight. They bordered a kidneylike water area at the back of the park, twenty-five jets shooting up through rocks and sand, against an interior background of uncut prairie-grass berm. All these features were developed side by side in free association without a center of focus. Eldred "wanted an oasis in the dense Mexican area like a womb; once inside you wouldn't be able to look at your front yard," hence the sense of enclo-

sure and portcullislike entry areas. These vestibules introduced a kind of hide-and-seek entry into another world, not only the child's but the whole neighborhood's; inside, the participant could not see the cars passing or parked at the curb. He became preoccupied with interior environment opening up before him in a natural and many-sided sequence. The water jets opposed the Kansas City heat as a kind of temperature-relieving sculptural mode "with kids seeing only the house tops."

This was not architecture, because "an architect could not afford a project like that in terms of living with it, watching it, doing as well as inspecting it." Its design would have meant as little to an architect as to a traditional sculptor; it was *sui generis*. Before it was finished, Elpidio Rocha left to spend awhile in Mexico and returned just in time for the dedication. At the dedication the city council, Mayor Roe Bartle, and Guadalupe Center Girl Scouts and Boy Scouts officiated; there was a Mexican band for dancing later. There was nothing of art-chic about this opening; it was a neighborhood hoedown. The Kansas City urban award and local yearly A.I.A. award were won by the park. "All my supervision was that of a sculptor so that I would get paid. I was asked to represent the 'office of Elpidio Rocha' at the award and refused. 'I represented myself, not Elpidio Rocha.' Elpidio went up and accepted both awards and took lots of credit. There has been some confusion over our respective roles ever since."

The park gave its area an unconventional focus, private yet open and contrived. It was a totally urban piece of sculpture set into the land for the populace. It had no pedestal or base. After all, a veld does not ask to be consciously framed like a painting. It was totally a thing in itself, environmental in many dimensions of appearance and use. As a playground it was written about in *Time* magazine and also in a book on playgrounds, but its sculptural connotations were largely ignored, for they were ahead of the times. While it was highly metaphoric, the park was not symbolic of Pop, Op, or anything else of current topical interest at the time. Its artistic unity was highly ecological. This did not prevent the Missouri State Highway Department from purchasing it from the city in 1965 for demolition

to make room for a freeway. There were many protests, including a letter I wrote to the *Kansas City Star* and a strong protest by Richard L. Brown, who wrote: "If anything in Kansas City is worth saving from the onslaught of urban ugliness, it is this little gem of a park. Even if it were not a brilliant exercise in sculptured landscape and an absolute delight for the children of the neighborhood, the park would be worth saving for its fountain alone. Kansas City prides itself on being 'The City of Fountains.' If one of those sweet, precious bubblers around the Country Club Plaza were threatened, there would be a clamor of unprecedented volume."* By 1967 not a trace of the park was left. Eldred comments, "That freeway ripped right through that ethnic community; the unity the park once gave them doesn't exist at all now. When the park was destroyed, people assumed I'd build it again somewhere exactly as it was. How could it be done? Where? It was unique to place and circumstances: *this* park only; no way to rebuild it."

The rough-and-ready textures of the Penn Valley Park grew out of the burlap and nail imprints of the cast wall plaques, but what a transformation took place. The scale was now geologic, Bunyanesque. Nature's raw materials went seemingly unchanged into the artistic maw. The rough-and-ready forms exuded for the first time a quality of elementalism, not to say gigantism. The pressures of the project produced a method of work that excluded any heed of nicety. Bulldozers do not encourage delicacy: they push hard. Their push constituted liberation from the limits of the artist's hand. The ground-line and sky replaced that hand. There was an eruptive, energetic directness that demonstrated a new and personal sculptural language. It was primitive at this stage, making up in portent what it lacked in refinement. But for a while a continuation of the park idea was put aside even by Eldred. He could think of no way to secure another application of the concept. It seemed a one-shot operation. A year or two subsequent to its

dedication, Penn Valley Park appeared little connected to anything like a trend; there was no recognizable earthworks category of art at the time. Though blending warmly into its neighborhood setting, it already seemed on the outskirts of art, quiet in its obscurity, awaiting its early demise.

* Richard L. Brown, *Kansas City Star,* November 27, 1965, and *Landscape Sculpture by Dale Eldred* (catalogue), Museum of Art, University of Kansas, November 5–December 12, 1965.

Blueprint, Penn Valley Park, Kansas City,
Missouri, drawn by Ralph Keyes, at the office of
Elpidio Rocha from Plasticine model by
Eldred (since destroyed). "I changed
dimensions and moved things from here to there,
so this rough drawing was only for contracting
bids. Many details and elements were
left open on the drawing" to be provided and
selected by the sculptor "because one could not
bid on undetermined elements that could
only be solved by building. It was quite
remarkable that the city went along with such
loose specifications. Evidently, a well-
intentioned lawyer read the contract and Elpidio
was shrewd." *Dale Eldred.*

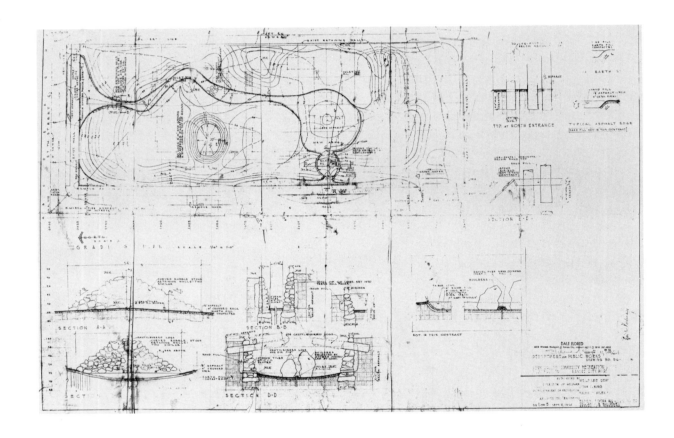

Penn Valley Park: view of east entrance from atop exterior berm. In background Dale Eldred's stone-clad mound and wooden sculptural construction presage Mark di Suvero's crossed timber pieces. "I changed a previous specification for that timber piece; originally there were to be stone serpentine walls set there, but these couldn't be bid upon, so I came up with the timber idea in three days. Those berms are 12 feet high. From the street the only visible means of looking into the park was through the two entranceways, and from inside you couldn't look out—very enclosed, more womblike than appears in the photograph." *Dale Eldred*.

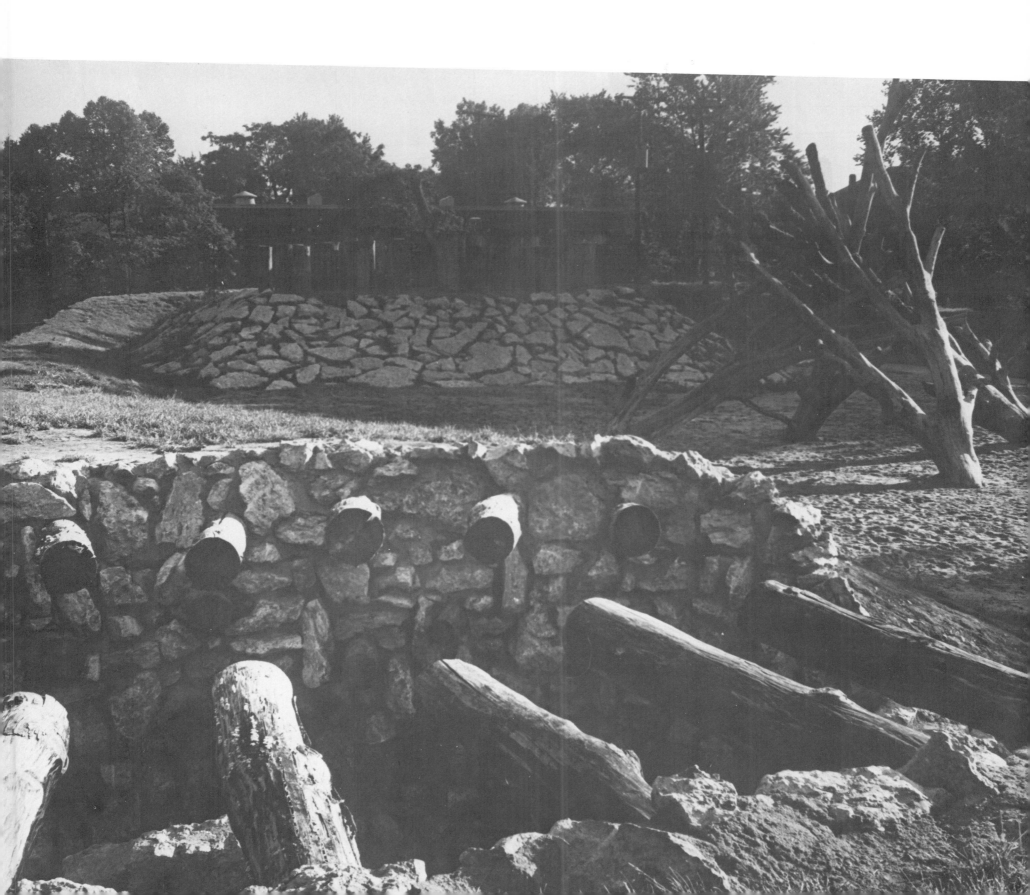

Penn Valley Park: close-up of stone-clad mound
surmounted by logs cut by prisoners at
the Municipal Farm. "These logs, mostly walnut,
were from south Missouri. They were
selected because of their hardy dimensions;
some were at least 4 feet across." *Dale Eldred.*

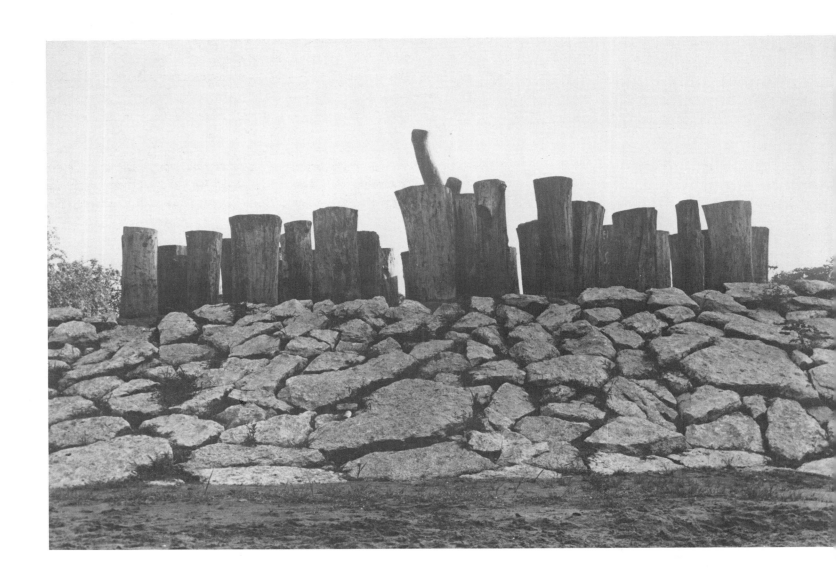

Farther into Penn Valley Park: children playing in Eldred's first
waterway, with mound and east entrance in background.
Dale Eldred.

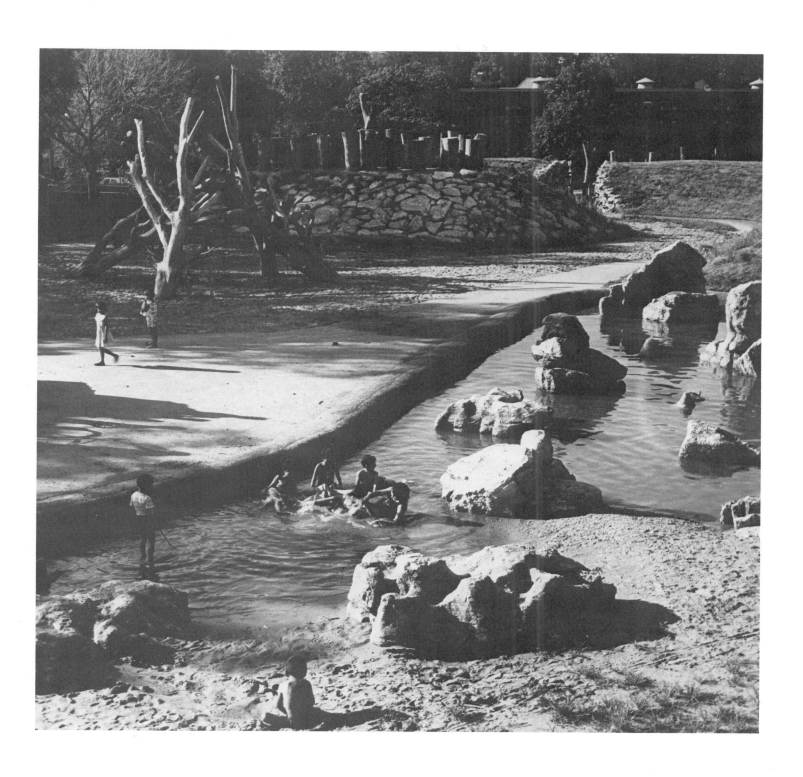

Penn Valley Park: detail of water jet.
A naked child plays in background.
Foreshortening makes wood
construction appear nearer than in
reality. *Dale Eldred.*

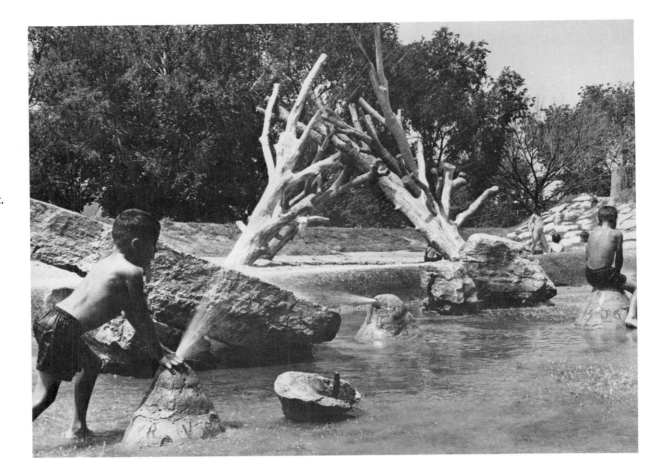

Penn Valley Park: water, rocks. "The
city was concerned that kids
could fall from the 30-foot high
timber arches; this never happened."
Dale Eldred.

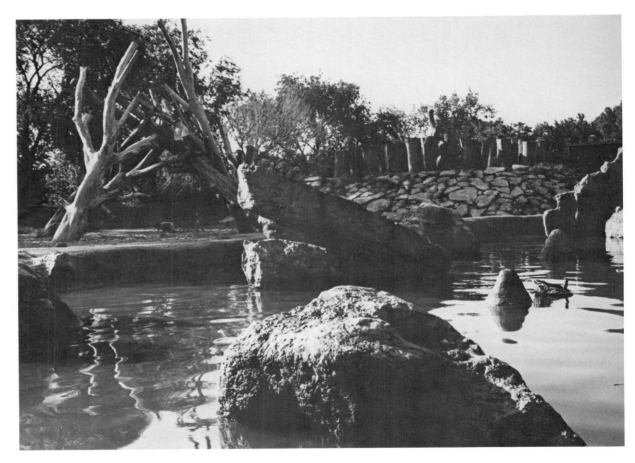

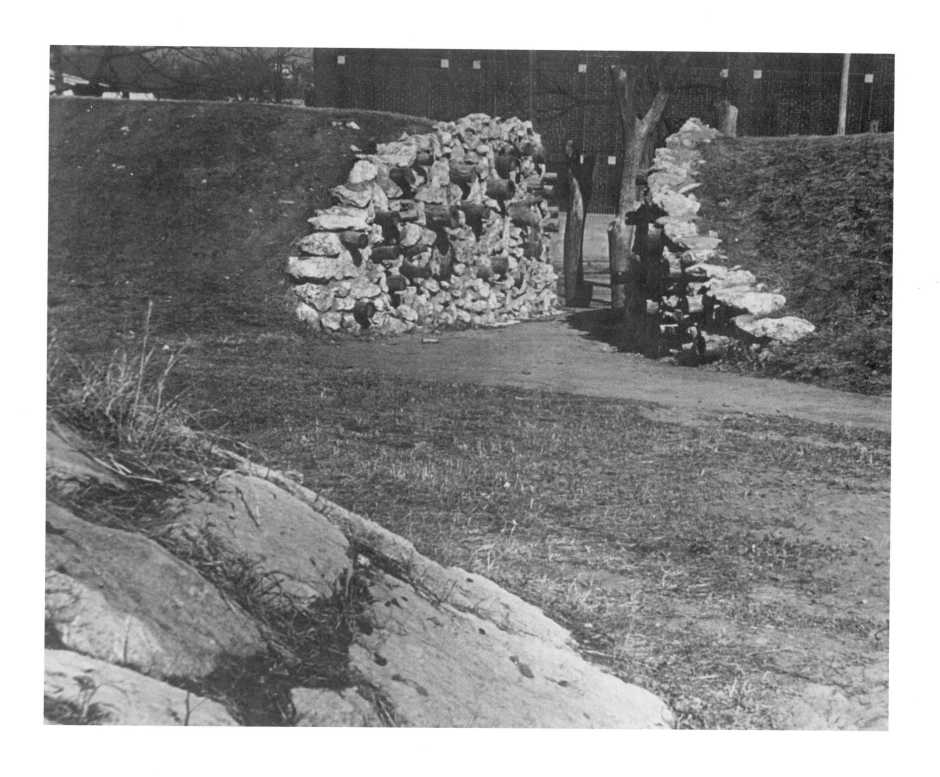

Penn Valley Park: ground view of east entrance.
Dale Eldred.

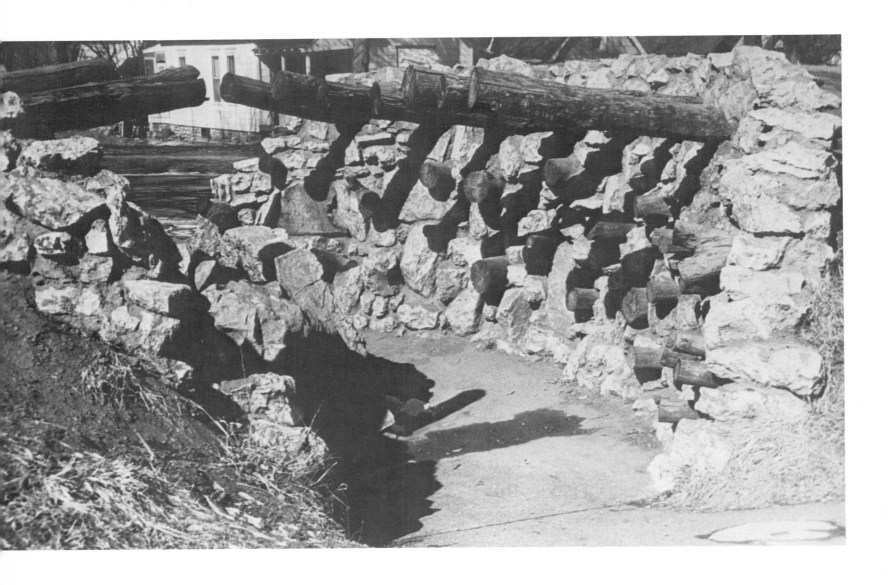

Penn Valley Park: view of north entrance with street, facing cluster
of upright poles. "Some of those timbers were inverted, adjusted
inch by inch on the spot." Some of the pole ends set in the
walls behind were cut nearly flush, some set out farther to vary the
room for passage. "I didn't see Mycenae or Indian Jantras until long
after this." The poles were meant to merge the entrance with
the street. *Dale Eldred.*

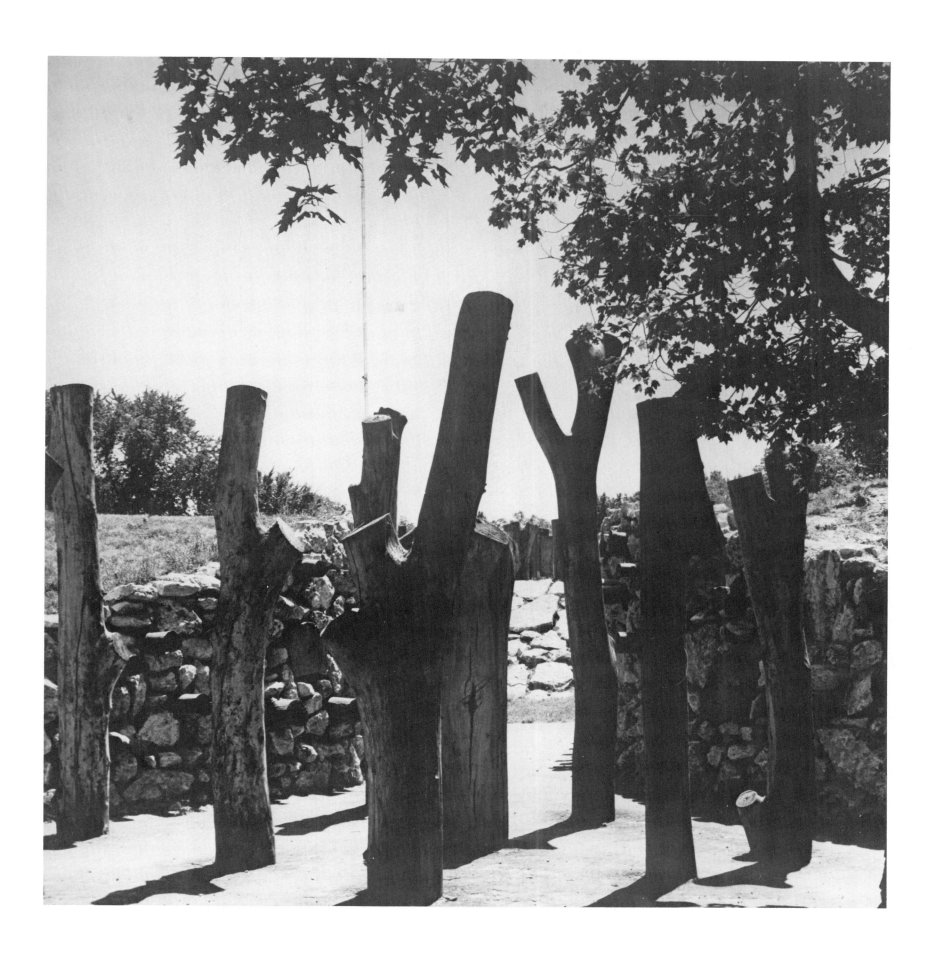

Penn Valley Park: interior view of the
north entrance looking toward the
street. *Dale Eldred.*

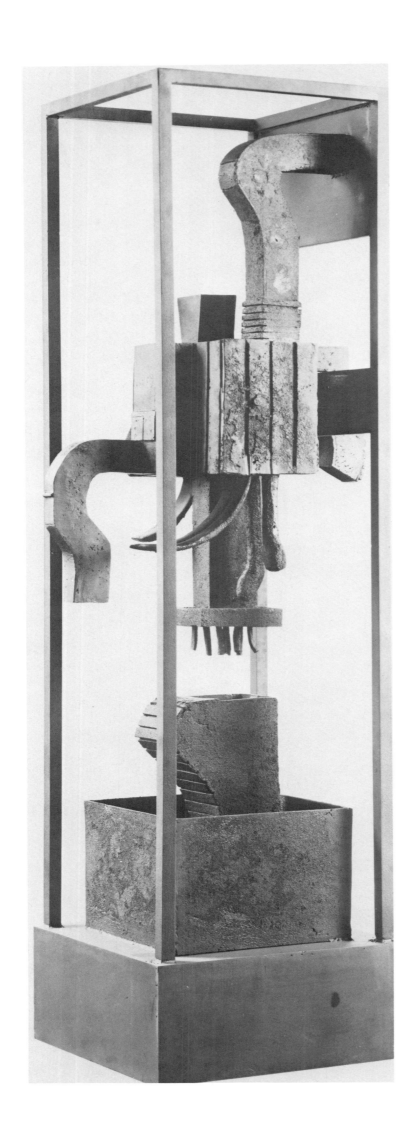

Dale Eldred, *Standing Iron,* cast iron,
87½ inches high, 35 inches maximum
width, base 25⅝ inches by 24 inches.
Nelson Gallery of Art–Atkins
Museum, Ford Foundation, Purchase
Award, Mid-America Annual
Collection. *Nelson–Atkins.*

3
FABRICATION

"After Penn Valley Park I had some money; with it I bought a hoist truck," Eldred says. He had seen what heavy equipment could do with that park; equipment was an extramanual tool that lifted the sculptor out of his usual frame of reference. With its employment the artist could break away from his media and get on to larger things, all the more powerful for being divorced from handcraft. "Penn Valley project made me aware of the possibilities of all that space. What I had done before couldn't stand up in that landscape. I wanted to work in a new scale and use the hoist truck to put my sections in."

Outdoor sculptural forms were ready-made forms, impersonal ones. No one else was really working in such outdoor forms in 1962. In Eldred's view Tony Smith was a drafting-board sculptor: "Mock-ups toward things." Models yes, but no mock-ups for Eldred; he wanted the design and manufacturing to be of a piece, involving the sculptor not as a maker but as a manufacturer. Why should the artist stay down on the farm when his studio could be a steel-yard? An assembled object when fabricated under heavy industrial conditions is never full of quaint surprises. These are all ironed out in favor of implacability. Fabrication does not involve simply putting things together but the creation of powerful entities. Girders linked by fabricated stiffener systems "take the noodle feeling out of form." One might as well compare the quality of a bridge to that of a lace doily. A well-connected machine part is a plain fact. With Eldred the ends and means had to be manufactured for the sake of unity. If ingenuity could be eliminated from the sculpting process, the more cut-and-dried, the more unified the result. "Sculpture, like engineering, is the making of good connections."

Calder's methods were an exception, "yet he is in another age of sculpture: full of personal ingenuity and surprises, still working at sculpture as a cutout." Eldred wanted the integral character of a bridge, not the ingenuity of a stabile, and set out in search of it through a series of heavy, fabricated pieces executed, approximately one each year, between 1963 and 1969. For him, the fabrication process extended sculpture beyond designation as a contrived idiom. In America the true artist was sep-

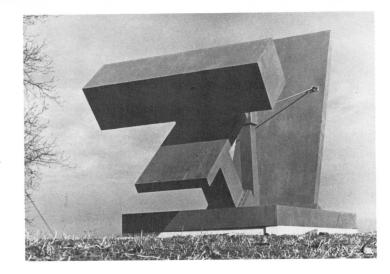

Dale Eldred, *Midwestern Landscape*,
American Republic Insurance Co.,
Des Moines, Iowa, 1963. *Dale Eldred.*

arated from the effete sculptor by the W.P.A. concept of the public monument with "art" in it. A corollary is the private collector's living room with art bought for it. The art was contrived to fit. How could the sculptor be linked to his society in a different, integral, and dynamic way? By getting rid of the "art" and leaving in its place the fabricated outdoor monument.

In the winter of 1962–1963 Eldred shifted his operations from the Haypress Foundry to Kansas City Structural Steel, the only large steel-fabricating plant in the Kansas City area: "Tommy Fitch, an official of the company, really opened it up to me. He sent me down to the foreman, a gem of a person. He showed me blueprints of structural systems. Any problem that I had he took care of."

At that steelyard "there seemed to be no limit— all the influences of tremendous scale. While I never saw anything assembled completely there, I did see huge sections of bridges built right out in the yard, on their sides to make sure everything fitted," Eldred says. Stock parts became huge extensions of intent. Compressive strength was observable in the yard's assembly system. Why not apply fabrication to nonfunctional pieces? "Steel could be cut, riveted, welded, to any designated geometrical shape; this factor and the principle of the cantilever continually were working for me." Overhead equipment was necessary to visualize what was on his mind (not until he obtained an N.E.A. grant in 1967 was Eldred able to match the steelyard by buying a motorized crane for home use). Then he moved into his own manufacturing. "I couldn't scale anything down. I mortgaged trucks and land rover to get sums of money to build pieces."

In addition to Kansas City Structural Steel, Eldred found sympathetic patrons in the scrap-iron brokers I. J. Cohen and Co.: "People like Harrison Jedel would carry me for three or four thousand dollars at a time, extend me credit for materials and the best of terms. They eventually found the crane for me. They were incredibly willing and helpful. Without them I would have been stymied." Eldred's first fabricated pieces were built in sections at Kansas City Structural Steel and assembled on his farm. "Then I decided I wanted to see things away from the yard, out in the landscape."

Pieces that were going into the landscape had to sit physically in that landscape without rusting: they had to be at ease with the elements. The anti-oxidation factor emerged. A Midwest Research chemistry student to whom Dale taught sculpture at night helped him test anticorrosive materials. They adapted a Cape Kennedy cold, galvanic, self-sealing coating with a pewterlike finish which "crawled over the surfaces."

Discovering the right finish was all important for Eldred: to him the paradoxical situation of American sculpture was that the sculptors had never found a way to deal with the problem of how to seal against weather, as had been done with bridges, telephone poles, or barns. The whole tradition of Indian bronzes, Renaissance sculpture, and African bronzes was a modeling one, with finishes to fit. But how do you protect manufactured pieces? Hardly by the same means. "My association with finish is protective. But there is the question of appropriateness. A slick finish would contradict everything underneath."

Once the connection was made between structure and finish, his imagination began to flow. His first fabricated piece was *Midwestern Landscape*, which "bridged out of *Standing Iron*"; but the intervening Penn Valley Park "put me up against a whole new thought." Instead of containing a piece within a four-cornered grid, the planes were splayed from a center pivot, in order that the visual elements could react dynamically. The slabs were held by tie rods, not by the base. Several trips to Chicago (one thinks of the area where Michigan Avenue spans the Chicago River by the Wrigley Building) had greatly impressed him: "Chicago has the quality of the drawbridge against the ground line." Out of these mixed impressions and facts came *Midwestern Landscape*, 1963, based on one of four stainless-steel models that "had guts."

Midwestern Landscape was built by suspending its elements in space "held way out overhead with chains." This seemed to be a nonsculptural method, hence its appeal to Eldred. The chains seemed too "obvious," and tie rods were substituted to fit tight and clean. The piece was welded and plated all over, no wood used, and then sealed galvanically. A platform base was retained, to bring

Kansas millstone on lawn
of Mr. and Mrs. I. Sosland.
James Enyeart.

Dale Eldred, *Kansas Landmark* (*Drum Piece*), as set near
the sculptor's studio in 1965. *Dale Eldred.*

the elements together isolated from nature. Purchased from the Des Moines Art Center exhibition *Eight Selected Artists–'66,* by Watson Powell, Jr., *Midwestern Landscape* was lent to the Des Moines Art Center until this year. Now painted black, it has been placed near the Republic Insurance building by Skidmore, Owings, and Merrill at the edge of downtown Des Moines where it holds its own comfortably, a distinctive element against urban geometry. "Six or seven months after I built that piece an article appeared on David Smith's new welded work. It really bothered me. My effort had nothing to do with David Smith."* As he came to know Smith's work better, Eldred shared in the admiration for it and could see that his own work would be compared to Smith's.

The next work that flowed out was *Drum Piece,* inspired by seeing millstones on the lawn at the home of Morton Sosland, editor of a grain-marketing periodical. The idea related to Celtic art in Eldred's mind, and was of serious, dour, grinding weight in character. In his hands the drum became elevated as an archway or gate; for the first time in his sculpture there was something to walk through. More importantly, *Drum Piece,* later called *Kansas Landmark,* 1964, was conceptualized as part of the landscape; a model for it has the drum-arch cast in a landscape, field and all. Damaged on exhibition, the landscape area was later cut down in size to accommodate the apartment space of the collector, George Sturman of Chicago. As exhibited at the University of Kansas Museum of Art's Eldred show in 1965, *Kansas Landmark* was mounted on a steel-base platform. The zinc-treated drum surged twenty feet above the Des Moines Art Center during the 1966 show. "An impeccable craftsman, Eldred grinds down and obliterates all trace of welded seams, treats his steel piece inside and out against rust, machines parts accurately, and fits them together with precision."** Particularly striking is the feeling received from looking up at the drum from

beneath; leviathan is overhead. Donald Hoffmann, art critic of the *Kansas City Star,* observed, despite the off-center drum, "The composition is essentially static; it lacks the tension of the other pieces."†

By "other pieces" Hoffmann meant in particular *Sisu,* a four-ton work that broke away into a new flexibility. Its name roughly translates from the Finnish as "guts." Steel casings, considerably larger than the slabs of the Des Moines piece, enclosed fitted wood planking, pressure treated with creosote. While Eldred was already concerned with multi-angled viewing of his pieces, the Des Moines sculpture still had its elements set in alignment. *Sisu's* three slabs were juxtaposed against each other "off center, so that the piece rolls and tumbles along." There was no pedestal base to impede the spilling out of the slab forms. "The idea of the pedestal stayed around until finally the earth became the pedestal." The chains connecting two slab elements (he had observed chains on tree stumps in Maine) provide support and countersupport. The edges of the slabs are not fixed to the ground. The third slab tilts off the ground: "Something began to change. In 1965 I built *Sisu* with my own facility, an A-frame crane, away from the steelyard, since in the yard there is no distance. It was the start of something I knew was going to get a lot bigger."

While the Des Moines piece was supported by the tie-rod system, base connections had been provided, to impart a feeling of security. With *Sisu,* "there was no base bolting. It was held up visually by its own weight and chains." Fortunately, Truog-Nichols (an air conditioning and heating firm) bought *Sisu* for its hilltop surburban headquarters in Olathe, Kansas, where it was set on a concrete platform. At that time Clyde Nichols, an officer of Truog-Nichols, also commissioned Eldred to design the concrete entrance to the Truog-Nichols building. *Sisu* has now been located only a few feet from that entrance; it is watching the rolling terrain of eastern Kansas become suburbanized.

Right after *Sisu,* Eldred started constructing an outdoor sculpture specifically for the lawn of the Kansas City Art Institute. The slab articulation was opened up farther. There are two series of opposing

* Eldred is most likely referring to Hilton Kramer, "David Smith's New York," *Arts,* March 1964, pages 29–35, or less likely to J. Rosati, "David Smith," *Art News,* September 1965, pages 28 ff, which appeared somewhat later.
** *Des Moines Tribune,* March 30, 1966.

† Donald Hoffmann, *Kansas City Star,* November 7, 1965.

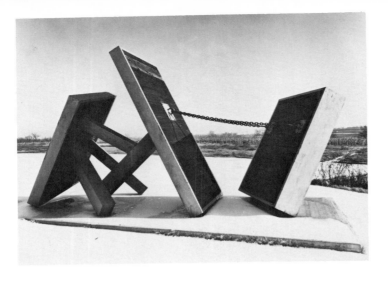

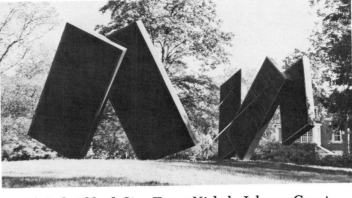

(*Left*) Dale Eldred, *Sisu*, Truog-Nichols, Johnson County, Kansas, 1964. *James Enyeart.* (*Above*) Dale Eldred, *Kansas City Art Institute Piece*, Kansas City, Missouri, 1967. *Dale Eldred.*

slabs anchored by tie-rods to neutral ground between. A two-slab unit overlaps like half-decks of cards in mid-shuffle. Across the way a three-slab unit features a smaller end plate totally suspended off the other two like an ascending scale. Eldred feels that "some of the most successful aspects of the Kansas City Art Institute piece are the clearings of one element over another." Steel-encased timber modules were used again, but with varying thicknesses and emphasis on finesse. That term certainly applies to the hand-forged couplings: ring, rod, and plates, and to the flange extensions which interconnect the flying slabs which barely touch the ground. A lot of thought had to go into placement; the slabs were preset in spatial relationship as the footings had to be poured first. This act locked in the entire spatial sequence. There is no reference, however indirect, to millstones or the folk tradition except through abstraction. The slabs are untitled except by locale: "Tense, yet tempered in aggressiveness, the rugged and weighty elements are disposed to effect a complex deflection of space. Their movement is centrifugal, the perspectives are innumerable."*

From 1965 to 1966 (one of the foot plates of the *Kansas City Art Institute Piece* is dated 1967, slightly after the time of erection since it was completed by December 25, 1966) Eldred had gone from static pedestal slabs in alignment to lumbering slabs in free tensional arrangement, to slabs almost clearing the ground. He had broken the mold of indoor dimensions to accommodate his forms to open and unlimited space. Carving or modeling, sculpture as drawing, sensuality, or voluptuousness had been struck down with vigor. But these were still lesson pieces, stations along the way in the amassing of a sculptural vocabulary. He had tried out different proportions, relationships, and solutions. In 1965 he even made a cratelike construction of steel filled with boulders for the campus of Tarkio College in northwestern Missouri (the piece has disappeared without a trace but two handsome models survive in Eldred's hands; see page 133). One senses here, for all the veering away from his early surreal and violently sexual cast pieces, for all the

replacement of anecdote by a relentless builder's aesthetic, that the mastery was still tentative. The pieces went in too many directions. Eldred says, "They related too much to reverence toward sculpture. By 1967 I began to feel fully irreverent about that and feel freer."

During the time between *Sisu* and the *Kansas City Art Institute Piece* Eldred built thirty to forty steel models, one at the Des Moines Art Center in typical drawbridge configuration has a cast-in ripple of landscape as base. Variations on *Sisu* hint at projects unrealized: these Eldred called "mockettes," not models. But each year saw the production of one large piece, and each was sold.

A National Endowment for the Arts award in 1967 made it possible for Eldred to make a down payment on a thirty-five-ton crane; he was also able to hire an assistant, Paul Slepak, so that his next piece, *Big Orange*, was fabricated as well as assembled at the studio. It marked a departure for Eldred, in that there was no concealed bolting or interior structure as with the earlier works. The structural system came together with honesty and unity: turned-out sections with all sides exposed. The ribs and carcass of the piece were absolutely integral. The simple structural scheme of *Big Orange* was arrived at through a process of distillation, by comparison to which the *Kansas City Art Institute Piece* and its predecessors appeared finicky. Three parallel plated girders thrust upward to a canted plate of gigantic dimensions. The return is effected by two girders which pinch a waffle grid against a pair of concrete base piers. Suspension rods were replaced by stiffeners; the structure was defined by orange paint—the color specified by the Missouri State Highway Department for bridges. Bolts studded openly.

For all its structural aplomb *Big Orange* conveyed a feeling of vague unease because its apex did not contain a right-angle bend but was deliberately canted, and because its design had been pushed "to a bare-bone quality." It was the first fabricated piece by Eldred to come to an unalterable conclusion: "It separated out the whole problem for me. Construct straight out without hidden parts or connections." *Big Orange* was built for the one-man exhibition given Eldred by the Albrecht

* Donald Hoffmann, *Kansas City Star*, December 25, 1966.

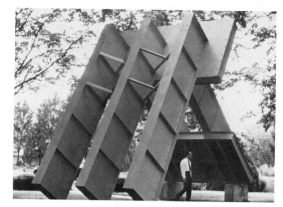

Dale Eldred, *Big Orange*, as assembled at Albrecht Art Gallery, Eldred exhibition, St. Joseph, Missouri, 1968. *Dale Eldred.*

Dale Eldred, *Mankato Piece,* Mankato, Minnesota, 1968. *Dale Eldred.*

Art Gallery at St. Joseph, Missouri, by Jim Enyeart, then director of the gallery. Eldred's first idea was to put the piece on the museum driveway so that cars would have to pass through it; he finally put it in the rear garden so one had to walk through it to get into the building. "It looked lovely in its installation." There was a movement to put up the money to purchase it for the museum, but the board rejected it as destructive of the museum's near-Georgian architecture: "a real disappointment to me." But he had built a piece one could drive through! Two cranes were required to raise *Big Orange.*

Eldred's approach was settled before minimal sculpture began to appear on the market and in the news in 1966. But sculpture by Bladen, Meadmore, and Tony Smith looks like "art"—intellectual concepts, not fresh construction. Unlike Smith, Eldred could never build a substitute in plywood to be duplicated; he could not endure such a split between thinking and feeling, conception and realization. Something vital for him would be lost in translation, so that the duplicate would become dry, hollow, overly arch—preshrunk art. He decries the process of fabrication by second-hand producers such as Lippincot in New Haven. Like the difference between building a real wagon and a plastic version by a Japanese consortium, *Big Orange* edged beyond comparison to David Smith or Tony Smith and became *sui generis,* a thing of its own. Besides, after two more capital works in fabrication, Eldred's concerns were to become environmental and beyond reach of the simple endeavor, except when the program fitted a recrudescence of individualism.

In the early spring of 1967 Martin Friedman, director of the Walker Art Center in Minneapolis, was contacted by the city council of Mankato, in southern Minnesota. They had a quarter-block vacant lot on Hickory Street, just off the main street, and were looking for a sculptor to put something there. A local banker, Robert Siebert, had urged that they contact a creative-minded consultant. Friedman recommended Eldred, and Dean Swanson, a curator from the Walker, accompanied Dale to Mankato. Dean A. Myhr, head of the Minnesota Arts Council, also smoothed the path. At a restaurant meeting of mayor and council Eldred proposed a structural piece, made a presentation of his work in slides, and vigorously made this proposal: "I'd build it in three months complete, providing (1) I did not have to send a proposed model [there was a construction model made of balsa wood, but it was never submitted for approval or disapproval]; (2) the concrete footings would be prepoured in Mankato and supervised by an engineer; (3) that one-half payment be made immediately to finance materials and fabrication and the remainder when finished; (4) that the artist would stand the additional cost should the piece exceed the budget." Eldred later commented, "They bought a pig in a poke, the whole project, and really stuck by it. No one knew how large it was going to be. They also agreed to leave me alone during construction."

Mankato Piece proved a monster problem in logistics: it took two gondola railroad cars to freight the steel parts to the site. At Mankato the cars had to be unloaded, then the steel girders and connector plates transported to the site on flat-bed trucks. "I did a lot of engineering by phone; during the pouring of the footings the engineer in Mankato and I in Kansas used a pair of grid drawings to detail exact locations and measurements." The street was closed for two days to all traffic. Two cranes and three or four helpers were used. A dynamic thing was happening in a fairly small town. One bystander kept coming back, standing and staring, wondering where the statue was.

Mankato Piece space-divided a vest-pocket park: Eldred referred to the project as the "park-ette." Moreover, it was an urban piece, involving a large part of a town block, dealing with inside relationships and "looming power" over traffic and everyday pedestrian problems. Just as *Big Orange* was beyond the hand of a single artist to assemble, *Mankato Piece* went even further, requiring a construction team and logistics system. Indeed it looked as factory-produced as a steam shovel. "Some people are still looking for their statue," says Eldred, but he likes to remember what a citizen of Mankato wrote that city's *Free Press* in September, 1969: "I like the sculpture. It's America the new, the untraditional, the brash, and the ugly. It's America the strong, the daring, and the immune to criticism. . . .

My husband calls it 'Dos XX'—Mexican beer brand."*

Another local citizen wrote concerning statuary: "How happy I am that our parkette does not contain, like so many cities, a marble statue! Statues . . . invariably go unnoticed by the citizenry and are appreciated only by the pigeons!"**

Mankato Piece reminds one of a pair of X's set near a disconnected lift bridge. Both groups (or sections) were "brought very exactingly into place; their physical action carried to a small area demonstrates how a sculpture holds power over its environment." There had to be enough mass to counteract a parking ramp on one side and the rusty brown Elks Club on the other. "It's very severe and graphic to me," Eldred states. "It travels around its given space and has no front or back; however, the area has." When the sun is high, the piece throws extremely strong shadows, duplicating itself on the pavement. Its platings, jutting overhead, lead nowhere. They were treated with zinc, then with a black-tar preservative emulsion, a starker treatment than *Big Orange,* to say nothing of the earlier fabricated pieces and models.

Mankato Piece is not an essay in suspension or tension, but in hanging steel out in space by pressure plates, gusseted plates, and cantilevering. Physical tension is expressed by bolt patterns. It is a sober, complicated piece which never rests, though it is ever in traction, constricted by the rigidity of construction.

"Those bolts can never forget what they're doing, like flyers and catchers in a frozen circus," Eldred says. The environmental quality of the piece led to its receiving a lot of state-wide attention. Busses entering downtown Mankato have been routed by it, and the Guthrie Theater used it in an outdoor theater performance. It marked an increased use of concrete work for Eldred (the steel elements are perched overhead on high pilings) and a consciousness of the intrinsic value of land: "That was a hell of a valuable piece of property they made over to me. That's what an artist should work with."

The piece came in on budget and remains an example of what a creative civic-artist relationship can accomplish when the motivational sequence is in proper adjustment. The city of Mankato bought the piece (at a cost of over $12,000). The State Arts Council of Minnesota paid freight and travel expenses (about $1200): weight, seventy-three tons.

After finishing at Mankato, Eldred went to Yucatan to visit the Maya ruins Chichen Itza and Uxmal.

When Salina, Kansas, businessman John Simpson decided to commission a sculpture in the fall of 1968, architect Dean Graves put him in touch with Eldred. Simpson had been impressed with the one-man exhibition at the University of Kansas Art Museum in 1965, at which time critic Richard Brown remarked: "I know no other Midwestern artist who has so eloquently evoked the spirit of his land." Simpson felt the same way, asking for a large piece. Size did not deter him at all. "He left it wide open to me to take a look at the properties he owned," Eldred comments. "I selected the field next to his house, thought of an image as big as a house existing in comfortable proportion to it, a sympathetic place to go back and forth, a sort of one-two relationship. I can never get over the fact that one person, not a conglomerate, bought it all."

Salina Piece owns its seven-acre field site. "Imagine all that valuable real estate occupied by a nonfunctioning object; that's getting well away from petty speculations." Out of the field rises a thirty-eight-foot high waffle-grid structure supported against a pair of angled girders. This huge inclined plane is balanced entirely by two five-inch suspension rods set into a footing flush with the earth, but sunk fifteen feet into the ground. In contrast to the heavy detailing of *Big Orange* and the crowded goings-on in the Mankato parkette, *Salina Piece* has the force of a single event abruptly rising from the earth. It lunges upward like a huge hinge, or like some Viking structure in a Nordic saga. The *Salina Piece* is Eldred's all-inclusive essay in fabrication, unless the airport piece is finally realized. Seen from the air or from any vantage point in the field, the Salina sculpture goes beyond architecture, beyond intuitive engineering, and beyond taste. It was the final form of those "nontaste" elements in *Big*

* *Mankato Free Press,* October 9, 1968.
** *Mankato Free Press,* October 9, 1968.

Orange, "dense and not arty in any way." It was all weight, presence, "there." It was truly multi-dimensional in that there is no front or side, no end or beginning, only an encompassing statement of thrust, compensation, return. The field was a neutral viewing ground; axes occurred through the artless exigencies of building.

Salina Piece was the result of a thirty-day battle with two cranes, thirty-five tons of brute materials, and open countryside. The three sections (restricted in width by highway transport regulations) weighed ten or fifteen tons each. Land and highway dimensions—no art gallery or dealer—determined the size and field of impact. On the mid-Kansas plain the sculpture stands black against the land-locked isolation of these vast spaces, confronting the big earth-plane with positivism. "It was a hell-and-gone place to put a sculpture. I liked that." *Salina Piece* is not surreal, but somehow one feels that Max Ernst might nod in recognition. The design did not speculate beyond fact, yet somehow "the mysteries are there," due to a vast romantic constructionary sublimation of ego, energy, and sex—the ego of master builders of the past. It outwardly abdicates personality, but pushes egocentric realization: impersonal materials versus individual synthesis.

Eldred's fabricating period was at an end. Earth had indeed become pedestal. Sculpture had become "a natural act on an inevitable basis." *Salina Piece* was finished June 1, 1969. Assistant Paul Slepak was let go. "On the following day I was on a plane to Greece."

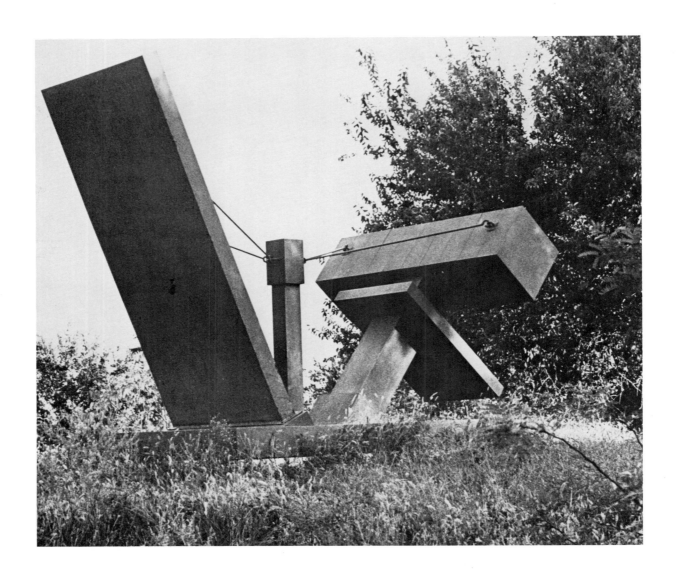

Dale Eldred: *Midwestern Landscape,* 15 feet long, 10 feet
high, 8 feet wide, zinc-treated steel, 1963, American
Republic Insurance Company, Des Moines, Iowa. *Standing
Iron* was cast, but this piece was entirely fabricated
and has lost the organic or machine design character of
the former. The rear horizontal slab was assembled from 24
panels; the vertical slab, from single sheets of half-inch
plate framed at 8 inch width. "When I fabricated
this piece, there weren't any other minimal pieces around;
now it has entirely lost its independence." *Standing
Iron* was cast according to an indoor aesthetic; this was a
post–Penn Valley Park piece assembled outdoors.
Dale Eldred.

Dale Eldred: *Sisu*, 30 feet long, 18 feet
high, 14 feet wide, interior of zinc-treated
steel, exterior metalized, 6-inch
timber fascia, pressure treated with penta,
1964, Truog–Nichols Company, Johnson
County, Kansas. "While the parts of
Midwestern Landscape were aesthetically
tied together, here I wanted to separate the
parts: I wanted the sections divided—
stretched—not attached in any way."
Dale Eldred.

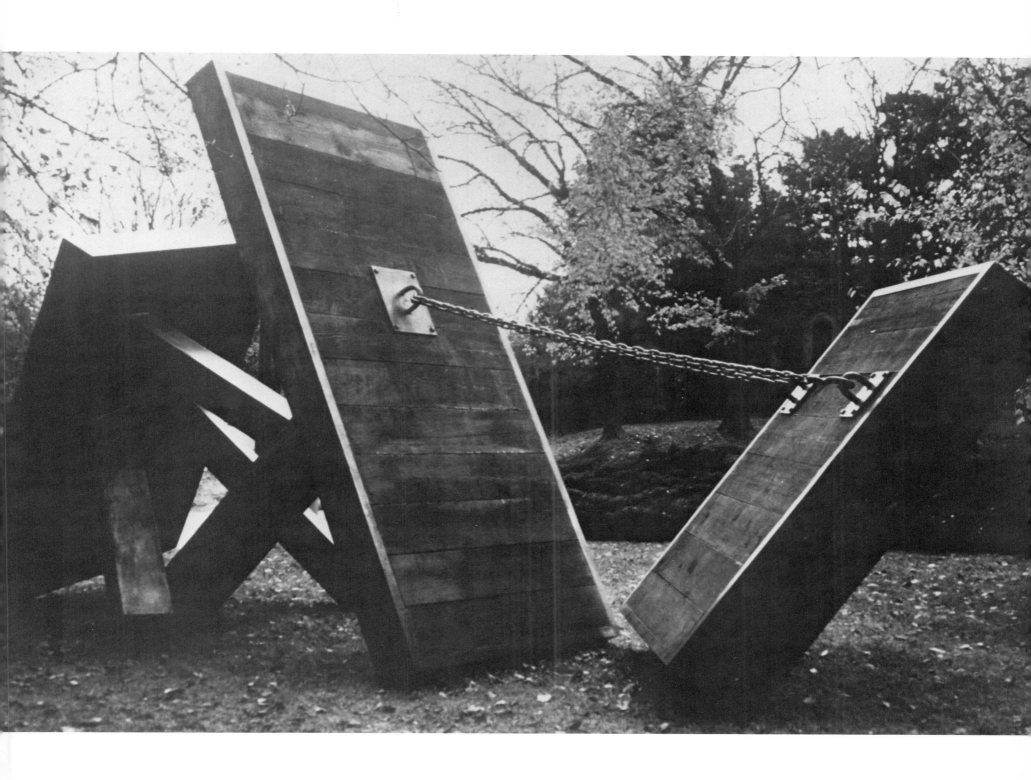

Dale Eldred: *Sisu,* 1964. Winter view of Truog–Nichols
Company. At the same time, Eldred also fabricated
another equally large piece similar to a reduced model now
owned by Morton Sosland. It was shown at the Time-
Life Building, New York (1965), and was sold to
a Connecticut collector, but its whereabouts are completely
unknown to the artist today. *James Enyeart.*

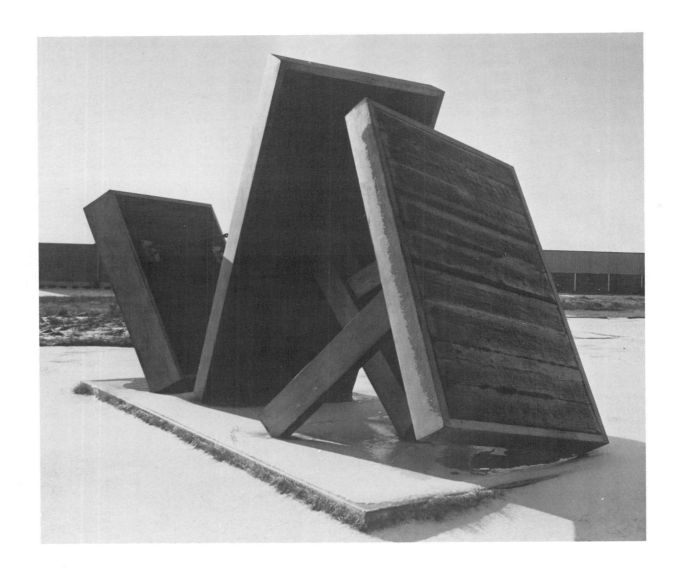

Dale Eldred: *Kansas Landmark,* 10 feet wide, 24 feet high, drum 8 feet in diameter, zinc-treated steel, 1965, Harrison Jedel Collection, Shawnee Mission, Kansas. The framework recalls the cagelike elements of *Standing Iron;* the "drum" marked a momentary desire to move away from slabs, as seen from the artist's studio in an earlier installation. Today the setting at the Jedel residence is more cramped. Also called *Drum Piece. Dale Eldred.*

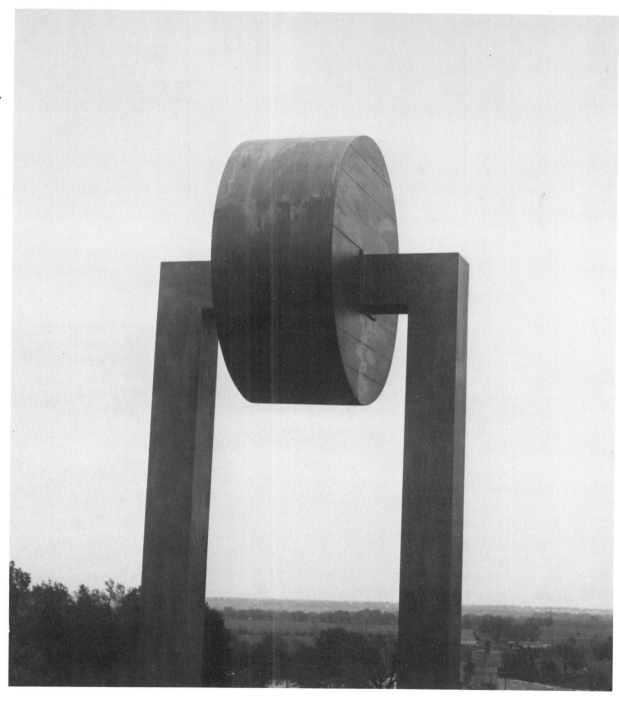

Dale Eldred: *Kansas City Art Institute Piece,* 18 feet
high, length of area 50 feet, Cor-ten steel metalized with
stainless steel finish "to get a dour grey surface,"
6-inch timber fascia (hand worked), pressurized penta
treated, 1966–1967. "They were old, dry oak beams,
so there would be no shrinkage. I bought a whole church
roof at Thirty-ninth and Main, Kansas City." This
Eldred project required a location *before* building, opening
up the idea of a site concept for his sculpture.
Dale Eldred.

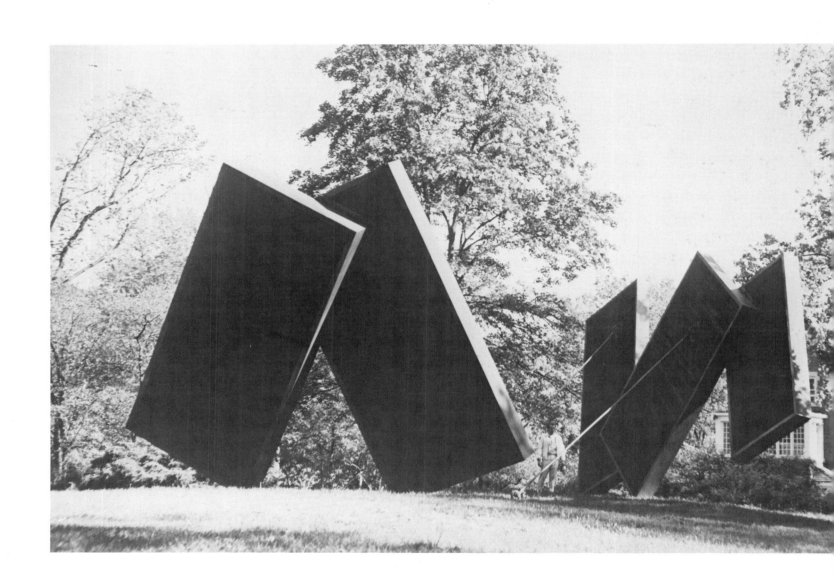

Dale Eldred: *Kansas City Art Institute Piece,* 1966–1967. "I feel this piece works best when you're up against it. I did not understand that people would treat it as a total view. When I built it, I was always close to it, assembling related but separate elements right on the site for the first time—you must go right up to it. You can walk under one of the slabs easily." *Dale Eldred.*

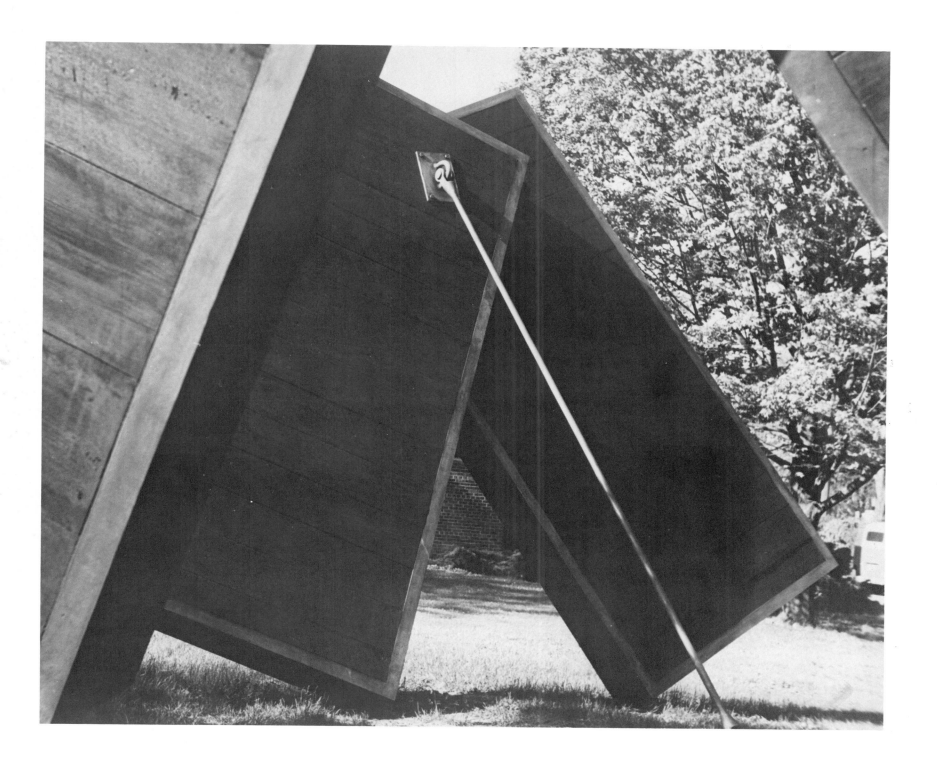

Dale Eldred: *Kansas City Art Institute Piece*, detail of
a suspension ring and 3½ inch steel supporting
rod. *Dale Eldred.*

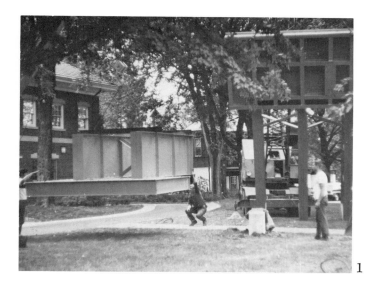

Dale Eldred : *Big Orange,* 30 feet long, 25 feet high, 18 feet wide, Cor-ten steel painted with highway bridge orange paint, 1967, Harrison Jedel collection (at present disassembled). Photographs illustrate stages of assembly for exhibition at Albrecht Art Gallery, St. Joseph, Missouri: steps in joining the sections. The third illustration shows the artist aligning two sections. "These photos give an idea of the weight of each section; each had to be moved by crane with two assistants. Without a crane, no sculpture." This piece cannot be assembled without special drawings to give construction angles: "I can redo those drawings at any time, but I don't know where the originals ones are today." *James Enyeart.*

1

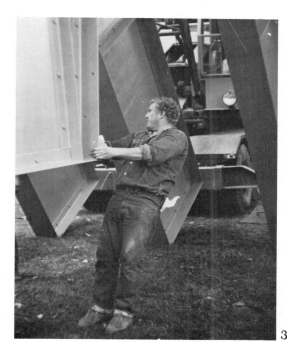

2

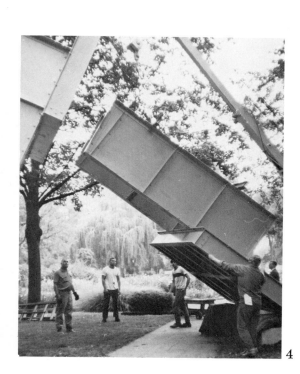

3

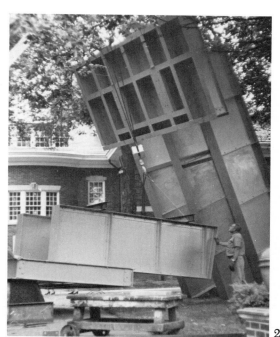

4

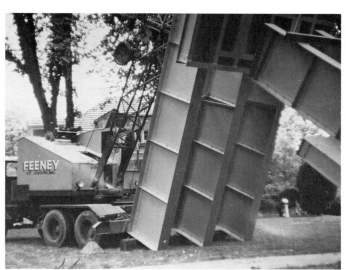

5

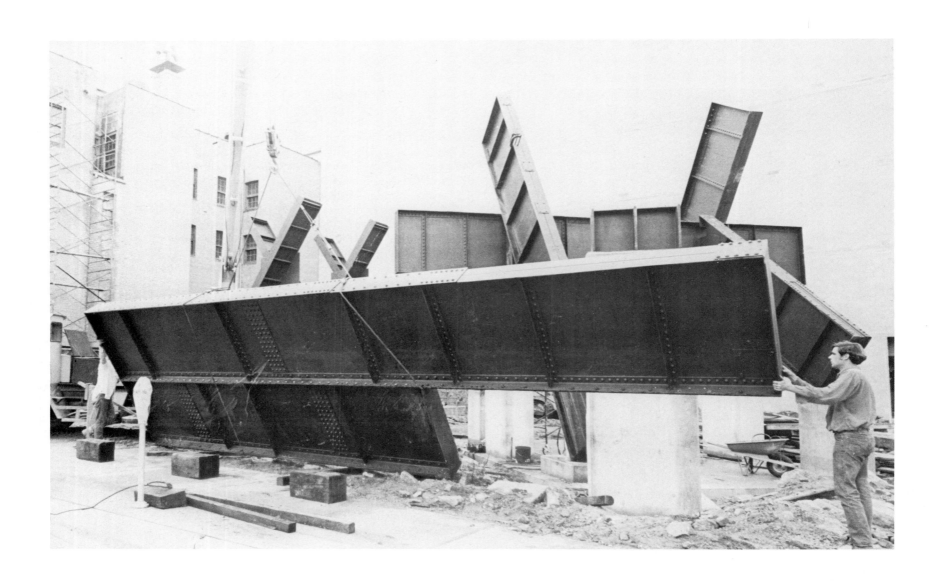

Dale Eldred: *Mankato Piece,* 1968, Mankato, Minnesota. Assemblage
of large cantilevered section in process, Paul Slepak assisting
at right. *Dale Eldred.*

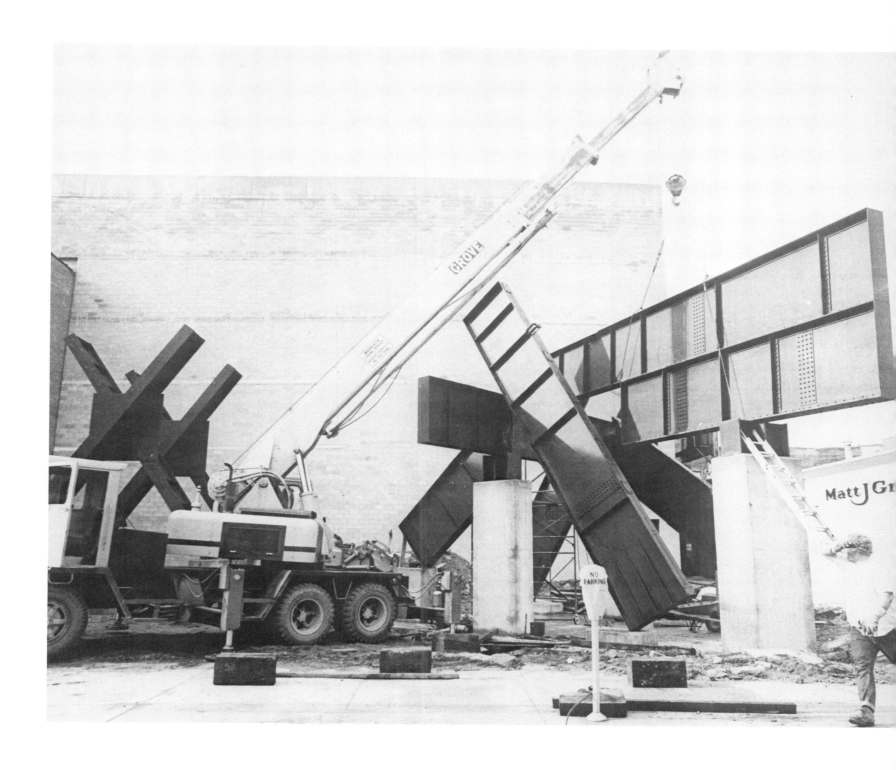

Dale Eldred: *Mankato Piece*. Further steps in
assembly of large cantilevered section. The artist
running back to operate the crane after
setting cantilever upon piers. Building at left
has since been removed in accordance with
original plans. *Dale Eldred.*

Dale Eldred: *Mankato Piece,* 28 feet high, site dimensions: 80 feet by 70 feet, Cor-ten steel painted with black asphaltum, concrete, 1968, site: downtown Mankato, Minnesota. View of finished sculpture from underside looking toward street. "All of a sudden I was occupying the equivalent of a downtown building—a far-out idea." *Dale Eldred.*

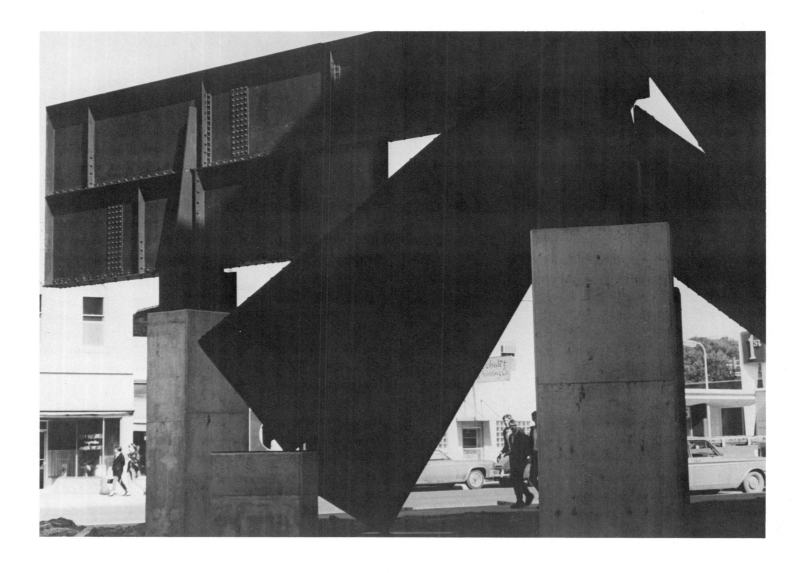

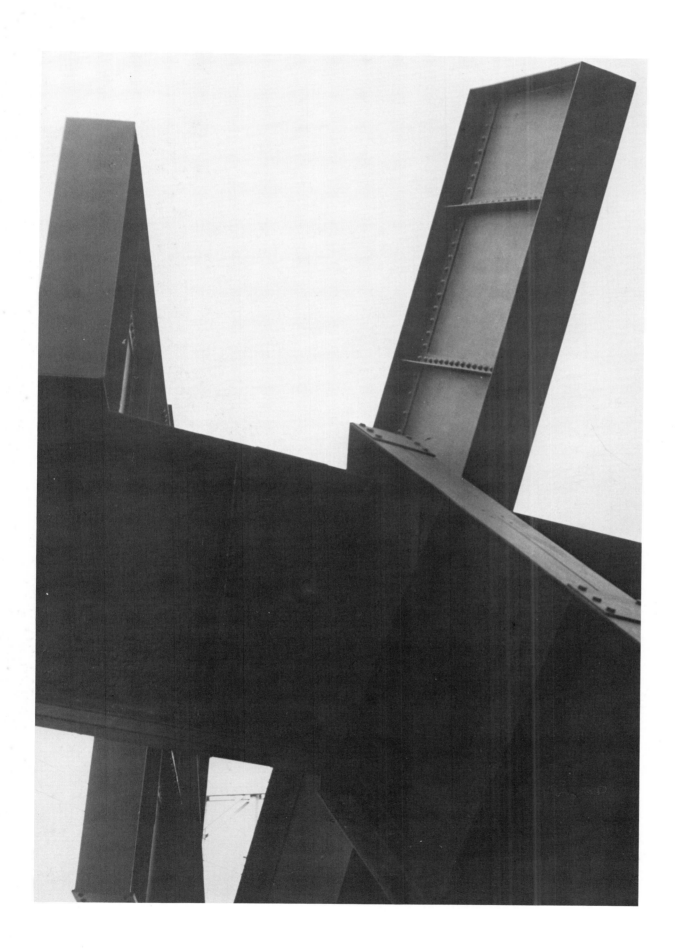

Dale Eldred: *Mankato Piece*. Detail looking east to west, from giant X's across large cantilever element.
Dale Eldred.

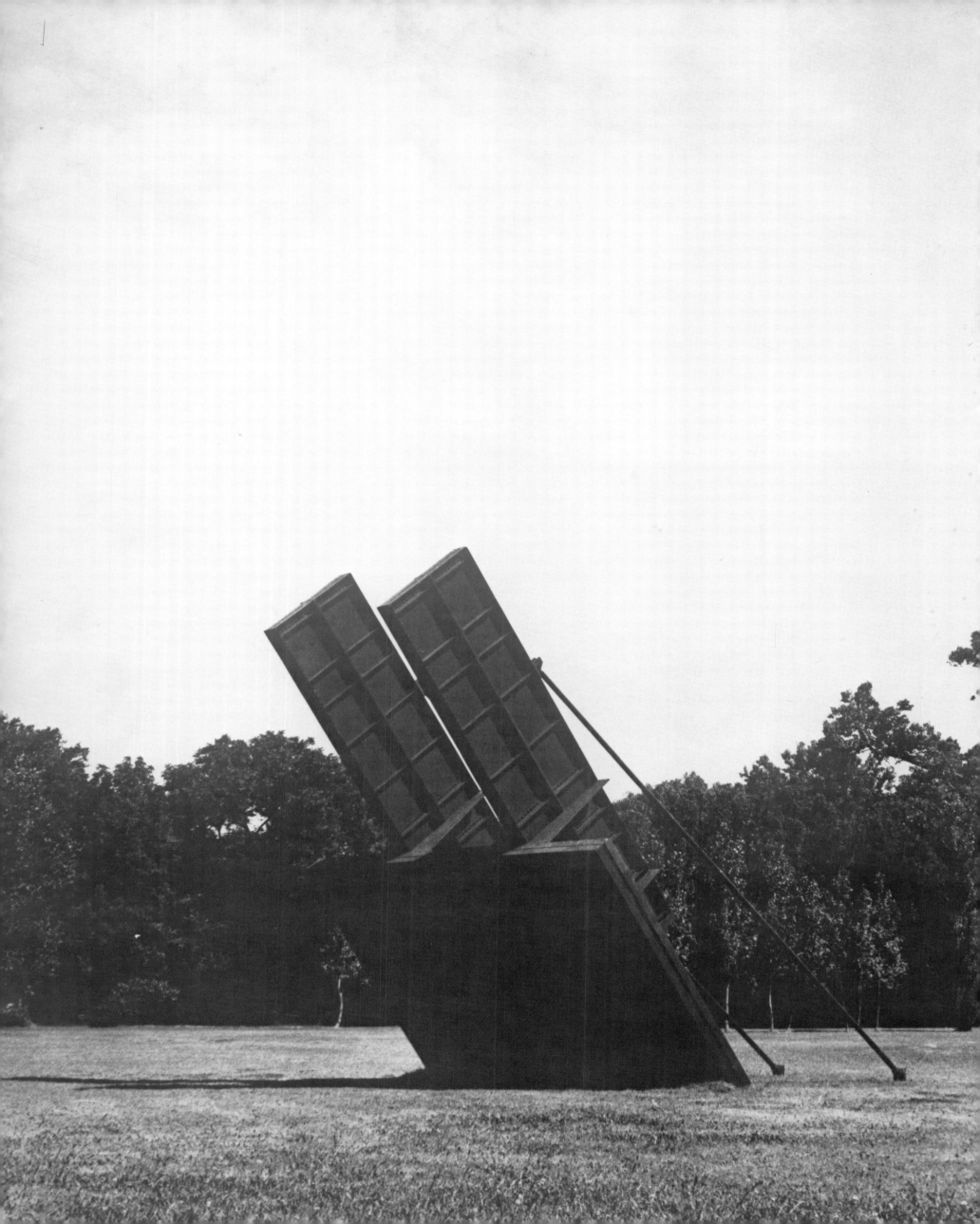

Dale Eldred: *Salina Piece,* 34 feet long, 35 feet high, 24 feet wide,
Cor-ten steel painted with black asphaltum, 1969, site: field adjoining
residence of Mr. and Mrs. John Simpson, Salina, Kansas. View
from north. "It's the best result of all that fabricating. So many things
came together in that particular piece; it's elemental like the
Mankato X's, but more definite about what it's doing. There are no
hollow boxes and no hidden connections to distract from the
raw-boned essentials. It has one of the largest environments I know of
for a single piece: no confines at all." *James Enyeart.*

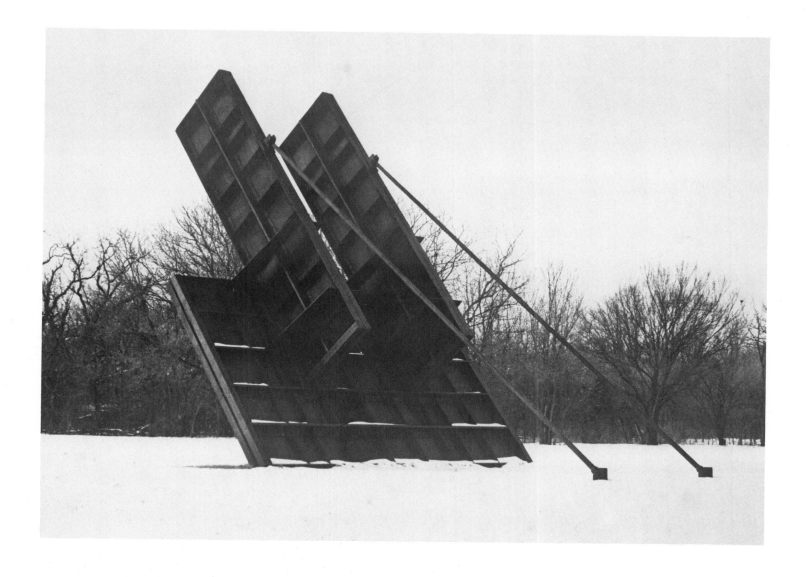

Dale Eldred: *Salina Piece,* 1969, Salina, Kansas,
winter view. "I'm very proud of where it
is, but if I had to put a piece in downtown
Chicago, it would be along these lines."
Dale Eldred.

Dale Eldred: *Salina Piece*. Assembly
process: the support systems being
attached prior to lifting the entire sculpture
into place. *Dale Eldred*.

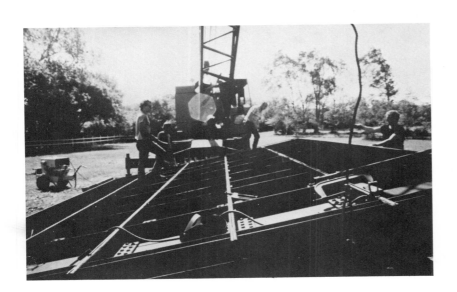 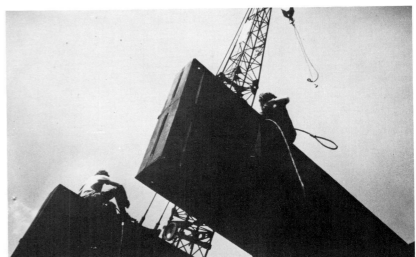

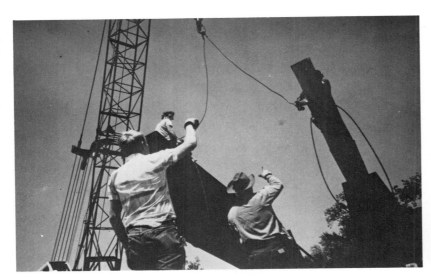 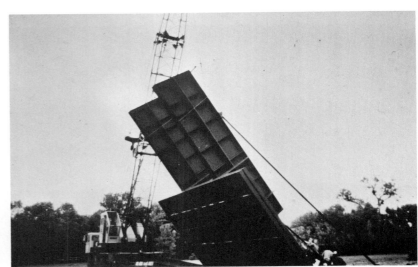

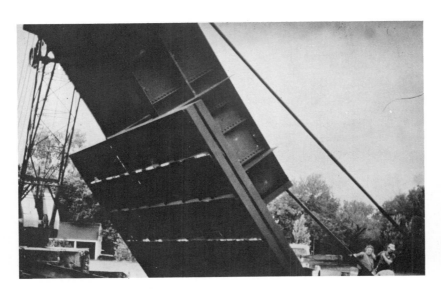 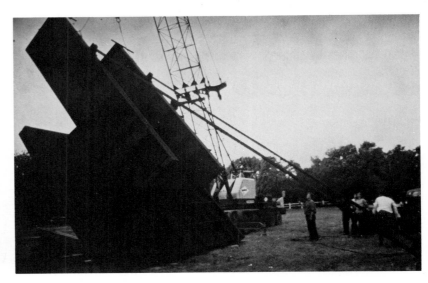

Dale Eldred: *Salina Piece*. Two construction drawings, blueprint size.
From them blueprints were made for reference on site during
assembly. Scale ¼ inch to 1 foot. These drawings were lost sight of
by the artist and only came to light as this book was going to
press. It is typical of Eldred's profligate attitude toward early stages of
executed work that drawings like these are discarded from memory.
"Something in me just erases them, like a meal you have eaten.
Can you tell me what you ate for breakfast a week ago?" Thus Eldred
has far-flung files, but he lacks memory for what they contain.
This book made him catalogue his productivity. *Dale Eldred.*

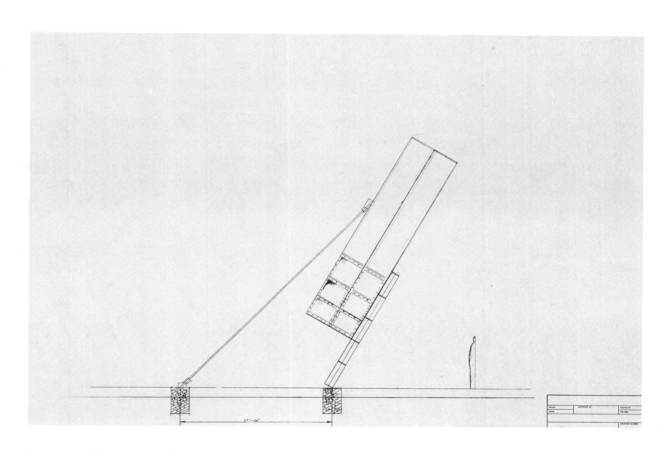

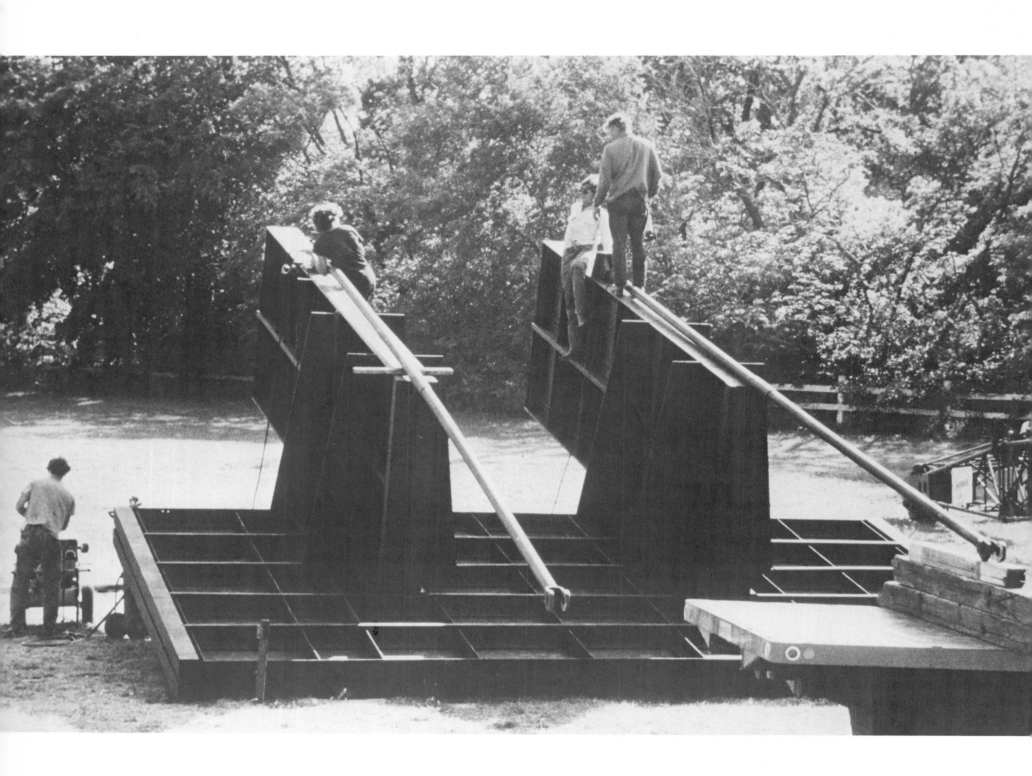

Dale Eldred: *Salina Piece*. Sculpture
assembled on ground just prior to raising,
artist standing on right structural
projection. *Dale Eldred*.

4
IMAGINARY GRAPHICS

If Eldred's seven large essays into fabrication were related to the myth of the American master builder, the 1969 voyage to Greece led Eldred into an enlargement of the building myth toward its more visionary aspects. The master builder was alive and well at other places, Eldred discovered. "I guess before I had been rather naïve." A Mediterranean three-months' trip drove home a whole new pattern of cultural dynamism and change. What disturbed him upon his return was that "we look at the art products of only a small part of the world and keep creating in our own image as if we had blinders on." What about other people's ways? Why not reverse the situation and create something for them? How to express the state of wonderment at seeing so much? What would it be like if he could, say, transport part of the Mankato girders to the landscape near Brindisi, or span an immense western canyon with a section of the *Big Orange* piece lifted high overhead on a cable system? What if one could look down on all this from above? How could a procession (or funeral) in Greece relate to sculptural experience?

The only way to expand this vision lay through the stimulation of graphic imagery. If Eldred's imaginery graphics were a carry-over of creative energy released by *Salina Piece* (a large commission like that is rarely offered and could not be depended upon), a lot of their making had to do with the recall of voyaging through many terrains and cultures. He had visited most of the accessible Greek islands, went on to Turkey (Ephesus, Bodrum), then crossed southern Italy to Spain and Portugal, and then went to London. "That trip stimulated me to question scale in relation to my entire work and thinking—a real self-questioning."

In Greece, Eldred kept a sketchbook. It was filled with imaginary projects for sea-immersed inflatables and mylar pneumatics, located off Mediterranean islands, collaged with silver paper from Greek cigarette packets. "I did a lot of them at Thera Bay and Port Paros, and the fishermen were really amused. They wrote legends on the margins." They were amused most of all by a collage of a giant predevaluation dollar being held off a sea cliff in mid-air by a tiny woman. "For this I used pasted photo collage and a real United States dollar. I also

Dale Eldred, imaginary graphic, Ireland, 1969.
Dale Eldred.

did a lion's head from Delos pasted on a tiny island mound in the sea," the colossus idea with a twist.

Upon his return Eldred experimented with a number of photo collages on white board with cut-out sections of blueprint girders (the blueprints obtained from Kansas City Structural Steel) set on low landscapes. They seemed terribly static, unsatisfactory. Then he tried "about a hundred times" duplicating by photocopy landscape photographs into which drawn Eldredian structures had been added in silhouette. The results were tentative and uselessly clouded in printing (only four were rescued from discard when I rummaged around the artist's studio).

Suddenly out of such trial and error the solution emerged. He had been reading the blueprint fragments as three-dimensional objects in his own mind. Their ineptness came from a disregard for sculptural content. Why not make them three-dimensional by building miniature models of structures in steel, photocopying them, collaging their photo-images into preexisting landscapes carefully culled from his collection of magazine photographs? His collection has been greatly augmented during his recently concluded trip. Many strange environmental situations lurked in that collection, waiting for some sort of use. Rephotographing the combined composition would "get what I wanted, everything sublimated on one surface, all coming alive simultaneously together in an estranged situation. I had an avenue beside drawing, a relationship of imaginary sculptures juxtaposed into a ready-made world." This way he could invest graphics with "dimension."

The first print realized in this way was an Irish landscape by the sea over which a metal monument loomed like a gantry. Only one print on mylar was pulled (now in the Martin Friedman collection). The original collage finally turned up in the files of the Kansas City dealer Jim Morgan. "Jack Lemon [now head of Landfall Press, Chicago] pulled a few lithographs of the first collages on white paper. I owe a tremendous amount to him for opening up the possibilities. The last thing he did at the Kansas City Art Institute was my color litho of dual wing-like structures montaged over a Minnesota farm-calendar landscape. There were five plates, the first color separations Jack ever made, and the cost was

52

prohibitive, $600. When he left Kansas City I stuck to mylar prints, only pulling them for my own satisfaction." Not until I questioned him closely did Eldred consult his file drawers and out of one pull eight pristine proofs of the color lithograph in question, each still wrapped in printer's paper. "Why, I didn't know they were there. I know the trial proof and print I showed you, but look at these!"

Eldred's attitude toward his graphics has been profligate, energetic, creative, but perspectiveless. "I've never attempted to make sense of them; I'm working through them myself, and I'm as surprised as you are." No records have been kept of the number of prints pulled (always very few), or whether, in two cases, any prints were made from the positives. On going through the architect's file cabinets at his in-town Oak Street studio, I found two collages that I did not know were in print, one of them a view on the Dalmatian Coast, and a moment later, their positives. Eldred agreed to pull Mylar prints on the spot by putting the positives through the Ozalid machine in his studio. The printing came out too weak, in spite of careful machine adjustments. "I guess that's why I didn't print it," Eldred mused. "I don't think the other one will give us a print either." But the collages were unaccountably beautiful, full of feeling for land and sky. By the alchemy of collage he converts a travelogue landscape into a supernatural event, allowing the juxtaposition, not any playfulness or trickery, to tell.

His graphic adventure meant much to Eldred, as sculptor, technician, and imagist: "It takes thirty days just to assemble a sculpture; here I can conceptualize pieces around the world by simply willing it, and presto your're there, so close to reality as to be beyond it. . . . My natural process was not to take them [the prints] overly seriously. I liked a free and easy balance, not involving a lot of proofs. I've never shown them anywhere, scatterings of people have seen them and know them at random. Maybe more are out than I know. The collages you have are what has survived the discards." He still occasionally works at retouching one positive depicting endless Midwestern farms and fields from the air, punctuated by giant sculptures like outsized oil

derricks. If he ever gets it right, it should be one of the best of his graphics.

"Oh, yes—I did select eleven prints, made a Mylar print-out of ten, boxed them in galvanized metal as sets with an inscribed silver foil cover sheet. Jim Morgan [Morgan Art Gallery] has one set; Phil Bruno [Staempfli Gallery, New York] bought a set when George Rickey came out here. Three went to Chicago. . . . Now I remember. Henry Geldzahler bought all the 'American' series prints for the Met; he saw the group at the University of Kansas Art Museum, took it with him, and I sent K.U. replacements, maybe not all the same prints. Only that one selection was ever boxed." Who has ever seen it? It has been shown nowhere.

The artless exuberance of these graphics only underscores the convincing category of their fact-stimulated fantasy. They are major prints in a new technique, derived from his long familiarity with the blueprint process. "I don't know anyone else using an Ozalid machine this way," says Eldred. "Before I bought the machine (three thousand dollars), I did it all at Western Blueprinting. There's a man there who knows what I want. They didn't really want my business because I did a number of laborious trial settings before getting proper adjustment of tone. Now they just make the positive (about fifty dollars). The cost of the machine for a silver Mylar print is about five dollars per sheet. If I didn't have the machine, it would be fifteen or twenty dollars. So I can't go crazy cranking out prints." Three or four proofs is fine with him. The machine can be set for tone, and the coated Mylar produces a layering up of the image like a super-negative transparency returned from an unimaginable depth. By juxtaposing fabricated sculpture images with eons of landscape "you really get a load up in the sky."

An Eldred print process includes always: (1) the original collage in color; (2) small photo-negative; (3) large photo-positive (24 inches by 36 inches in size); (4) the silver-toned print on photosensitive Mylar paper, made by laying the positive over the paper and running both through the ammonia-activated blueprinting machine at slow speed twice. Differences in the various photographic backgrounds are compensated for by the tonal control of the printing process. Thanks to the machine the prints become totally integrated. "Once you have the positive you have an avenue into the Ozalid machine; I always keep it accessible so I can print if I want to." A number of positives were also etched onto aluminum plates. When Eldred told the plate-maker to seal the plate surface he exclaimed: "You had me make these and you don't want to print from them!? Are you crazy?" Eldred does not know where any of them are now. "They're like fish that got away. If only I could pull one out of a drawer right now."

These graphic activities absorbed Eldred from shortly after his return to the United States in the fall of 1969 to the end of the designing of the Minnesota Avenue urban-renewal project in December 1970. There are two series: fifteen early positives dealing with American landscape situations, and about the same number of European dream landscapes. A few collages were never converted to positives. The boxed set drew from both groups. Eldred's prints have never been catalogued.

The most striking "American" graphic was of cowboys out on roundup, one rising out of the saddle as he regards the enigmatic metal sculpture on the horizon. "How did that get there?" he seems to say in amazement. Is it a signal? A sign? A portent? This print established the kind of wondering, twisted relationship between situation and object that Eldred loves to explore. In the Mylar print-outs the sculpture can point to infinity, in this case against a landscape gatefold from *Arizona Highways* magazine. Another in the "America" series shows *Drum Piece* soaring above a river valley with Cyclopean mystery: The incorporation of bits and fragments of his executed work became compelling out of context.

For many of these prints he constructed new miniature models of steel—"I had a drill that could make miniature bolt holes"—which were usually discarded after being grafted onto the chosen landscape environment. In one case he went so far as to cast the minuscule model in bronze (Georg Sturman collection, Chicago). In this case the interplay between the gigantic and tiny became exquisite.

Notes on viewing the eleven prints in the boxed set imply the irony behind untitled graphic situa-

tions; they come at you out of stream-of-consciousness experience, shared by artist and viewer alike:

1. Portuguese salt-flats, with arch lifting off into sky. The arch element is a model. Perhaps the finest Eldred print is this composition seen from above, with the arch taking off into the blue like a space "jump" in an Isaac Asimov science-fiction model. Photograph acquired in Portugal. For boxed edition, printed both collage size (negative) and full size (positive).

2. Desert. Photograph source: *National Geographic*. Uses same arch model laid on its side and printed in reverse from collage to heighten dramatic effect. The horizon sculpture figures in graphic number 4. (The positive can be printed either way.) "Tracks in the desert lead nowhere in the sands of time. Or do they?"

3. Village, mountains, cactus. Illustration source: *Arizona Highways*. The "soft" cactus in foreground contrasts with the "hard" sculpture. What interested Eldred most was the isolated village located way down in space: "You have to run this composition back and forth through the mind to find that village." Reversed from the collage.

4. Rocky Mountain view, from *National Geographic*. The metal image was composed from snapshots of gusset plates loaded on a boxcar at Kansas City Structural Steel. With outstretched arms the park guard lectures on the phenomenal structure behind him, as it competes over the mountains for group attention. Was it placed there by interplanetary agents? "Gutzon Borglum is put by it to shame."

5. Desert panorama, *Arizona Highways*. Makes use of a steel section Eldred actually built. Does it remind one of an oil field gig? Or what? "I conveyed an impression of unease by the quietest means."

6. Funeral in Greece. From a photograph found in Greece. Makes use of the steel section in number five rescaled and combined with gondola car wheels used for transport at the yard at Kansas City Structural Steel. Reversed from the positive. Eldred notes that "the dog in the foreground is indeed Mr. Everydog. "I've seen him lots of places."

7. Desert landscape with three erect sculptures. Source: *National Geographic*. Like number five,

highly abstracted use of landscape, with the make-believe sculptures unconnected to human possibilities or events. They are present as enigma.

8. Nelson Gallery of Art, Kansas City. From a color postcard obtained at the gallery's sales desk. Eldred restructures this classic architecture in a monumental park setting by at right inserting a cut-out from the *Big Orange* piece (with the artist seen rear view), behind a fragment of the A.S.B. Bridge, spanning the Missouri River at downtown Kansas City, and at left the model from the Irish scene, the first print made. "The sacred precincts of art bared! Shades of Gustave Eiffel on the Champs de Mars."

9. Canyon view. From *Arizona Highways*. A section of *Big Orange* piece suspended by cables. Descended from the inflatables with cable drawn in the Greek sketchbook, and the suspended dollar-bill collage. "What is it doing there? I don't know!"

10. Italian landscape near Brindisi. From a photograph found in Italy. The erector-set–like sculpture is recreated from parts of the *Mankato Piece*.

11. Western waterway. Source: *Arizona Highways*. The bridge sculpture was specially built for the occasion. This and number 8 are among the earliest prints, according to the artist's recollection: the setting and sculpture are less complex.

"In those prints I really went after a slice of geography; I could go after fifty extensions of ideas right away having to do with land and site." Eldred wished to take advantage of fields, mountains, estuaries, rivers, more than he could ever deal with in reality. Part of the need for such expression arose from an old desire to design billboards. "When I was working in Mankato, I suggested doing a billboard at the entry to the town; they didn't pay attention; it would have been in the Minnesota landscape mode." His single color lithograph conveys the same idea: a nostalgic, chromatic Minnesota landscape idyll combined with twin missilelike structures recalling Cape Kennedy or impersonalized from outer space.

But a leading reason is to be found in environmental-geological considerations. "I've never built pieces that big and couldn't from any practical point of view. On the other hand, I'd never want to con-

demn or sacrifice a site like a mountain, river, or gorge, or destroy a canyon to bring it off. But to stretch the imagination on a par with all that, confronting you with the exact use of reality, well, it's exciting and stimulating to try." Most of all he wanted to create a visual archaeology—"I'm pretty well read on that subject"—out of fragments of his own thought. "The result could exist forward and backward in time, chiefly afterward perhaps." So the prints are a sort of *memento mori*—Fellini-like in scope—to a metallic archaeology. There's that monument to a fallen dictator near Brindisi, the Martian remains on the back side of the Rockies. Who built them? When? Why? To many people a photograph is a very real thing. Eldred's print-outs play on those habits of identification and acceptance. "At least mechanically that's the way the thing works."

If Eldred's silvery, semi-opaque print-outs of simulated reality had been produced under professionally controlled conditions, and marketed systematically under the aegis of print concerns like Gemini or U.L.A.E., there is little doubt that they would be widely recognized in modern art circles. In contrast to Oldenburg's monuments, they come right out of the sculptor's own constructions and are not superimposed ideas out of the head applied à la Magritte. "I was not influenced by Oldenburg, though I admire his work. I'm essentially self-connected." Though everything is played straight, his own clarity of image and bend of logic tell. "Sculptures can't possess this mystery because they deal with given situations, real land, and don't sit out in never-never land."

A group of these graphics impressed a Guggenheim jury sufficiently (among the jurors were Robert Motherwell, Geldzahler, and Tony Smith) to confirm a fellowship for Eldred. How else could he have sent the jury so much so easily? The positives remain for future—and one hopes limited—printings. To date Eldred's home-oriented technology and studio printing methods have assured that his graphics remain a *rara avis*. Perhaps it is a relief that he is not overly up-tight about them. Lest the surreal aspects of these prints seem unconnected to pragmatism of Eldred's executed work—you don't expect to find a spanner in Aunt Mary's teacup—it

should be pointed out that a give-and-take relationship does in fact exist here. The cable idea was to crop up importantly later in the Kansas City International Airport scheme and the St. Lawrence University quadrangle sculpture. Waterways and land formations were to have a corollary in a series of independent models that followed soon after. The idea of artificial elevation against the horizon was to be reinvoked in the projection screens for Washington Square Park. From above, the cones of the Cypress Park project read like a print-out in land archaeology. "There's a reversal, in that some of these things are actually coming into being," says Eldred. The fact is that after his graphics Eldred's imagination was also better lubricated to deal with a variety of forms and materials at once, as represented by the renewal of a city street.

Dale Eldred: *Cowboys on Roundup,* lithograph
montage, 1969, printed by Jack Lemon,
edition of ten, reproduced from the original
collage. *Dale Eldred.*

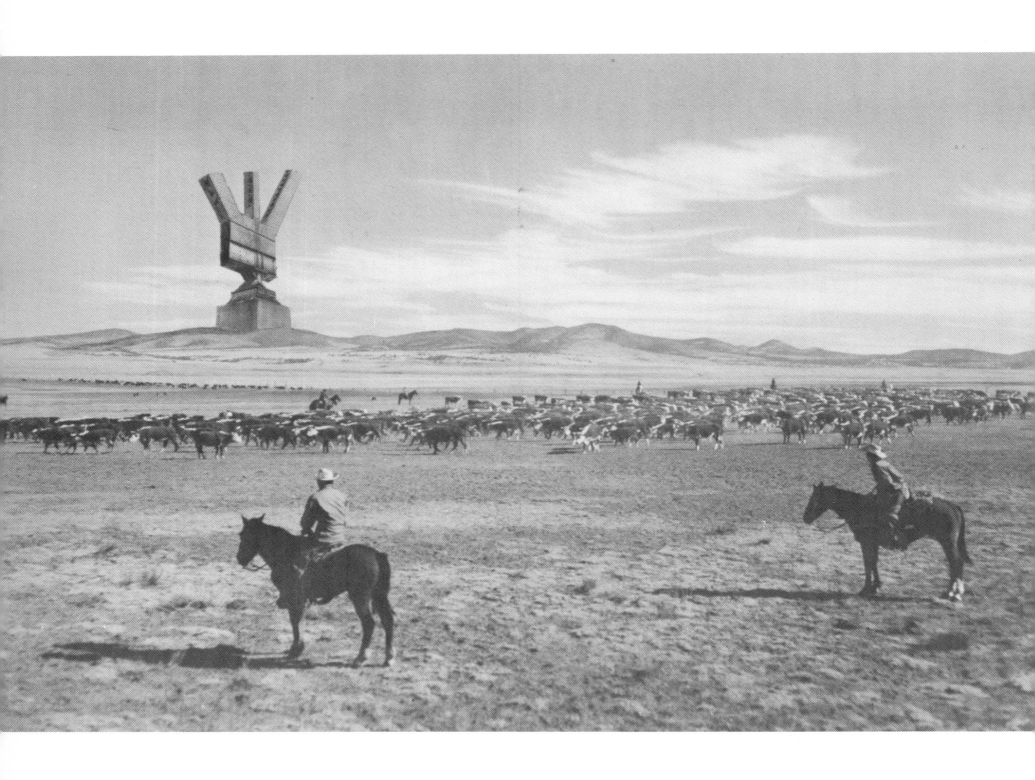

Dale Eldred: *The Nelson Gallery,*
lithograph montage, 1969, printed by Jack
Lemon, edition of ten, reproduced
from the original postcard collage. Also
printed by the artist on Mylar, boxed
edition of ten. "You point out to me that
Oldenburg used postcards, but I
didn't even think of this. The only influence
was your Nelson Gallery sales desk."
Dale Eldred.

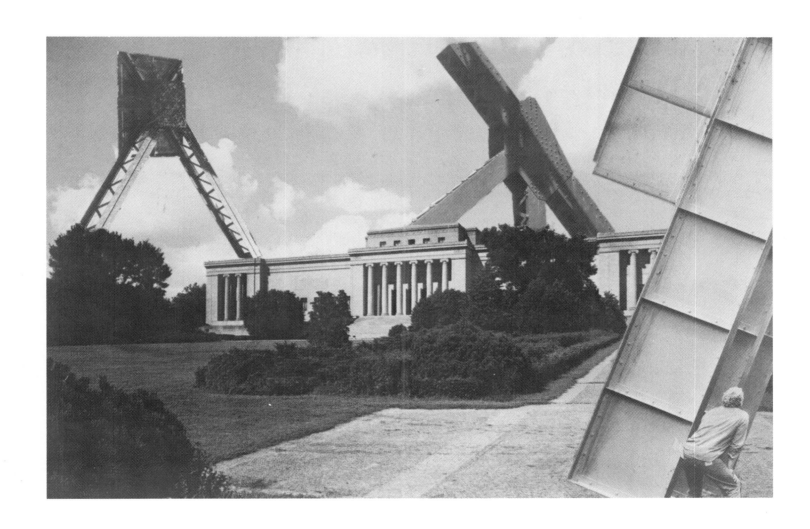

Dale Eldred: *Canyon View,* Mylar print-
out, 1969, boxed edition of ten, reproduced
from the original collage. One print
executed on etched zinc plate, 1974. *Dale
Eldred.*

Dale Eldred: *Western Waterway*, Mylar print-out,
reproduced from original collage, boxed edition of ten.
Dale Eldred.

Dale Eldred: *Western Landscape* (reproduced
from original collage), Mylar print-out,
1969, edition about three. "I have no idea where
they went to." *Dale Eldred.*

Dale Eldred: *American Dam Site,* collage, 1969, never printed to the artist's knowledge. *Dale Eldred.*

Dale Eldred: *Western Lake*, collage, 1969,
paper print-out proofs only. *Dale Eldred.*

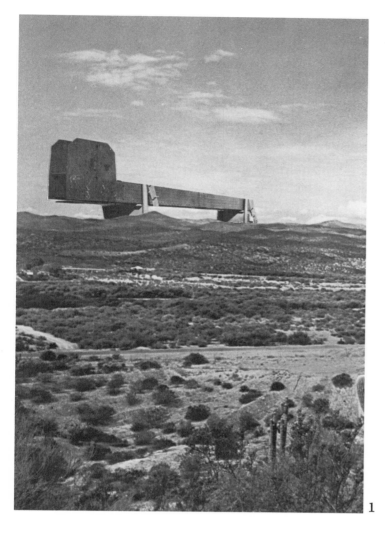

1

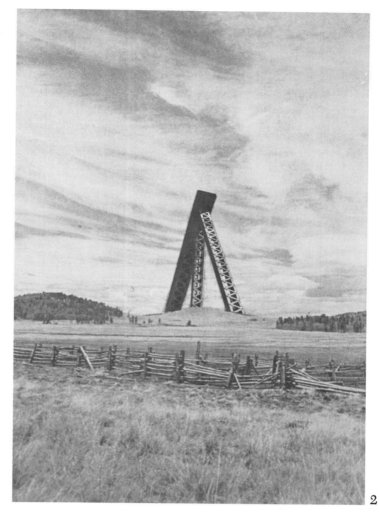

4

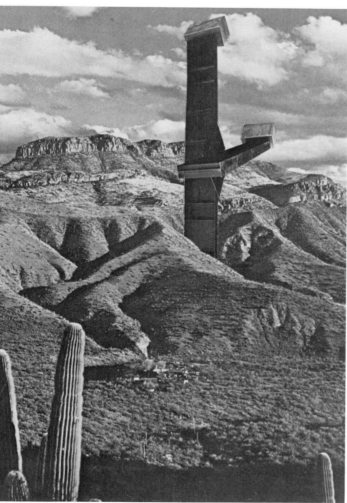

3

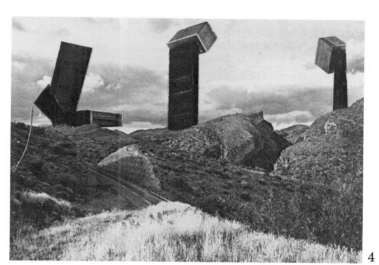

2

Dale Eldred: four Mylar prints: (1) *Arizona Highways Desert Panorama*; (2) *Fence Row Western Landscape*; (3) *Village, Mountain, Cactus*; (4) *Desert Landscape with Three Erect Sculptures.* All these illustrations from original collages; (1), (3), and (4) boxed edition of ten; (2) copy proof only. *James Enyeart.*

Dale Eldred: six line drawings printed singly on transparent Mylar, 1969–1970, no edition: (1) road passing through gigantic mirrors; (2) flotation piece; (3) flotation pieces; (4) highway, predates Minnesota center city mound project, but shows similar tumulus at left cut by highway; (5) large crater (concave) with automobile passage; (6) flotation pieces. "In between the prints I wanted to go back to the pencil again." Not until Eldred was forced to go back over his prints and collages by this author did it occur to him that they constituted an *oeuvre*, not just old items stashed away in drawers. This recognition lies behind his more conscious effort in undertaking his new print series, and his prideful enlargement of their format into work of outstanding dimension. "My sculpture I put where I can. My prints show where I'd like to put them. They're my form of reflection and idealism. I'll never rest until I put sculpture in those places!" *James Enyeart.*

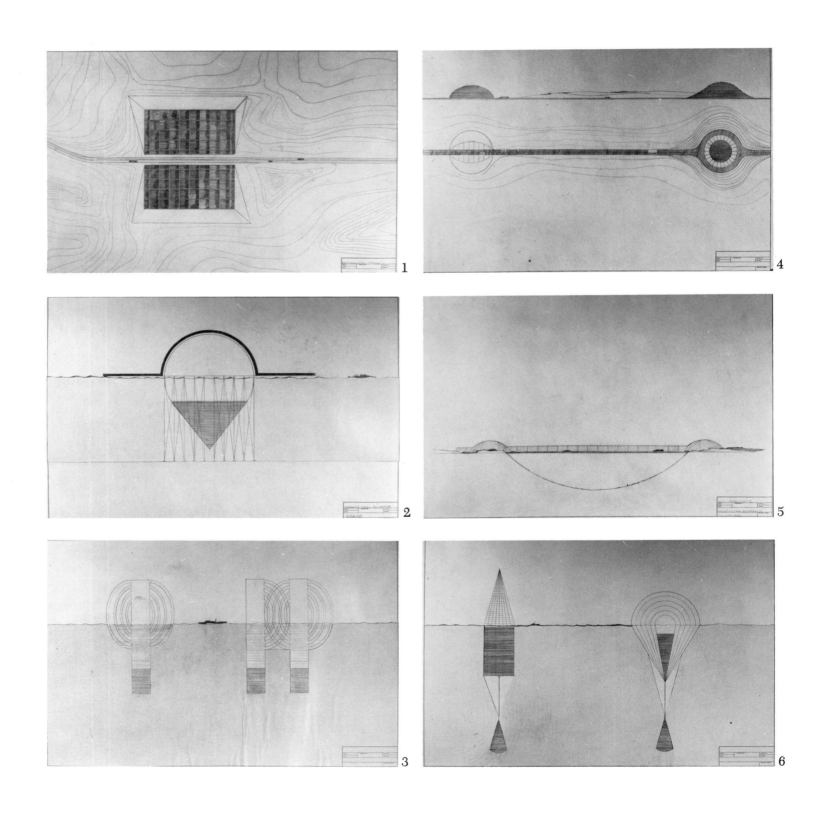

5

URBAN RENEWAL COLLABORATION

After completing the Mankato project Eldred had abandoned his hilltop studio, although he and his family continued to live for a while on the adjacent farm. *Salina Piece* had been assembled on new land at the studio he built from a pair of silo tops, each twenty-five feet in diameter, as an adjunct to outdoor fabricating. The sale of *Big Orange* to a local collector and the Salina commission provided Eldred with the cash to buy a wooded and grassy sixty-acre plot on rolling land in Shawnee, Kansas, which he had coveted for years. "I've known that land since the first year I came to Kansas City."

He began to envision a house on this wild land for his family and himself: "I did not want the house to be the apparent element in the landscape. I wanted it to arrive and disappear among the grasses." What was the aesthetic behind the house? The answer is of interest because it has nothing to do with style but everything to do with concept: "A matter of shelter, as fundamental and basic as possible. That quality and feeling should be conveyed rather than this-or-that style of design." The construction should effect a marriage between something basic and something sophisticated, all locked together. "It is not indigenous architecture, but very close to it." As he worked out its construction program, the house appeared to him as much a sculptural project as anything else he had done.

In late 1969 Eldred began to excavate the site of his house. "The drawing was in my head all the time. I don't sit down and search out ideas. I wouldn't know what to draw. I never draw until I know what it's going to look like." One wonders if the builders of old-time Kansas soddies conceptualized in this manner—for Eldred's house bears a resemblance to this type of Kansas earthwork dwelling, including the bunkerlike elevation and the grass-sod roof. While a nineteenth-century sod house responded not only to environmental necessities but also to their limitations, Eldred had no such limitations imposed upon him. His program was one of choice: he wanted no maintenance beyond simply care-taking; all components were to be "self-functioning"; there must be built-in protection from grass fires because there was no fire department in the immediate area; he wanted a simple plan that would allow for change. "I'm always changing it by build-

65

ing furniture. There have been two fireplaces, a sheet steel one and an adobe ovenlike one now."

Considering the extreme simplicity of this scheme, it is surprising how comfortable and visually pleasant the interior spaces are. The large living room creates a warm, hospitable atmosphere. In lesser hands it would have been cavelike, for it backs to the earth. Eldred discovered that concrete was a livable material, capable of being "sculpted" environmentally. While the four bedrooms have no doors, privacy is assured by curving vestibule walls of boulders, reminiscent in miniature of the entries to Penn Valley Park. Floors where mud and dirt are tracked in are easily swabbed like a ship's deck. In the winter forced-air heating is piped beneath the floor and then vented to warm the floors; the window wall receives a maximum of sunlight. Earth insulation provides coolness in summer.

The free-span concrete roof was poured all at once as a two-way waffle slab thirty by one hundred feet. Joists are formed by boxes seventeen inches deep by thirty inches high, strong enough to support the earth load together with added snow in winter. Earth covers the roof and three sides and is planted with brome and prairie grass: "It has never had to be cut." Excavation of the earth resulted in a pond: "I built the lake and got a house at the same time, using the principle of road-fill construction." Cost was only $5.50 per square foot. Opposite the buried façade there is a hundred-foot length of glass facing the stream, broken into eight or twelve foot segments with a concrete roof overhang of four feet—an earth embankment for living.

"I rehired Paul Slepak, got a contractor, John McFall, to help in slump time. A couple of times fifty people worked at once to save time and for efficiency. Callegari Construction Company did the concrete finishing (machine troweling, water sealing). I did most of the plumbing myself, burying the water pipe as it neared the house after laying it for fifteen hundred feet from the road." No doubt the home focused his attention more than ever on the possibilities of team-work in building.

During this period he often talked with Elpidio Rocha at the Kansas City Art Institute where both harangued students about the importance of landed space. "Buildings are a minor part of architecture,"

Rocha would insist. "Public spaces financed by tax monies are the logical place for a people architecture—symbolism as architecture—an architecture that represents all the people in those spaces."[*] Both men had been concerned with the idea of earth since Penn Valley Park: "how to let the earth embankments flow out." After a period of fabrication Eldred had returned to earth and had associated it with his own home.

Like Eldred, Elpidio Rocha was opposed to placing buildings on pedestals above the people. Like Eldred, he wanted to turn to concepts of shelter, grass, and design features that kept the character of the land. Both were among the collaborators on an ill-fated underground museum of natural history for Kansas City which never went beyond the project stage. The museum project had raised the question of how to put together teams of people to formulate a solution to urban site problems. Elpidio Rocha—hustler, structural engineer, and park planner—was looking for an opportunity to put the pieces for such an ideal solution together on a large scale.

Eldred, too, had explored working with a site—his house. He believed in the "creation of landmarks." Were not his prints created landmarks? He had worked with the "major" part of architecture, the space, or placing within the site. From the beginning all his sculpture had pointed toward a regard for and cultivation of placing, toward the defining of The Place. Shortly after Eldred's house was livable, the two talents melded in a huge project, the largest urban renewal design that ever employed an artist as designer-sculptor: Minnesota Avenue mall in Kansas City, Kansas. The mall, considered as an urban-renewal project, is an administrative *tour de force*. Our concern, however, is with its visual appearance, its aesthetic impact, and a sculptor's role in that development.

Until bulldozers began reshaping its contour in October, 1970, Minnesota Avenue, the main street of Kansas City, Kansas, was a trough of drab commercial building fronts overlooking the bluffs across from the more imposing skyline of neighboring Kansas City, Missouri. Separated by the Kaw River and

[*] *Kansas City Star,* June 18, 1972.

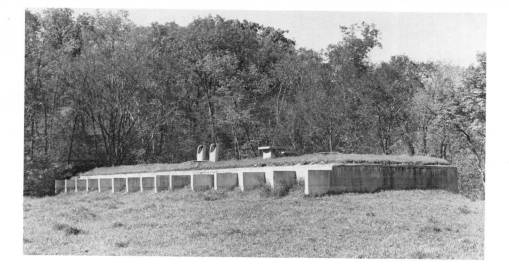

Dale Eldred, the artist's house,
Shawnee, Kansas, 1969–1970.
Dale Eldred.

its valley as it joins with the Missouri River, the "Missouri side," as local inhabitants refer to it, is to the "Kansas side" as Manhattan might be to Jersey City or Newark. Minnesota Avenue never possessed particular architectural distinction in the first place, and in recent years encroaching urban blight threatened its survival as the shopping and commercial center for Kansas City, Kansas. As Eldred states the conditions in his ideas of renewal, "the stores are more disrupting than my elements of design. The people can travel through my contributions, walking around them not in awe, but commonly and naturally, like strolling through a park or street. They are what should really be there. Contrasting those façades with the mall is like putting a book with a fine binding on a shelf with cheap paperbacks. Everything is shown for what it is. I think that's the function for urban design from a sculptor's point of view."

The loan contract with the federal government was signed on January 25, 1969. "Chris Vedros, agency director, said the agency would ask for $2.8 million of direct funds for the first phase of City Center."* An imaginative mayor, Joseph McDowell, and an enterprising urban-renewal agency director wanted a mall. A Chicago firm was hired to make a study; while the report pointed out shortcomings, it provided no plan upon which to move ahead. Early in the game a number of firms were vying for the project, among them I. M. Pei and Lawrence Halprin. Eldipio Rocha, with his ear to the ground, had heard about the Minnesota Avenue project a year before it was announced to the public. Rocha, always the entrepreneur, was appointed to the position of environmental planner for the urban-renewal agency with the purpose of putting together a team. The *Kansas City Star* reported: "Rocha's primary job will be to fit together the pieces of urban design, planning, rehabilitation, and site improvement, especially in the City Center project. Rocha will inspect structures that will remain in the City Center area and then confer with overseers and architects to see what can be done to bring them up to urban renewal standards.**

It was Rocha who verified the programs in writing and made them intelligible to the agency: "When he sits down at a typewriter, he's quite a programmist," recalls Eldred, who was hired as a sculptor "to design the architectural elements."† Other collaborators on the project included most importantly, perhaps, Richard Reynolds, the California environmental planner and ecologist for the Sea Ranch development north of San Francisco; Charles Moore of Yale, who held responsibility for graphics; and Patrick Hickey of San Francisco, lighting consultant.

Reynolds's major point in his contribution, an ecological survey of the state of Kansas, was that—contrary to popular misconception—Kansas is not boring. The first roads and settlement patterns took the most level trajectories, he noted, and the vastness of the landscape, viewed from the settlements, tended to blend toward a preconception of dullness. Another factor for this ecological truism was psychological: nation-wide travel insures that by the time a traveler crosses into Kansas from either direction he is tired and bored, and all too ready to project his inner frustration into the Kansas landscape. Once implanted, these negatives are difficult to displace. But they are not always true. The charm of Kansas is that it can unexpectedly disappoint this categorical expectancy through waterways, flood plains, and hills.

What Reynolds admired about Kansas was exactly what Eldred most admires: unwalled space—the three hundred and sixty degree mirror of prairie and sky—an entity, considering today's urban congestion, well worth celebrating in a direct and auspicious way. Rivers in the eastern part of the state and the unbroken breezes of the western plains area are punctuated by table lands, uplands, grass, and the depressions between the Flint Hills. The wind

* *Kansas City Star,* January 16, 1969.

** *Kansas City Star,* January 16, 1969.

† Eldred's contribution was termed "architectural elements" because urban renewal contracts cannot be made for sculpture. He signed his contract on May 16, 1969. It stipulates that he was "(1) to prepare design development documents consisting of two and three dimensional visual statements, and assist in preparation of preliminary specification, to fix and describe the size, character, and location of architectural features; (2) to designate materials to be utilized in the installation of architectural features; (3) to collaborate and assist with the agency and other special consultants involved to assure a unitized and cohesive design."

of the west, the water of the east, speak of movement. Reynolds wrote in his report: "Topographically, the state of Kansas is not flat. There are essentially level places in it, principally along the river courses, but the state as a whole is not flat even in its western portion," despite the vast horizon lines and the horizontal dominance. "Horizontality is strong (not heavy) and all pervasive."* At the horizon line the dominant color effect of mid-Kansas was green and yellow, with highlights of cobalt blue and poppy red. When Dorothy in *The Wizard of Oz* was admonished to follow the yellow-brick road, the color image was thoroughly appropriate.

The City Center mall design is, to date, the only imagery after Thomas Hart Benton's paintings to try to come to grips with that vast, little-known entity called Kansas. How does one articulate this immense and often beautiful space? One can almost echo the William Allen White-isms if not the Walt Whitman-isms! Eldred says he never read Reynolds's report personally: "I never had to, for I absolutely knew what he meant. We all worked constantly back and forth together. Rocha, Reynolds, and I were very close at that time, bouncing ideas and discussions back and forth in the context of the project. We 'lived' in the context of that report all the time. Richard is a vibrant man well structured in his ideas. What he said about urban ecology meant little to me as a report, but the urban-renewal people listened almost alone to him except for Elpidio. They all believe in words. That's why there is confusion over identities within the project. Richard verified things I'd been living with all the time."

There were no drawings at first: an eighty-foot-long model of the four-block-long street area was already prepared at the urban-renewal offices facing the street to be renovated. The façades were indicated by transparent plastic silhouettes, so that one could see through to the impending design features. "I just walked in and walked up and down the 'street' with Plasticine in my hands. I'd work up

a section of the project, rough it in; project staffers worked it up to scale, corrected it. The first day I think I roughed in two blocks." Several staffers were students of Eldred's or recent graduates with architectural training. Drawings were then worked up by them from the model. Early ones exist showing tricks Eldred would not condone and which were ousted, such as a path crossing through the cleaved mound on its diagonal way across the plaza area: "Let that mound and plaza alone; no tricks." Two landscape experts came in to consult on plantings: "they seemed lost all the way through."

Elpidio Rocha's role was that of critic: "We'd go through a lot of maneuvering, real collaborators on how to move a roadway system." At one point Bill Turnbull, architect-designer, was hired as additional critic: he advised staggering the rows of Eldred's tower sculptures at the center of the mall's linear progress. "To me it made no sense, just architect's busyness. I wanted to expose the major features to show how emphatically they stood upon their planes: 'I exist; I am.' Let the pedestrian or driver accommodate to them as part of the identification process. Do you know of any cute landmarks that lasted? Were the pyramids cute?"

A great deal of planning collaboration was expended on practical answers to material questions: can a snowplow cross this roadway? How much gradient can a car smoothly take? Can a fire engine traverse the trafficway? The concrete color—it is beige earth with yellow overtones—was based on cost studies that paralleled the design process. "Richard Reynolds wanted an earth color; everybody did. Naturally I did. The material mass came together as ideas were traded and discussed. Elpidio made it all pull together; hiring staff according to need, bringing down the deadlines, handling the politics which were a major issue in a project with $23 million in federal funding and agency supervision, to say nothing of local government. Sometimes I don't see how we got the thing done."

One landscape architect resigned in the middle of the four-month designing period and left, exclaiming "it can't be done." Eldred's method of participation was often to come down to the Minnesota Avenue office late at night or to correct drafts at the Kansas City Art Institute. Elpidio would take El-

* Richard Reynolds, "Kansas Design Reconnaissance Report," prepared for the Kansas City, Kansas, Urban Renewal Agency, May 1969 (mimeographed copies only, but reprinted in *Entrelineas,* vol. 2, no. 1–2, 1972).

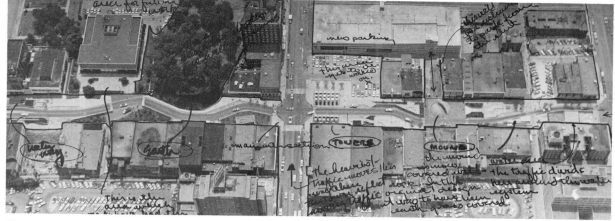

Kansas City, Kansas, City Center Mall, aerial view with notations
by Dale Eldred, 1970– . *Dale Eldred.*

dred's new tracings down to the office. In no way did he gear into the urban-renewal administrative mills: "I never met the urban renewal director . . . oh, once I met him with five others during a general session, but never had a conversation with him. . . . I was reluctant myself. What they knew of me was through a hiring dossier. Perhaps that is why Chris Vedros thinks I had nothing to do with it. . . . You see, Elpidio was able to put up a fantastic smoke-screen."

Next to Eldred, an industrial designer and former Eldred pupil, David Samuelson, had the most to do with the Minnesota Avenue mall's outward appearance. "David had a lot to do with the finishing work: sidewalk patterns, curbing lines, trash cans and benches, the practical things." He was the only other person who laid down a design idea within Eldred's concept. "He drew in my manner and gave consistency." Samuelson's hand can be seen in an aspect of the waterway system at the western end of the mall. The tube-header at the top of the waterway was designed by Eldred, but the other two water ejectors were designed in his image by Samuelson. The seating area, rather like a sunken sundial, at the eastern end is Samuelson's design, while the sloping concrete water-chute that parallels it across the avenue is solely Eldred's work.

Lynn Walleck was drafting captain in the final working drawing stages. He took charge of preparing drawings for construction bids. Eldred recalls that one of the most crucial aspects of collaboration concerned planting. He and Elpidio insisted that trees be kept small enough not to disrupt the dominant feeling for earth works and also to ensure that the landscape contours were subordinate to the concrete abutments. To Park Department people used to the idea of "covering it up by planting a hedge," Eldred's design system must have been innately frustrating.

Several special features and ideas caused difficult design problems. An old Indian cemetery became a key issue. How far out into the street area should the cemetery's embankment flow? The cemetery sculpting Eldred considers successful in retrospect. After it in point of design came the semicircular arrangement of pie-shaped concrete slabs, tilted upward, mirrored on top, set close to one another.

These were to have fanned from the terrace before the Kansas City, Kansas, Public Library. They were to have concealed Freon tubes to produce frost in summer and a heating system to melt snow in the winter. This essay into open-air reversal was never built: "The territory in front of the library the urban renewal never got hold of; he [Eldipio] missed the shot on that one." The tumulouslike half-dome on the roadway plaza Eldred designed to be of grass rather than to be clad with a revetment of boulders. Eldred does not know who ordered the surface rock. Its cleaved interior was to have been lined with polished steel mirrors, so that by walking through it pedestrians would dissolve into reflections and the mass of the mound would in effect disappear. Only dull, nonreflective metal was used, killing the intended effect. Furthermore, the plaza upon which the mound is placed was to have been surfaced with Neoprene rubber, altogether a much more exciting exploration of materials than those finally settled upon.

In fairness to Eldred it must be pointed out that the parallel rows of towers at the crossing of Minnesota Avenue at Seventh Street were not originally designed with steel casings, but in transparent, bronzed solar glass, to be framed in nickel-plated steel, and were to have been connected by interior cross cables. Instead they were built wholly of stainless steel. Their proportions, awkward in metal, would have related more appropriately to the whole schema in copper-toned glass. They would have glinted in the sun. At one moment they would have appeared solid, at the next moment not. The keynote was ambivalence. The fountain-pool in which they are set was designed to throw a continuous water mist—encouraging the tower bases to disappear into a man-made atmospheric cloud. At first the water jets were regulated as Eldred desired; but now they spew conventional streams of water. Referring to the towers as built, Eldred comments: "I'd have never produced surfaces that do not come together as a unit. The glass was to have been manufactured in twenty-foot sections, but the steel towers are seamed across the middle ten feet up: completely wrong."

Not long ago David Samuelson sent Eldred a trick color-photo of the towers looking reflective and

coppery in the setting sun: "Now that's what you meant it to look like in glass," he said. Eldred feels the main waterway, one block beyond the tower, a series of rippling concrete sluices, is successful, except that "I had glass sections provided so that people could look down into the pump room below the surface—with a greater sense of mystery."

Eldred also remembers that he was promised verbally a supervisor's contract, but that it never materialized. This was a crucial point in maintaining designing standards. As it was, the chief designer of the project had no choice during construction. "Either out of rush, or frustration, or appeasement, or some combination of these, some very rash, unfortunate decisions were made. When I'd go down, I'd see it was of stone [the mound] or not polished [the concrete and metal entrance barriers to the mall]. These were to have carried mirror strips on their faces, not the present dull metal. I don't understand the changes," Eldred says. "I don't think it would have cost any more; the materials recommended were stable and unbreakable, including the glass. The towers now read flat-on as objects: reflectivity would have afforded a subtle contradiction. Someone didn't understand the subtlety, the quality of reversal—traveling by mass that doesn't read as mass."

As to the trees across from the library, Eldred says: "I don't know where they came from." Still waiting for completion is a terminal two-block section leading off to the west, a green belt softened with Russian olive trees and shrubbery. The losers in this confusion are the city and the people who live there and, of course, American sculpture. One can only hope that in future years restitution of the original specifications might be made, but considering the enormous amount of money and energy expended, the hope is a dim one indeed. While one can deplore the loss of distinction brought on by the design changes, there can be no doubt that the general visual language of the Minnesota Avenue mall is indelibly Eldred's; he is the only artist in the area who could have devised such a chain of visual experiences. What flexibility of episode! The precedent of his house and a signed set of drawings for the Minnesota Avenue project bear witness to his creative presence: the tough sense of coordination of

70

visual elements is due to him. Two of the signed original drawings are reproduced following this chapter.

The mall is comprehensible in terms of basic abstraction at the same time it contains subliminal reference to the varied ecology of Kansas. Eldred's fresh rethinking of a city's center in relationship to technological possibilities on one hand and man's eternal proximity to nature and the primeval past on the other illustrates his preoccupations. By compacting this duality, he hoped to square the present-day swelter of the city with what is continuous and conserving. He wanted to buy some peace of mind, even some perspective and distance. "It was like creating an archaeology for a modern city. Designing the archaeology was the capacity to live out a dream: the absurdity for me is that I couldn't control the end result." Archaeology designed in the eternal present was geared, however, to the automobile as it passes us through events of raw concrete, metal, stone, and grass, giving us momentary glimpses of reshaped natural features never found on usual streets—concrete berms that are in effect gigantic planters for prairie grasses, spillways rushing water in diagonal patterns, and at one point the old Indian cemetery forcefully extended outward from the old street line. Is the spherical mound a dolmen or a moonscape? Are the stainless steel towers in parallel rows, bisected by the trafficway, a metaphor on trees, grain elevators, a reminiscence of the fort stockade, or futuristic light sculpture by night? Is the raw concrete pumphouse (for the waterway) a bunker, a Kansas soddy, or a Greek isle house? Water systems remind us of modern hydroelectric plants but also of Ozark streams. The angles and rhythms of design switch back and forth throughout the mall "like a controlled earthquake that pushes the street from one side to the other."

Despite all the conflict in its building, the City Center mall follows its coordinator's precept: "I want to clarify," Rocha wrote, "that by no means should we build a miniature Kansas, or copy literally the man-made structures that we find in the state of Kansas, but rather that these objects, nature and man-made, would through their configurations, their forms, their color, and structure, provide inspiration

which in turn would serve to be expressed in an abstract but useful way in the mall."*

Is the Minnesota Avenue mall really successful? Not totally, in Eldred's view of course: "I look at it as a great idea. It's like a great site with circus tents pulled up [read "shops"] from which to gape at it. But it does have sitelike qualities. And I think that as the plan goes ahead, the three parking access areas and their ramps will force changes. Things will change, and that is healthy. The mall was designed to meet changes at either side, in fact accommodate easily to them. The period of time for acceptance of the mall is not now, but fifteen years from now." It could grow like a cathedral. He feels positive over the opportunity it afforded him ("we got away with a hell of a lot") to deal with such vast dimensions—"moments in space drenched by the sun or rain." Quietness was a positive result. There is an inward quality conveyed by these silent monuments that is restful and yet compelling at the same time. Even the waterway is not a true cascade but rather like a film of water passed over rollers on ball bearings. Most of the design elevations were canted or sloped so that edges were not overly sharp. These recall table lands and mesas, land masses known to be visually expansive and restful. Even the towers were rather squat, stable rather than soaring, for all their size. The traffic is controlled by the shifting road pattern so that it moves slowly. The pedestrian is free to wander, as in a ruin. The seating pit is a zone of silence. Above all, for him "it gave a chance to bridge out into sequences of ideas that I'd played with but could not build unless I broke away from restrictive self-constructing." In flow of episode, use of concrete, in variety of experience, and consolidation of technics, the mall was a marked advance in sophistication over Penn Valley Park and was a gigantic expansion of the team spirit which had inspired it. The mall was not a playground for children, but a somewhat similar, exacting experience for adults, for children grown tall.

One criticism may be leveled at the mall. Its scale simply does not fit the dimensions of a rather narrow street. It was perhaps an over-vigorous statement, but such athleticism accords with Eldred's

vision of things: "You don't get one without the other."

Eldred emphasizes that "the mall is not selling anything. It's a habitat. It is not a commercialized come-on, replete with gimmicks. It is deliberately neutral and creates a malleable situation. There's no designer tie-in to merchandising like Ghirardelli Square. It sets the responsibility of the merchants to pursue and stimulate quality. After all, the merchants approved the design at several meetings and looked at the model." This fact should be borne in mind in view of the fact that Mayor McDowell lost his office during construction of the Minnesota Avenue mall to an opponent who campaigned to curb expenditures for such pie-in-the-sky projects. A number of merchants have complained that the mall is not helpful to their interests. A suit was brought by the owner of a colonial office building directly facing the steel towers to dismantle them, but it was dismissed in court. One wonders if such opposition would have been encountered had the mall been part of a privately financed shopping center. "Damnedest expenditure of my good tax money I ever saw!" muttered a pedestrian when a group went through the mall on foot recently. When Charles Moore's graphics and signs were put up, they added another dimension to the experience, contributing to a pictorial sense of order. In time, the mall will undoubtedly be publicized and admired. People shouldn't look for what is not there, but simply for what is there. It is hoped that Minnesota Avenue will gain in attractiveness, especially as the grasses and trees take hold and the flowers grow. The mall will have to be tended carefully and the water must be controlled to achieve its intended effect.

Participation in the City Center project taught Dale Eldred one outstanding lesson. He describes his frustrations: "I never laid a hand on any surface. I couldn't direct that the expansion joints be properly lined or make corrections when craftsmanship became sloppy. But there are elements in the mall that afford an experience like nothing else in this country. They absolutely do not function! Why should they? But I could never participate in an elaborate scheme again without having control over

* *Kansas City Star*, October 5, 1969.

my part of the collaboration. At that time I was content and couldn't do anything about it as things happened. I feel foreign to a lot of it now. You go on. Don't look back in regret. But I'll never lose that element of control ever again. Once you've got the nugget you can always throw away the shell."

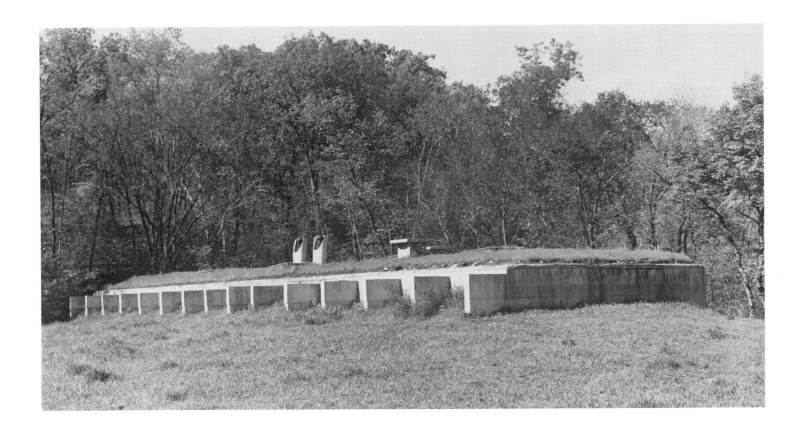

Dale Eldred: the artist's house, 1969–1970, Shawnee, Kansas. View from the rear, showing buttresses, grass roof, chimneys, and skylight. The earth is sloped at a two-to-one grade against three elevations of the house. In full summer, rye and tough fescue grass fully submerges the house into the fields so that it almost loses structural identity. *Dale Eldred.*

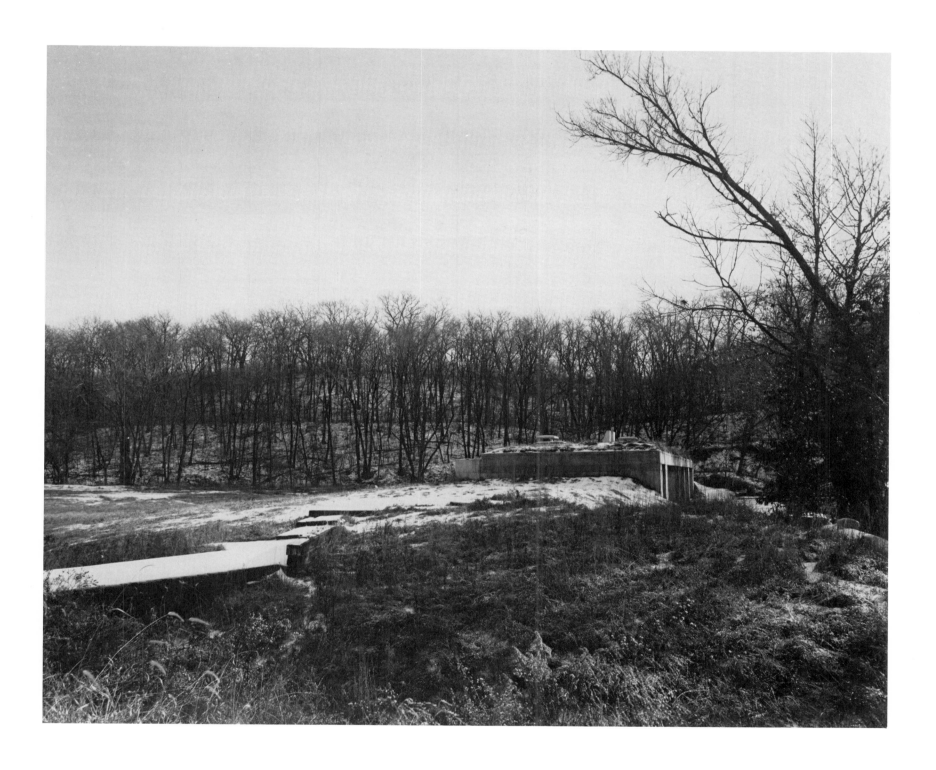

Dale Eldred: the artist's house. View from
the side with concrete entrance walks.
Dale Eldred.

Dale Eldred: the artist's house. The living room
looking toward kitchen area and bedroom corridor.
Furniture at left and fireplace designed by the
artist. The fireplace seen here has since been replaced
by an adobe structure: "I've changed that three
times now. My chairs have heavy white duck cushions
now, and the floors are loaded with Ethiopian
rugs. The place is sustained in terms of livability."
Dale Eldred.

Dale Eldred: the artist's house. Winter view
looking east upon exposed or glazed
façade. The house presents its most structural
aspect in winter: "Then it has the sharp
presence of an exposed archaeological site."
Dale Eldred.

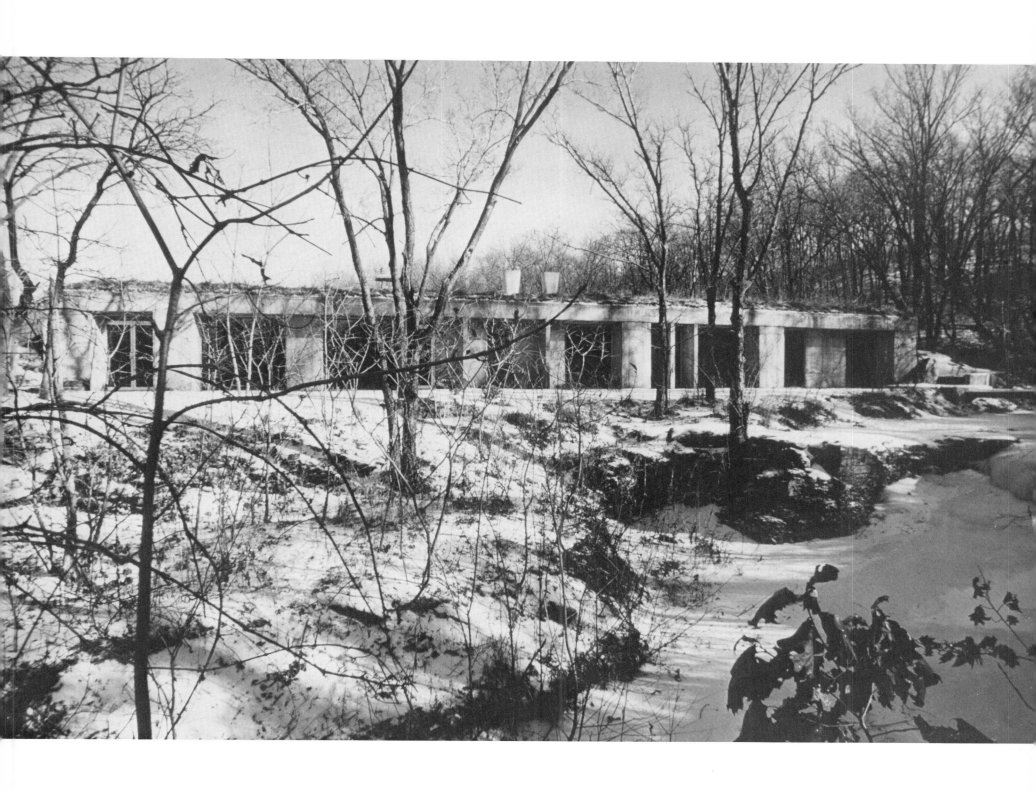

1

2

3

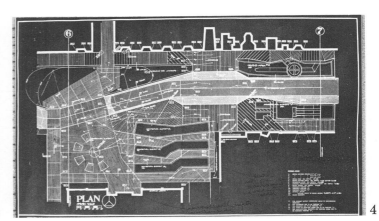

4

5

6

7

8

Dale Eldred: Center City, Kansas City, Kansas, urban renewal project, 1970– . Chris Vedros, administrator; Elpidio Rocha, design collaboration coordinator; sculptor-designer, Dale Eldred: (1) Dale Eldred, signed drawing, detail of mound, specifying stainless steel mirror-finished interior cut; (2) Dale Eldred, signed early scheme for towers, before glass surface was decided upon by him; (3) projected development area in front of library showing mirrored concrete hemicycle and zigzag berms which were not built; (4) final drawing of mound with site plan (not finished according to sculptor's original plan); (5) expanded detail of (4); (6) closer detail of mound and plaza; (7) large waterway, including pump house; (8) finished specification drawing. Numbers (3-8) design collaboration, finished specification drawings, showing framed section for towers in stainless steel (not glass). Eldred feels that drawings (1) and (2) were probably returned because of faulty blueprinting; the rest are lost to him, as they were sent down immediately to the urban renewal office: "Elpidio would come by and get them." *James Enyeart.*

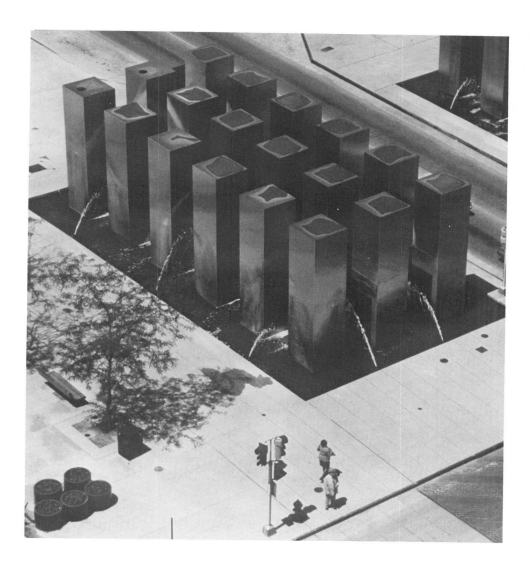

City Center, Kansas City, Kansas. Stainless steel towers complex as executed; the water system is not creating a flotation quality because the spigots are not operating at sufficient pressure nor are they hitting the water "to keep the pool surface vibrating." These towers were conceived as a filter for traffic to be processed through, together with light and water. "It wouldn't take much adjusting to get the water action as it's supposed to be. At a recent meeting I said I'd help them to do it— free." As this book goes to press (June 1977), these towers have been removed on the initiative of the local merchants. *Dale Eldred.*

City Center, Kansas City, Kansas. Pedestrian walking
by the steel towers, July 1974. The towers anchor
the major cross-street intersection. *Dale Eldred*.

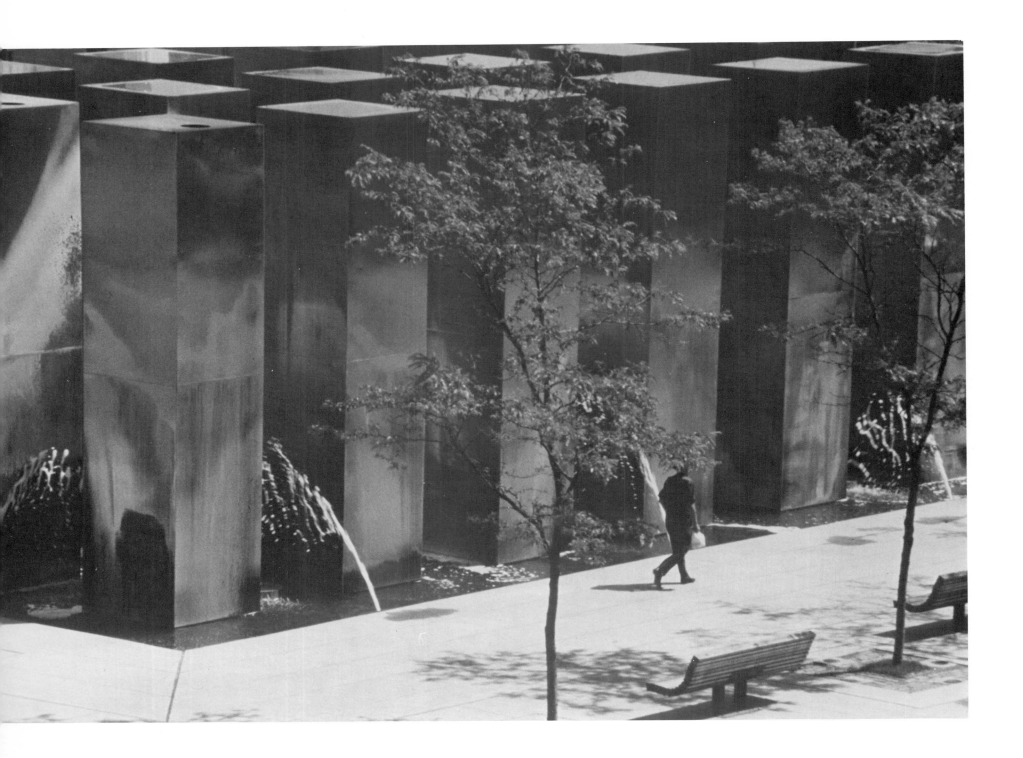

City Center, Kansas City, Kansas. Overall view of water systems sculpture, located in the west sector of the mall, the water now running. *Dale Eldred.*

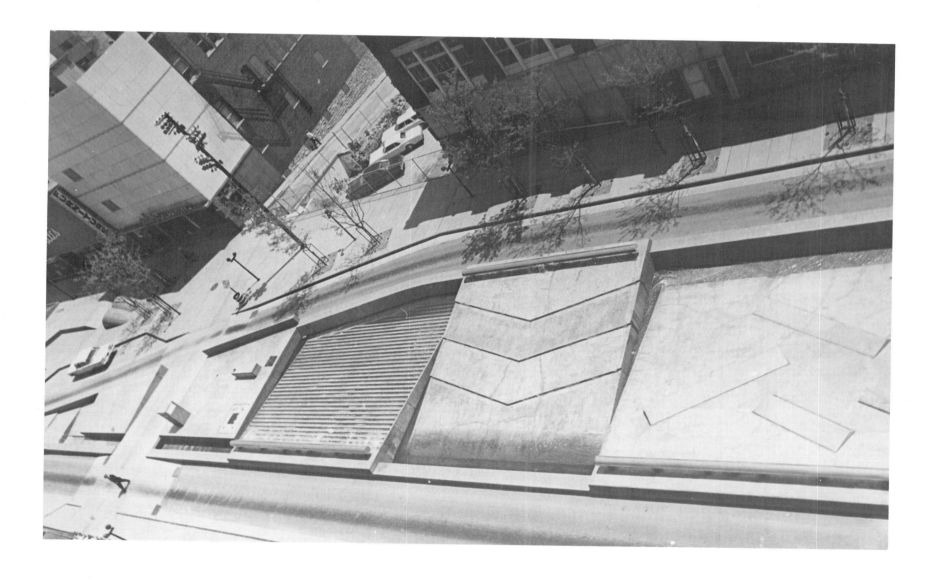

City Center, Kansas City, Kansas. Pedestrian walking by water
system header. "It reminds one of the flow of a hydrant—like the ones
the park department opens in summer so kids can play in the
street flow." While the spigotlike mechanism in the early *Standing
Iron* was a dummy and did not discharge liquid, its successor
here certainly does. You'd think there is no relationship between
extremes in my work, but there is—when it is pointed out!"
Dale Eldred.

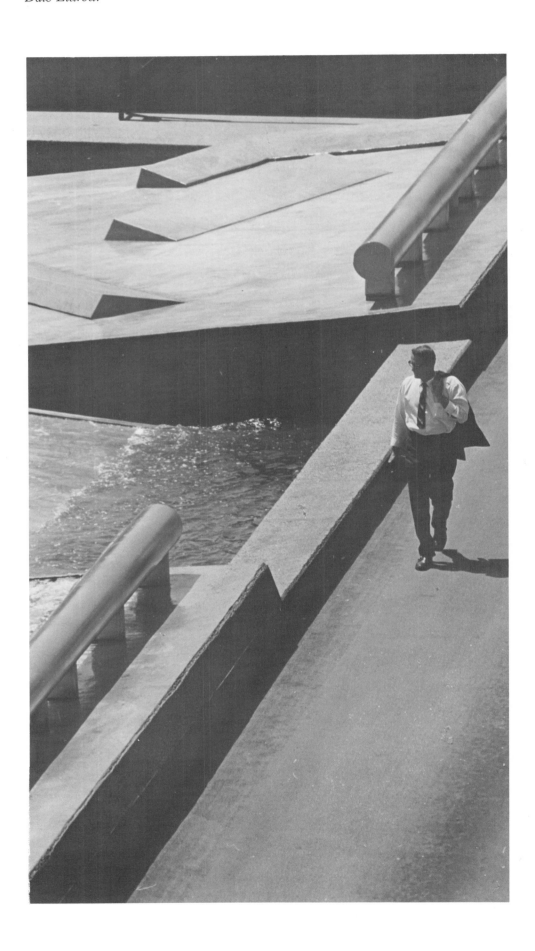

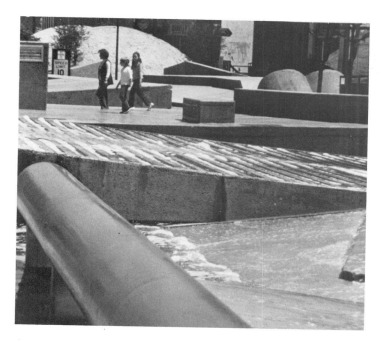

City Center, Kansas City, Kansas. Views of water system at work. Directed water flows in several directions across spillways, yet the bottom channel always moves water in the same direction. *Dale Eldred.*

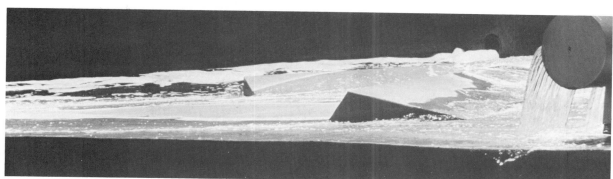

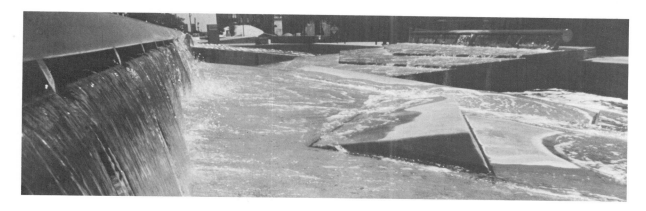

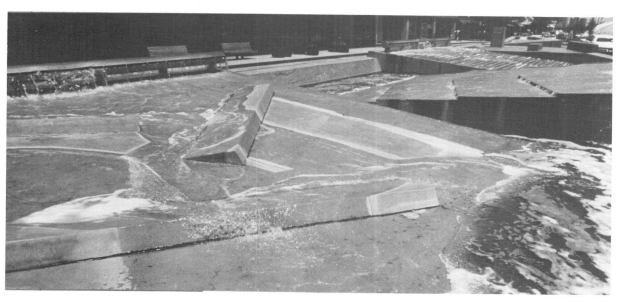

City Center, Kansas City, Kansas. Overall view looking
east from pumphouse past the mound.
Water starting from the header at left center is channeled
under the pedestrian crossway to join the major spillways.
The supply pipe acts like an irrigation pump.
Dale Eldred.

City Center, Kansas City, Kansas. "Washboardlike"
channel system. The stepped channels were
formed by pouring concrete around two-by-four
wooden strips, then removing them. The frothy effect
is intentional—"like soap suds on an old fashioned
washing machine." *Dale Eldred.*

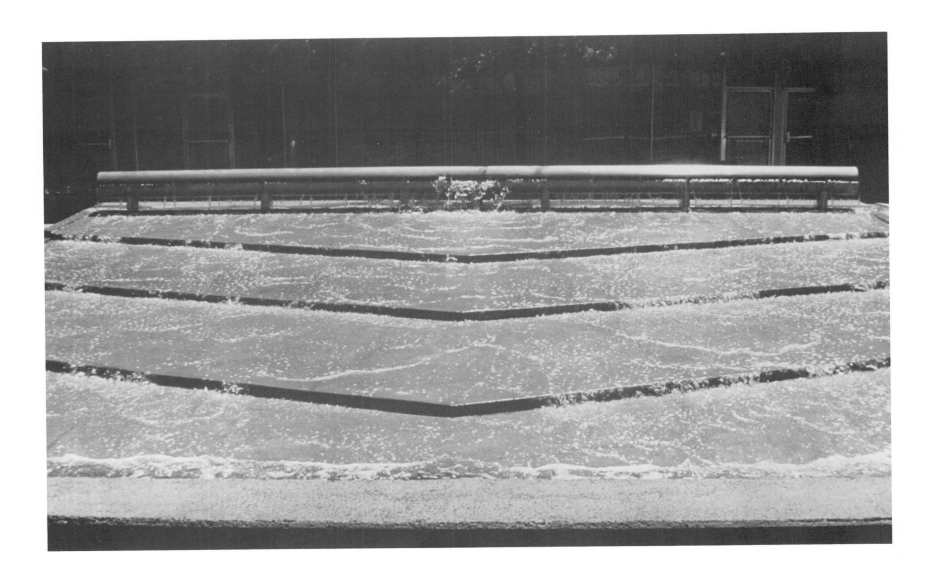

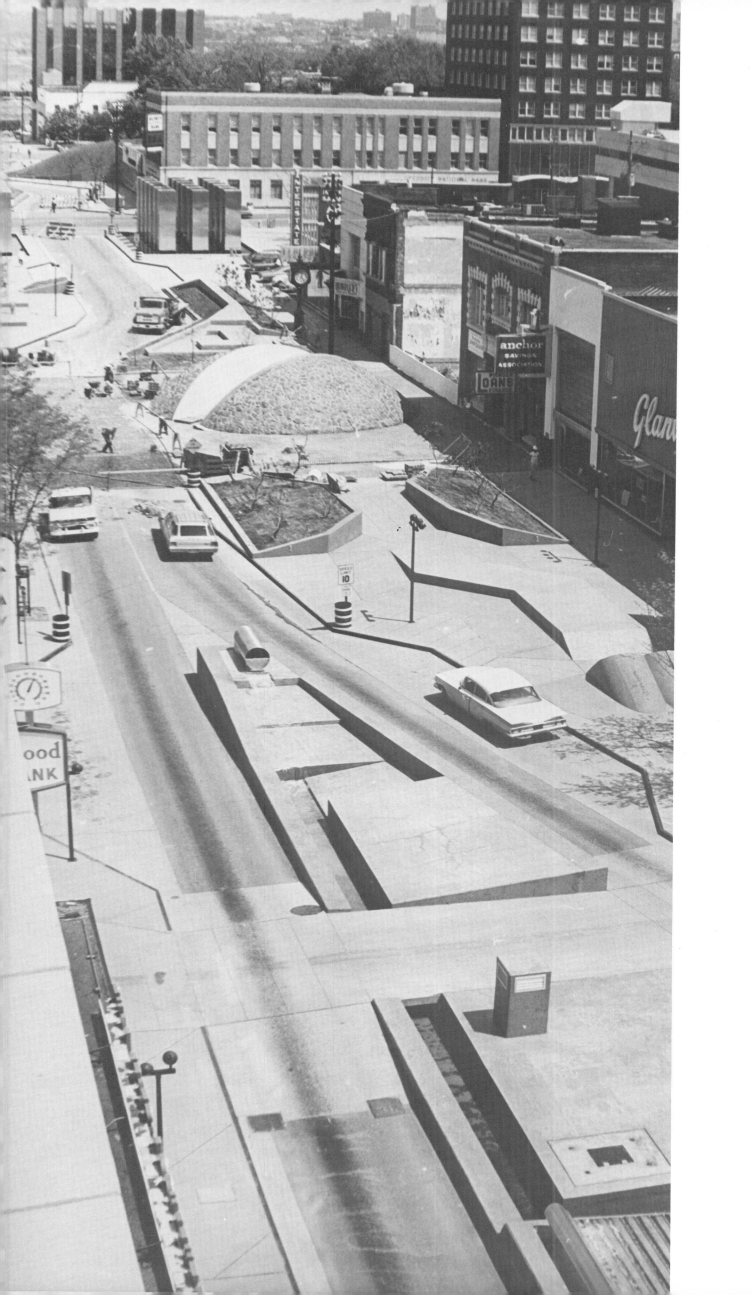

City Center, Kansas City, Kansas. Aerial
view of stone-clad mound with adjoining
plaza being surfaced. *Dale Eldred.*

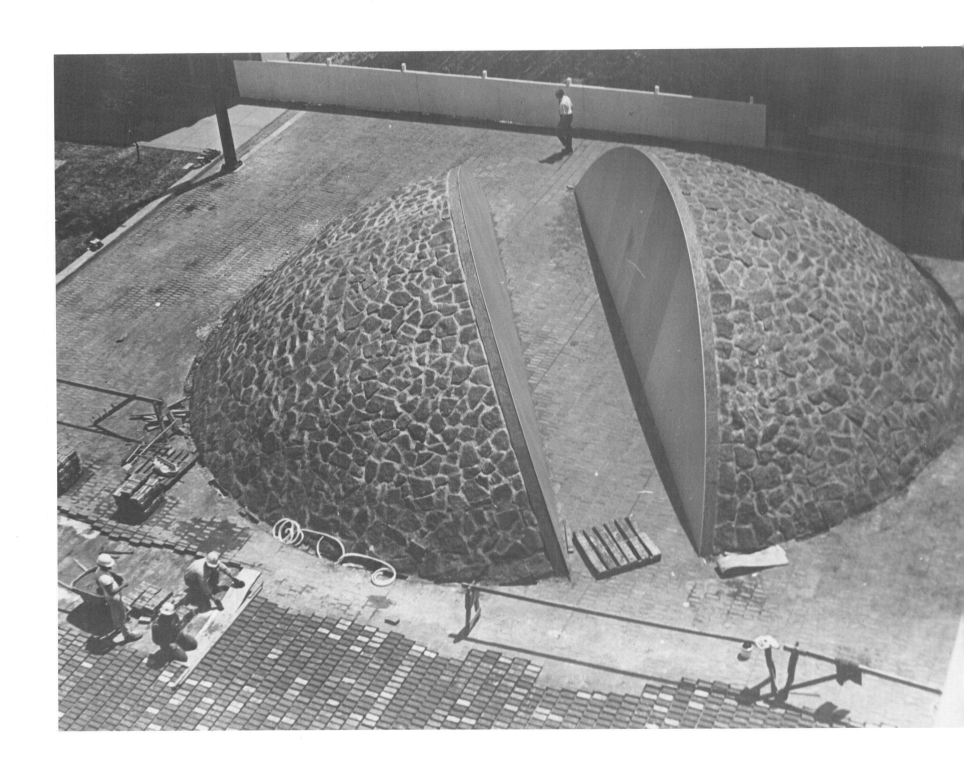

City Center, Kansas City, Kansas. The
mound as viewed from entranceway
to parking ramps, July 1974. The parking
ramps and garages (not designed by
Eldred) are located at two points behind
the shops, with ramps leading to the
street level. Some of Eldred's works are so
simple that the onlooker might naïvely
confuse elementalism with simplicity. The
former dominates here. *Dale Eldred.*

City Center, Kansas City, Kansas. Berms
near east entrance to the mall, showing
walls buttressing back against the
earth—"container walls"—filled with
prairie grass. The pipe is a purely
sculptural element. "David Samuelson was
involved in this one." *Dale Eldred.*

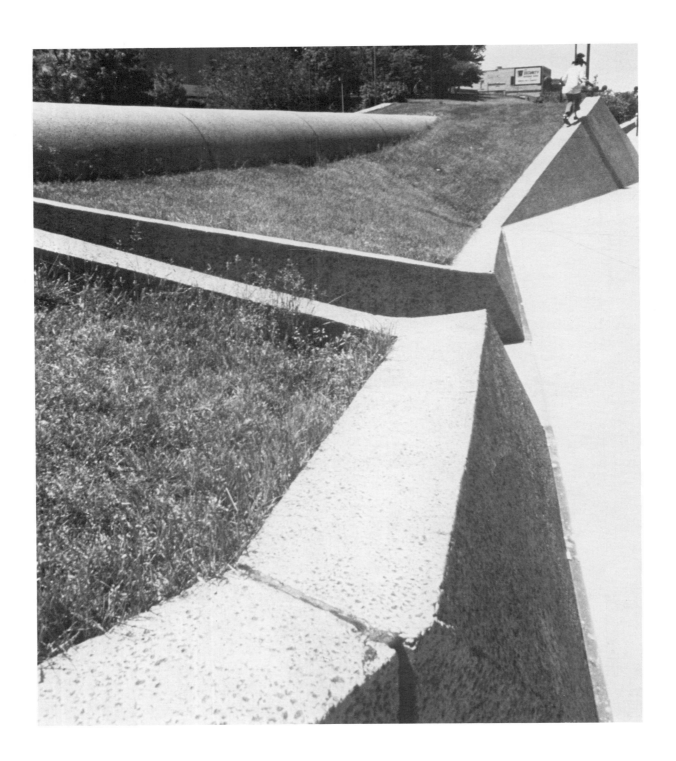

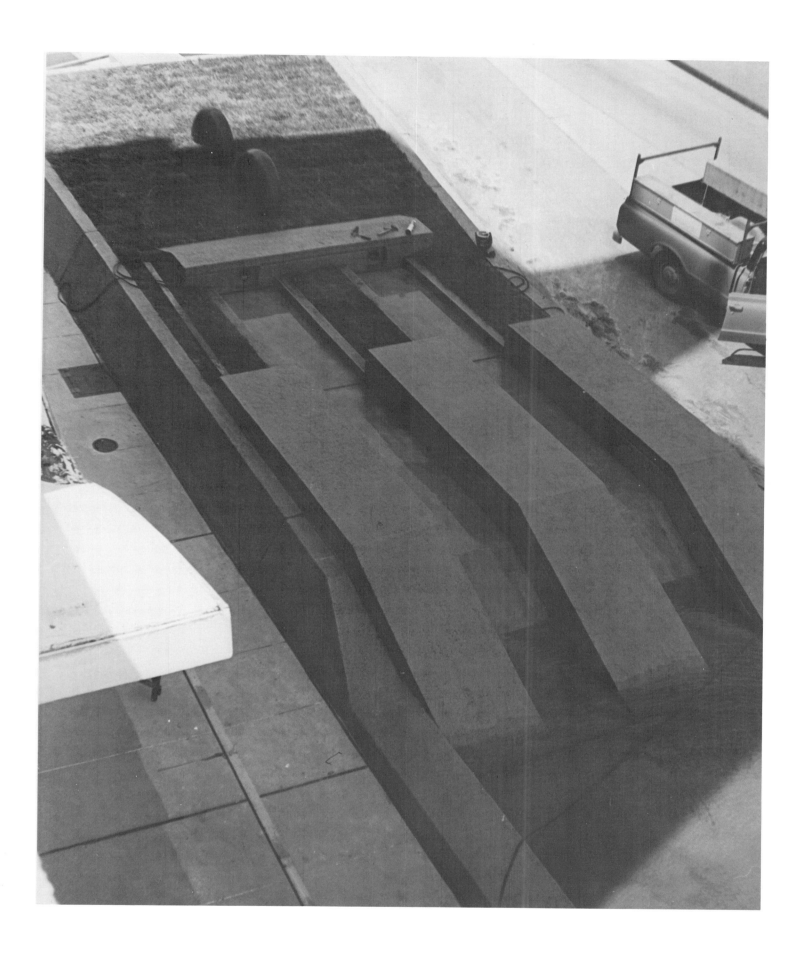

City Center, Kansas City, Kansas. The east water channel
located across the street from preceding illustration.
"Since this system involved the attention of pedestrians
more than vehicular traffic, I made it simple and less
agitated than the west one. It's like a trough." *Dale Eldred.*

6
LANDMARKS AND SITES

While the City Center project was in construction, Eldred took advantage of a Guggenheim Foundation grant "to devote myself full-time to working on sculpture and developing my ideas further in sculpture without teaching interruption and to travel to areas that have meaning in my work." These words must form one of the more terse applications the Guggenheim Foundation has ever received. No further comment was added. The fellowship, however, was granted to Eldred. Because it relieved him of teaching during 1971 and reduced his duties in 1972 and 1973, it was doubly instrumental in furthering his travels, giving him time as well as money: he could get away!

The urge to travel became a fever. Why not survey the sites and landmarks lying east of Suez, that other world where colorful patterns, magic, ritual, and symbol prevail to this day over our tradition of Western humanism? "I'm tired of humanism," says Eldred, "tired of the idea that only Roman-Renaissance and its distillations function in our world. There are other ways to look at things. Why not inject a respect for craft abstraction into our environment to make it more coherent? That too is individual, but is it collective in spirit, organic in design, and folkish in its vigor? By folklike I mean close to nature. The simple people of the world have much to teach us builders and technicians."

Lofty artistic ideas are no longer the only source of inspiration for art in this century, according to Eldred. Vernacular traditions can be more steady. By that standard, Erasmus of Rotterdam might offer us little to go by. Nor would pure science offer much, for an academic think-tank can be equally lifeless as an artistic source. Art should be close to life's inexorable forces: sustenance, being, procreation, expression, craft. We are often blind in our adherence to technological faith: "That's also an intellectual trap. Why not create technology in the spirit of those folk—or at least the poetics they have not relinquished to this date?" The product can of course vastly differ from the source of inspiration. "Nothing in my work looks Ethiopian or Nepalese: I just had to do it, see it all, I mean."

Between 1971 and the end of 1973 Eldred made a series of trips far away from the Western Hemisphere; one took him from western Europe to

Photograph of the artist
at Karnak. *Dale Eldred.*

Harverstore Silos, Kiowa County, Kansas. *Larry Schwarm.*

Greece, Egypt, Ethiopia, and the Sudan, to India, Nepal, and Japan. The succeeding voyage extended around the world: "During it I spent more time in the air than on the earth. I logged about sixty-eight countries." The next trip was more carefully focused: England, Austria, the Soviet-bloc countries (including Brancusi's sculpture park at Targujin), Egypt again, Libya, Tunisia, and Morocco, where he was spellbound by Berber architecture. Before returning to Europe to study the buildings of Gaudi in Barcelona, he made an excursion into the south Sahara desert to visit the Tassili cave paintings.

A little later on, villages in Mexico and Guatemala were combed for textiles, masks, and carvings. This time he drove from Kansas City to Guatemala City and back. Another time he joined a Nelson Gallery archaeological field trip to Yucatan and Guatemala. The most recent trip was undertaken to collect Turkish carpets and folk art from India, Afghanistan, and Nepal for exhibition in Kansas City. This last trip was a reprise, like the return of the native to old haunts.

Eldred has obviously seen a great deal of land studded with many monuments, both natural and man-made. In his experience the pylons of Karnak coalesce with modern-day Kansas grain elevators. Inaccessibility has offered few barriers. He knows how to make friends in a remote Ethiopian village by drawing faces with a handy pen on the outstretched hands of little boys, or how to bargain by the hour in Anatolian bazaars, which he now knows intimately by the dozen. He has learned to improvise or bend with the wind. Patience is needed to sway Arab guides into showing the off-beat sites. Another sort of patience is needed with government archaeologists. And another with rug merchants. There is always a fresh village to visit, a new craft to relish. It isn't hard for him to feel at home in most places, no matter how far away or remote or different the customs.

Eldred's picture of the earth's shape has become in many ways complete; his familiarity with the family and ways of man extends beyond nationalism. Few artists can command such an impressive catalogue of sites and landmarks absorbed and assimilated with characteristic personal gusto. "When I saw the observatory at Jaipur, I was astonished at

90

the way it related to Minnesota Avenue; I couldn't believe it." Both were malls with abstract geometrical structures with similar orientations. In addition to Oriental travel, Eldred has visited many sites in the Americas: Cape Canaveral, Etowah, and the Cahokia mound, among them. "The two stone cult figures at the on-site museum at Etowah are amazing, so grave and impassive."

In spite of complexities of distance, Eldred has found time and energy to design, build, and supervise sites and landmarks of his own. Establishing a strict chronology for all this sculptural achievement is difficult. The current projects tend to flow into one another in time. They have been interrupted at various points, then have surged forward unexpectedly, a new project rubbing shoulders with an older one a long time in building.

Since the Minnesota Avenue project, Eldred has deliberately tried more varied materials and approaches. This diversity unmistakably reflects his travels. His technology advances. "In order to be more factual, I have become more abstract. I don't feel any alliance to anything. Who are my compatriots? An Inca image-builder maybe? Maybe a sand dune somewhere? An Afghani silversmith?" Old sketches and ideas are reused like a quarry. Motifs sprout anew with old connections. His vision is sharper and longer, his vocabulary has the ease that comes from experience, from "feeling at home in the world." There is less constructive exuberance and more regard for composition in these recent projects. The attack, however, is as vigorous as ever. Primitive (the Thirtieth Street and Cypress playground) and refined projects (the Olathe mirror construction) both carry forward differing aspects of high finish of visualization. This sense of craft has come to dominate the fabrication process. He is more given to universal solutions to space definition, rather than parochial ones. The inland ground is used to state a world view. This ground has become a plateau facing all directions and connected by cables, mirrors, and terraces to three hundred and sixty degree infinity.

Eldred's recent work divides into two conceptual polarities: "landmarks" or "sites." These concepts for the use of outdoor space define the aim of his art at this time. Neither concept has been ex-

clusively associated with art before. A site can be non-art. A landmark may be only historical. Eldred treats both concepts as design, in order to enlarge the definition of art: "It is far more invigorating to walk where we have never been before, but where nature and man have always felt at home and left their marks."

An Eldred site is an "environmental battleground of ideas visually proven. There has to be more space to a site than one can assimilate from any single position." Accordingly, complexity of sides, angles, and construction became paramount. "You can't know a site from one aspect. It pushes and pulls at you. It changes at each move, but you make the moves. It is forever stationary." Reaction to a site can vary with the individual, setting guidelines for environmental experiences. The participant defines them. "I get a selfish reaction, fulfilling to me, from contemplating a site," says Eldred. "I can't predict a person's given reactions any more than could the builders of the Brooklyn Bridge." While a single tombstone is not a site, rows of tombstones and surrounding land might qualify, though not as art. A site, for Eldred, is the result of an idea, a design; it is not merely a conglomerate. Who designs and what is designed connote the essential difference. "You look at a building the way you look at a candlestick; a site must be capable of being viewed sequentially from the air, experienced multidimensionally. Once it is designed, you can't dismantle it, or take it apart or rearrange the parts. It's not nomadic." To define the matter further, Eldred states that a site must: (1) be landed in basic dimension (definite and spatial in geographical character); (2) be physically permanent; (3) afford a multifaceted visual experience; (4) convey a compelling sense of quietude; (5) be optimistic in feeling—"I can't build a site pessimistically"; (6) be factual in program yet abstract in conception, with no definite practical function.

A building complex could not be in itself a site, only built upon a site, according to Eldred. Neither is undeveloped land a site, in his estimation; it has to be developed, receive a special designation, through its masses, submasses, accessory elements, access ways, exits, and visual shifts in emphasis. Each of these features is activated by an inner sense

of ritual. Those rituals must remain depersonalized. At this point the artist steps behind his materials. The mounds and masses remain behind to testify of his presence. The ego is sublimated. The final site design must seem so inevitable in character as to seem predestined to exist in its given space. A site always conveys a sense of its own inevitability: "When you've gone through it, there's no way you can feel that it wasn't there before. It's an indivisible part of things. I felt this presence at Sanchi."

In contrast to a site, a landmark has a greater quality of focus, sometimes a single focus. It defines the space surrounding it, but does not belong to it, while a site is space itself. A landmark marks boundaries both physical and psychic by its presence. It can be an object. It can relate more to sculpture as traditionally known. One walks up to it, or around it, not usually through it. But those points can be stretched. There can be see-through interconnecting elements, even accessible interior subspaces. "Stonehenge is a landmark with such interconnecting links." Landmarks can look like towers, in fact often have a high-rise aspect, though they could be underground. A landmark should be noticeable at a distance, for it is detached from its surroundings rather than integral with them, as in a site. One walks by or up to a landmark but stands *in* a site.

In ancient days a pile of stones or a notched tree served as a boundary mark to a tract of land. Thus was the land measured. Similarly today's artist can produce a prominent singular object (or set of objects) to demark a site that otherwise may be lost or forgotten. Since a landmark is more self-contained than a site, it can be more dour, reaching out less to encompass optimism. It is an agressive rather than a relaxed presence. It looms, while a site progresses horizontally. It doesn't convey quietude so much as inspire awe or respect.

For Eldred a landmark provides an essay in abstract recognition. In his view landmarks constitute a designed measure against the environment. They exist to be inscribed in our memory. Both sites and landmarks contract human awareness of space, constrict and compact its meaning. Sites and landmarks are a plus and minus system for dealing artistically with the environment. When the sculptural

project at hand is huge and elaborately programmed, elements of both polarities can blend into one another. Minnesota Avenue encompassed such duality in its makeup. "But usually one concept or the other predominates with what has subsequently followed, given any freer attitude toward creating in recent months: I guess today I'm less uptight. Designing is easier; there are all sorts of modes. But all modes relate to the creation of sites or land-marks."

7

TWO PARKS (SITES)

On the night that the Friends of Art of the Nelson Gallery voted to buy a Paul Klee at their annual purchase meeting in the elegant great hall of the gallery, Dale Eldred was elsewhere selling an ordinary Kansas City neighborhood on his proposal for a park. But he was working for art extension in his own way. Eldred comments:

> They'd never heard of Klee in that neighborhood, but they're the people I enjoy working with. I brought the model down to a house in this mixed neighborhood. We had cake and cookies, a real Midwestern klatsch of about one hundred people. They looked and listened as they walked around the model. Most of the questions did not relate to the design but to what kind of sports could be held, what kind of rest facilities would there be. A representative from the city watched over the ballot box. It was voted in with no trouble at all. If I'd tried to put the park out south among fancy people, they'd have thrown rocks at me. These blue-collar people have a lot of choice in some things: they are down to it immediately without pretention or fuss. They gave me a very good feeling.

Eldred had previously been contacted by E. F. Corwin, architect for the Kansas City, Missouri, Park Department. "He wanted to know if I'd be interested in doing another neighborhood park, with the construction facility of the department put at my disposal. The head of the Park Department, Frank Vaydik, really believes in buying up land for future parks, and so there were several tracts to look at. I selected an eight-acre plateau and hillside jutting out to the north above the I-70 expressway leading east out of the city. All the way down to the freeway went this land." The south edge (or entrance) faced the neighborhood of small houses, the north overlooked a whole panorama of rolling landscape beyond the cars passing right below on route I-70. There was a distinct drop in scale from high to low elevation across the site, accompanied by change in activity from the quiet to the tumultuous. "Just what I wanted," says Eldred. His contract with the city was signed on April 14, 1971, with the "sculptor-designer" given full supervisory power.

93

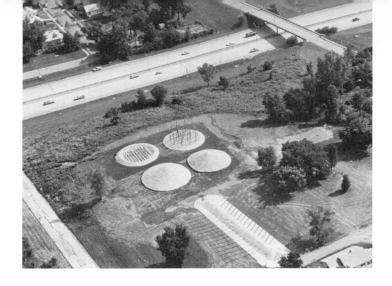

Dale Eldred, Cypress and Thirtieth
Street Playground, aerial view, 1972.
Dale Eldred.

Eldred did the surveying himself as a way of becoming totally familiar with the nature of the site.

While Penn Valley Park was built by outside contracting (despite Eldred's finishing many of its parts), the Cypress and Thirtieth Street playground was built entirely within the facility of the city Park Department. "The first thing they did was furnish me the city's heavy equipment list." Eldred waxes enthusiastic over the role a city Park Department can play in environmental construction:

While the schedule is very slow and seasonal (it is still going on at this time of writing after nearly three years), the Kansas City department has performed carefully and well, taking time to see that detail work is exactingly executed. Right now I've got Angelo, an elderly Italian stonemason who really understands how to finish the two conical mounds. Nothing but the best finished work for him. It's amazing how much diverse talent a Park Department of a large city has among its laborers and technicians. I don't have to support my own office staff because the Park Department has all these resources built in: engineering, landscaping, machinery operators, skilled workmen who can handle all sorts of construction—and all geared to nature. Nowhere will you find better sites and situations than a Park Department has to offer: they're a good breed of people to work with.

E. F. (Rusty) Corwin, who represents the Kansas City Park Department in the Cypress and Thirtieth Street Park endeavor, personally endorses Eldred: "It's exciting for the people in the department to work on this sort of project in the office or in the field. It's stimulating and different, and his energy and attack excite us in turn. He's his own best P.R. man, whether talking to our board or demonstrating his ideas amidst a pile of rocks and mud. You feel assured something's going to come out of it." Why did the job come Eldred's way? "Dale will in time take his place as a leading sculptor, I mean at the top. The playground he did for the recreation division and Welfare Department (Penn Valley Park) was exciting, and it was destroyed. That to me was tragic," says Corwin. "Look, we've got to have another Dale Eldred playground here in the city.

94

To me the physical design of the new park is remarkable as sculpture/land use/playground. It's all integral."

Integral is the right term for Cypress and Thirtieth Street playground. Everything has been integrated and compacted toward a tight-fitting sculptural statement. Initially the tandem stone mounds were to have had low tail or commalike appendages reminiscent of prehistoric American Indian effigy mounds. These redundant features were eliminated after the drawing stages. In compensation, the rims around the two adjoining craters were made steeper in order to relate directly to adjacent verticality. All these visual relationships are closely set, not discursive. Less says more.

While the earth for Penn Valley Park was hauled in, its later counterpart has no earth added to the site: like Eldred's house, the two depressions and corresponding mounds are built on a plus-minus system. "What was there originally is still basically there, but repositioned."

While the earthwork profiles and the long entranceway come generally out of the Minnesota Avenue project and clearly also recall Penn Valley Park, Eldred feels that he "has sharpened up the edges of design since then." The mounds are more studied than their predecessors: each has a bottom flange a foot high, then the angles turn to converge twenty-two feet above ground. The stone work upon them is noticeably more refined than Penn Valley Park; smaller stones (much more laborious to install) are used. The diameter of the mounds and their corresponding pits is exactly fifty feet and of even turn. No measurements were left to chance.

Logs jut at forty-five degrees and are set in pairs to overhang the one-hundred-fifty-foot long entranceway. There are twenty sets of logs. They are not rough farmyard products but matched thirty-foot jack logs from the Northwest, as ramrod straight as telephone poles and "very expensive." They compose a clean-edged harmonious procession, each pair adjusted to the angle of descent of the dual pathways. There is an even visual procession of overhang as visitors are led visually to the paired mounds and pits immediately behind. "The poles can't be set by eye, but only by surveying."

All this accuracy and regard for measurement

Dale Eldred, drawings on Mylar, 1970. *James Enyeart.*

has made for a tighter unity of space, a more economical, less episodic design format that is welcome in Eldred's work: "I don't want that accidental look anymore."

The relationship of the artist to his materials is less robust, but also less extroverted: "I really calmed things down." The pits, one filled with cross-set logs, the other with vertical stands of logs projecting four feet above the surrounding rim, add a fictional element, but gone are such contrived features as the tangled driftwood sculpture at Penn Valley Park, or its labyrinthian interior events, all hidden from view by earthen walls. Now the land is open to view on all sides, including the forced entryway: "all those V arches pushing you to the cone areas"—like huge animal ribs left to dry on the plains. The cones beyond resemble young volcanoes. They have been refined from a number of drawings on Mylar of imaginary projects. The pits behind are like craters. "All the action centers way in the interior," according to Eldred. But the interior is silent, with the surrounding grasses a calculated buffer zone. One looks off the northern perimeter into a void. This may be a playground, but it is a spartan one. By contrast, Penn Valley Park was more a children's park, geared to amusement. The reader can judge which solution is more elemental! "A developer could never afford such a psychological space."

Will Eldred's second playground be longer lived than Penn Valley Park? At least it cannot become the victim of a superhighway, for the highway already runs below it.

The Cypress and Thirtieth Street park led to further exploration of psychological space through a series of land-elevation graphics. "I'm always trying to push out further, attempting to go beyond what I'm constructing. The blueprints for the park suggested further visionary possibilities." The blueprints induced an extensive group (175, at least) of drawings, in turn reproduced on Mylar. Together the drawings and prints form an imaginary geodetic survey of nonexistent hillsides, valleys, canyons, cones, islands in bays, and isthmuses surrounded or traversed by water systems. This is psychic creation of lands, primordial geography of the imagination. "If you can open up the road, figuratively but in a documentary way, it will eventually feed back into the body of your work. I work with the channeling of water, a series of bridgeways crossing from one land mass to another, with still-water lakes and ponds." There are also "sky" systems seen in cross reaction (rather, map elevation). These depict helium storage tanks, flotation things, or cables suspended between promontories. Some suggest a function, many none at all. All gave him huge abstracted hunks of land to shape "until I can get back to the real thing." When at home Eldred has drawn up to five or six of these land formation drawings a week; he has accumulated a heavy drawer full of them. With the exception of a summer exhibition at the Nelson Sales and Rental Gallery in 1972, he has never exhibited any of these. "The only one I ever sold was to John Simpson." They are his own private exercises. They exploit the mechanical skill of his draftsmanship, documentlike, matter-of-fact, almost to the point of artifice. Some of them strangely recall Renaissance drawings of moats and fortifications. Back there Eldred had some kindred spirits!

One has the feeling these earth formations ought to exist somewhere. We stare in suspended belief. Supplementary outlet is provided for Eldred's effusive, unquenchable feeling for land and water. Additionally they reveal his kinship for fantasy architecture, for the projects of the French eighteenth-century architect Louis Boullée, or of Paolo Soleri, whom he knows and has visited in Arizona. There is a hidden beauty in maps, in elevation sections, in their symbolic abstraction of the completely material earth, that plays on our false capacity for visual acceptance: it all ought to be real. Like newsprint and media describing an event that took place somewhere else, or a rumor, Eldred's topographical mono print-outs substitute utter fact for what we know to be pure conjecture. Who is to cast stones when he decrees a reservoir, a set of mirror slabs canted at a roadway, or a set of storage tanks floating on the sea?

While Eldred's earlier landmark prints on silver opaque Mylar presented a photographic simulacrum, printing on transparent Mylar transforms a drawing into a blueprint with supramechanical opulence. Only one print is pulled of each topographical drawing on the Ozalid machine.

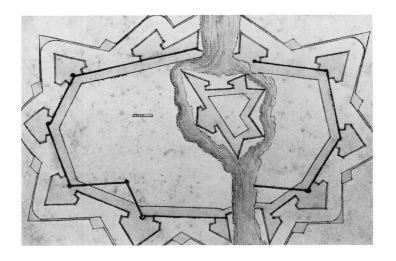

Anonymous, Italian, ca. 1565, "Manuscript Sketchbook of Naval and Military Warfare and Fortifications," page 43, Rosenwald Collection, Library of Congress, manuscript number 27. *Library of Congress.*

By stopping out the light, Eldred can invest these prints with a bluish cast or brownish overtone, adding to eerie resonance of effect: abstraction and reality further blend in these schemata. Overlay printing encourages a progressive focus that operates on us like a zoom lens, so that psychological space is created.

In our dreams we have encountered such canyons, such isolated placid lake surfaces, these intake tanks, and spillways. Like these prints, they never become tangible but remain distant images. Never, despite mechanical intrusions, is the vast scale of nature interrupted, let alone disturbed. Unlike the "landmark" prints, these "site" prints elude tactile interruption. They seem to spread lines across spatial barriers through fluid capillarylike attraction. The effect is a little unworldly. It is reassuring to know that the artist has used poetic license after all, since the topographic situations are figments of the imagination.

In recent months the building of table-top and wall "models" of topographic situations has supplanted the making of prints. "The models came out of parts of the drawings; I've selected down, refined the situation. The drawings can step off the drafting board and become emphatic projections." If Eldred attempted to create a visionary archaeology for Minnesota Avenue, in these models he has constructed an artificial physical geography. Earth features are simulated in laminated, superimposed mahogany cut-outs. Each layer represents an elevation contour. Cardboard mock-ups of these models were made first, then destroyed after having served as templates for the wood cutouts.

When layering is complete (thirty-five to forty layers of one-eighth-inch wood per model), a box is formed about seven inches high, with canyonlike elevations contained within. Clear or rippled plastic sheets are inserted to indicate water. Each model follows different patterns. Upon the water surface—suspended above the bottom elevations—lathe-turned aluminum objects are positioned by Eldred. "I gave the man who turned them for me a drawing." Are they storage tanks or intake plants? "I don't think I'd ever have put them in there had I not done the model of Cypress and Thirtieth Street Park with its cone elements." Over the top of each model a

96

tight-fitting sheet of solar glass is fixed, gray in all but one of the twelve models so far finished. Once the glass is fitted, the unvarnished laminations beneath turn dark and rich; atmosphere is created: transparency is transformed to varying degrees of opacity, depending on strength and angle of available light.

Quality wood was used for the lamination process. Eldred was lucky to buy four thousand dollars' worth of mahogany boards, "now very scarce. I made one model with Neoprene elevations and glass water. One other has a bronze solar glass cover. There are six or seven studies and four larger models. The one bought by Byron Cohen has the drawings and specs for it in an accompanying mailing tube. It is a table piece. There are still three or four studies incomplete at the studio."

The largest and most complex of these land models (Harrison Jedel Collection) hangs as a wall piece. It is seven feet long by forty-eight inches wide and "brings together all the smaller models and previous studies, coalescing them into one clear statement." Ripple plastic is used here to denote water, for animated effect. Here inlets are created, not just a simple body of water. Three systems of metal-turned "tanks" stud the waterway. The land surroundings dominate "for greater continuity." The Jedel model can also be read from the sides, as the inlets are troughed at the side edges, allowing the viewer to peer within and scan the canyons and declivities. Eldred has created in these models an elementary reduction of the Cypress Park idea, using ecological symbols and geographic demarkation for the purpose of art. Measure here becomes seemingly infinite, as compared to the finite character of a relief map. Undoubtedly this increasingly conceptual grasp of the earth will play back into the mainstream of his work as it forges ahead. "I'd like to make some cut-away models standing on end. They could be read like a book, pored over."

In the spring of 1973 Eldred's interest in collecting folk art joined professional role and sculptor-designer role in a project fully designed but not yet built. If constructed, the Washington Square Museum of Indigenous American Art will make an outstanding contribution to the history of artistic display in our time: it will also rank as well among the

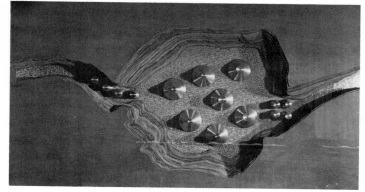

Finished wall model, channel system (topographic view), 4 feet by 7 feet, mahogany, glass, stainless steel, and plastic, 1973. Collection: Harrison Jedel, Kansas City, Missouri. *James Enyeart.*

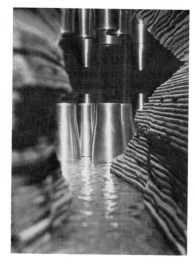

Finished wall model, section detail, showing laminated construction and stainless steel cones resting on plastic flotation. Collection: Harrison Jedel, Kansas City, Missouri. *James Enyeart.*

great and unique environmental designs for a city center. At present three models for the project exist, two section models and one overall maquette, together with a prospectus issued by the Kansas City Park Department and schematics. The first Plasticine model is now destroyed. Its design elements were bread-boarded, tried out, eliminated, or finally accepted after passing mutiple adjustments. Working drawings await a hoped-for go-ahead signal.

In 1972 E. F. Corwin informed Eldred that the Kansas City, Missouri, Park Department intended to renovate Washington Square Park at the edge of downtown. This park is situated east of the Union Railroad Station. It faces the new Hallmark Crown Center development to the south. Crown Center is a distinguished complex including office buildings, shops, and hotel built under the general direction of architect Edward Larrabee Barnes (the hotel is designed by Harry Weese). Directly beyond the wide railroad cut abutting the opposite or north rim of the park, the downtown of Kansas City, Missouri, begins, the skyscrapers mounting in size in a northward march.

Planned in 1923, at the time of railroading preeminence, Washington Park once functioned as a recreational extension of the much-used station. Today the huge neo-Baroque station, a local landmark, is nearly deserted, and the park ignored. It is marred by signs along Main Street—"low nicotine, low tars" —and only three elm trees are deemed salvagable in the five-acre area. The remaining trees are dead or dying. Garbage is strewn about, benches are an eyesore. Pavements are badly cracked. Passersby are usually ignorant of the extensive area occupied by the park. Eldred's open-air museum proposal links the downtown area with its recent southerly extension of Crown Center, tying both together with new vitality. Without the stabilization and improvement of the park, a key area of the city will suffer further blight. Urban continuity will be disrupted. Washington Square (it is actually a triangular plot of land) is a land bridge from the downtown to the inner city. A positive and creative renewal of the derelict park is needed in order to bring people into it, to give it a useful recreational purpose, and to make the area safe for the apartment dwellers who will reside nearby when Crown Center is completed.

"It's hard to go to New York City to get foundation money for Kansas City, but my folk-art idea caught on so forcefully that several foundations were interested," Eldred says. One national foundation proposed an outdoor sculpture museum instead. "That's been done elsewhere; it simply wouldn't have turned me on." At first Eldred wanted the museum park adjacent to the Nelson Gallery. He even put together a traffic study of the gallery area to demonstrate its centrality. But Washington Square is still far more "central," compellingly urban in the problems to be solved, and susceptible to a more animated design solution. Brian O'Doherty, of the National Endowment for the Arts, helped Eldred and John Lottes, president of the Kansas City Art Institute, to secure a grant of $23,000 for preliminary design work. Four months were expended on the design; Eldred worked with Michael Malyn and John J. See of the Kansas City Park Department: "They spent hours in my studio."

Eldred's museum is to be open twenty-four hours a day, "interesting at any hour." Although without walls, it is easily guarded, vandal-proof, and susceptible to well-composed lighting effects at night. Display cases are in effect transparent sculptures of unbreakable Herculite, laminated glass with tight-fitting roll-out sides for interior installation. "Nothing is to be transitory; a major concern is building for permanence, for endurance in future time." Two large motion picture or slide projection screens of sand-blasted Lexan plastic, complete with an audio system (which will be restricted to a limited area), provide focal point of interest. "You can present on film the background of the pieces on display, show the artists at work, project images that will enhance the high visibility and lead-in approach of the design."

To demonstrate the point for interested parties, Eldred has made a slide presentation of the range of folk art that could be installed in the transparent cases, "from tools, vinegar jugs, and weather vanes in the cases, to soaring towers of tile or stone set on the terrace."

There is nothing of the vernacular, however, left in Washington Square's design. The leading materials are dark burnt brick, stainless steel (expansion joints, case ends), and glass. The bricks

will be of standard form, arched or flat, laid out in very finished, carefully considered patterns. Eldred picked the brick to harmonize well with any of the pieces of folk art on display. Brick allows delicate detailing impossible with concrete. This attention to scale and reliance on all-over patterns of brick mosaic is a new departure for Eldred. He comments:

> After all, it's a museum, not an out-and-out sculpture. So I see it all in different terms. Washington Square must reflect the services—intellectual as well as commercial—which will ring it. With the development of Hospital Hill, the Penn Valley Junior College complex, Crown Center with its shops, the present and future business developments radiating out from downtown to midtown, and the potential that exists at Union Station, Washington Square will soon find itself a hub of activity of easy access to all the city's citizens. It's a far more sophisticated site than Minnesota Avenue in downtown Kansas City, Kansas, just across the way.

Washington Square museum will consist of an elaborate but well-integrated series of brick terraces and walks, canopied by trees, demarked by areas of still and flowing water. Space flows unimpeded and fanlike across the terrace elevations. The terraces will be divided by a six-inch riser module, by directional patterns, and stainless steel dividing strips. Some of the terraces form entrances, even vestibules; others, more platformlike, are for points of more complex interest. "Think of them as open-air galleries," says Eldred. A radial area at the southeast corner, defined by seven large exhibition case slabs, recalls the unexecuted area of the Minnesota Avenue project adjacent to the public library. The radial area provides an entrance focus.

In order to separate the museum area from the bustle of Main Street at the park's narrow west end, a long waterway leads toward the center of the park. "This basin will be waist high and consist of a fog spray against one wall which will disappear beneath the brick and reappear in a center collection pool, from which it will be recirculated." The portion of the park behind the irradiating entranceway is given over to exhibition of the permanent collection. Behind it is a more intense water source: it begins at the top as a vertical wall of bubbling water and

descends as a series of waterfall steps until it disappears under the brick pavement to reappear in the second collecting pool at the upper right of the entrance. If the spillway at Minnesota Avenue recalls a hydroelectric plant, this sumptuous cascade aligns with the great water gardens of the past, like those at Tivoli. It is an eminently civilized feature. The right side of the plan provides more exhibition areas, a lower terrace for further display of the permanent collection which leads in turn to an elevated area, more isolated than any other part of the park, where temporary exhibits will be on view. Here the character of the cases will be different; they are semiround, tubular, and encased with metal at each end. Underground storage areas will be provided. An elaborate ground cover and dual planting plans insure "a variety of experience through the changing seasons, complement the entire design, give leafy summer protection and lacy shadows against the brick in winter, and contrast with the mechanistic aspects of the park. A band of trees frames a barrier against the railroad below the northern perimeter. . . . There will be no dark areas in Washinton Square, only differences in light intensities."

Especially considering the museum and recreation functions, the Washington Square plan is integrated with a masterful sweep of the designer's hand. In it radial, geometrical, and concentric terraces dovetail into expanded and contracting centers of visual interest. The display cases are distributed like side chapels and altars, or the stele on a Mayan terrace. To judge by the plans and model, one feels breadth of invention tempered by judicious restraint, more than in previous Eldred endeavors. Parts are more carefully orchestrated. The materials are elegant. The trees and ground cover have been managed to obtain color and textural contrast. The light patterns—each rise has built into it a continuous low-level light—should be stunning in themselves. If built, Washington Square will unify the promise revealed, then partially obscured at Minnesota Avenue.

Since the park is neither architecture nor sculpture, and since it comes close to breaking Eldred's dictum of "nonfunction," does it conflict with his chosen role? Not at all, declares Eldred. "Why shouldn't a sculptor work that way? If Michel-

angelo could span from the David to the staircase of the Laurentian library, why can't someone else? Some of the most limited people I know are sculptors. We sculptors are in danger of being isolated. We can't keep going on without participating actively in what *is* going on in this world." That is what environmental art is about. The sculptor, to cover himself, must link up with the world surrounding him.

Washington Square aims to unleash, not imprison the beauty of objects. It hopes to join art to the natural world in creating a unique display environment. It is Eldred's answer to formula-practicing urban sculptors, like Clement Meadmore, "who just come into a city and plunk something down like a package on a shelf." Its terraces encompass levels of artistic appreciation and excitement. They are stages for dramatic visual presentation. Perusing the cases, visitors will be put in touch with "things that should not be forgotten, the practical arts of our ancestors. There are root marks, soul marks, marks of conscience that are so much part of us, yet so often ignored." Washington Square seems ideally suited to celebrate our connections to the past precisely because it tactfully does not interfere with it.

At this time Washington Square's future hangs in the balance. The mayor and city council of Kansas City have applauded the concept. Crown Center officials are weighing the matter. Its concept heavily accords with the Hallmark Corporation's long-time interest in folk ways, even to maintaining folk-art shops in the area and sponsoring folk fairs. It is tailor-made for the area, sociologically speaking. Unfortunately, a *Kansas City Star* editorial writer has attacked Eldred's project:

> The outdoor museum is an ambitious scheme and no one can fault the planners for thinking big. At another location it might become a major addition to the urban life of the community. But at Washington Square—surrounded as it will be by massive buildings—grass, shrubs and trees should create a more congenial park setting. . . . The recent proposal to replace the grass in Washington Square Park with brick platforms, display cases and other gimcracks to create a 24-hour-day outdoor museum is only

the latest example. Over the years plans have been put forward to carve up large sections of Loose Park, Swope Park and other Kansas City playgrounds. Fortunately most of them were abandoned before the damage was done.*

Actually, Eldred's Washington Square is partially a green belt, with flowers that will bloom the year round and stands of plane trees, pin oaks, and crab apple, white birch, flowering dogwood, and Washington hawthorn. Be that as it may, the plantings and ground cover projected are far more attractive and pleasant than what is there now, "a display of scrubby remnants in pursuit of an incinerator." The area is not large enough to simulate open countryside. Any attempt to do so would be an anachronism today. A meadow would be pointless, a forest constricting. The space is urban, highly so. A multipurpose solution seems ideal for stimulating urban life and reconstructing the downtown with its adjacent domain. Eldred's plan is semipastoral in content, yet finely machined. Atwell Bohling, the editorial writer in question, has never examined Eldred's plans. Nor did he read the section of the brochure "Planting at Washington Square." "I never talked to him about it," says Eldred with a sigh. "He made up his own mind."

In response to press criticism of the park as bereft of greenery, Eldred wrote in part:

> One tree does not a forest make, not even on 4.7 acres of land. Start then with three fine old sycamores, the only trees now there that merit saving. Outline two sides and intersperse throughout the park fifty-five London plane trees. These trees have a potential height of one hundred feet. The leaves are maplelike, and the bark peels like its cousin, the sycamore. Because of its high tolerance to city conditions and its wide spreading branches, the London plane is widely used as a city canopy tree.

* *Kansas City Star* editorial, May 18, 1973. Also *Kansas City Star* editorial, June 8, 1973: "The recent proposal to replace the grass in Washington Square Park with brick platforms, display cases, and other gimcracks to create an outdoor museum is only the latest example 'of not leaving' trees and grass alone so the public can enjoy a quiet oasis in the middle of a congested setting."

Add a grove of twenty-three flowering dogwood. This is a small tree, growing to a height of thirty feet. In the spring, it becomes a cloud of white blossoms; it also features red berries and brick red foliage in the fall.

But seventy-eight trees still do not make a forest. So plant along the northwest side of the park sixteen sweet gums, a tall pyramidal tree with interestingly textured bark and scarlet colored foliage in autumn. In conjunction with the sweet gum would be thirteen pin oaks. At seventy-five feet the pin oak is a large tree, though not as large as the sweet gum, which can reach the height of one hundred and twenty-five feet. We are now approaching the concept of a forest, but it is not yet complete.

Divide twenty-eight Washington hawthorns into three groves. This hawthorn has tiny white blooms in the late spring followed by bright red fruit. It is a favorite of birds and one of the last flowering trees to bloom in the spring. In autumn, its leaves turn to scarlet and orange.

At the opposite end of the park to the flowering dogwood would be a grove of thirty-five Van Eseltine crab apples. This twenty-foot high tree is valued for its double pink flowers in May and its red and yellow fruit in the fall.

Do one hundred and seventy-three trees make a forest? If not, it certainly makes a well-wooded site, with approximately thirty-seven trees per acre.

Whether the park is ever built depends on Crown Center and promised partial financing for the Park Department: "Vaydik didn't want to go cheap, but a million today is cheap for a museum"—a green and brick museum site created for visual adventure at the city core.

Dale Eldred: Cypress and Thirtieth Street Park, Kansas City, Missouri, 1971–1974. Five of the sculptor's construction drawings: (1) first idea for entranceway; the stone dividers at right were eliminated so that the entrance proper is gained abruptly; (2) study of mounds and pits; (3-4) details of the two concavities, including underground drainage provisions, lodging of beams, and connection point ("You can tell this is right after Minnesota Avenue because my drawings are so tight and the specs so completely detailed according to that experience."); (5) overall plan with contour elevations; the tail-like mound appendages were eliminated in construction, and more land has been cleared and added to the lower right section of the site, evening the property lines. "Where else could an agency buy three houses to square a sculptural area just like that, but wait for construction to proceed inch by inch over the years? But the work *has* been beautifully executed, no complaints!" The relationship of this park to Eldred's imaginary Mylar drawing is apparent (see text illustration, page 95). *James Enyeart.*

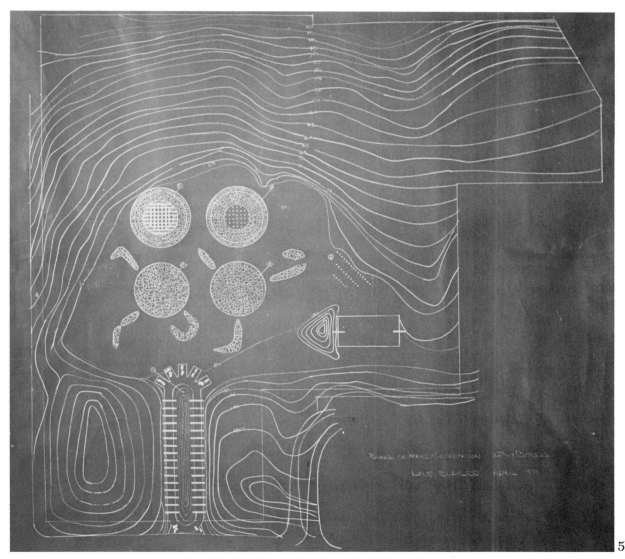

Dale Eldred: Cypress and Thirtieth
Street Park. Aerial photograph taken
during winter construction, 1972,
looking eastward with Route
I-70 to left. *Dale Eldred*.

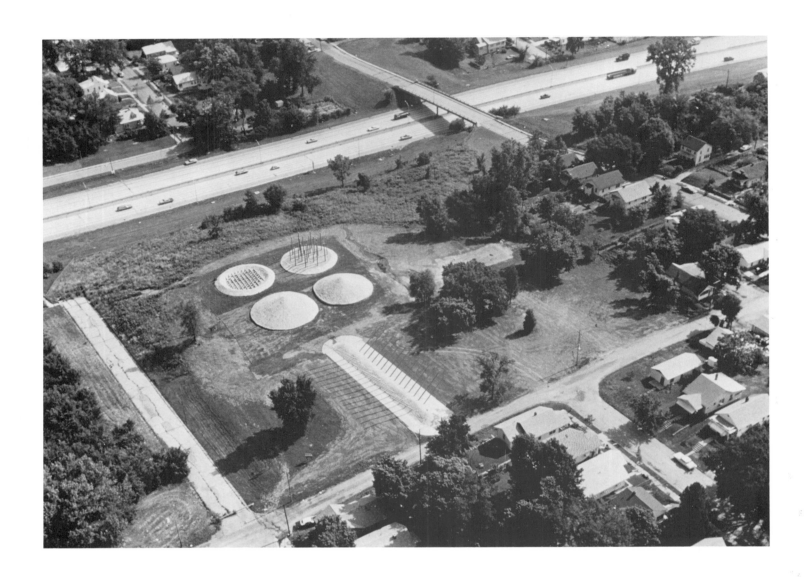

Dale Eldred: Cypress and Thirtieth Street Park. Park
Department stone masons laying stone cladding in grout on west
mound. The surface the men are standing on has been
previously stabilized with Gunnite to prevent seepage and
heaving during frost conditions. Another layer of stone is under
the Gunnite: "This is necessary for duration and stability;
we've reinforced it to last after all of us are gone." *John Lowrey.*

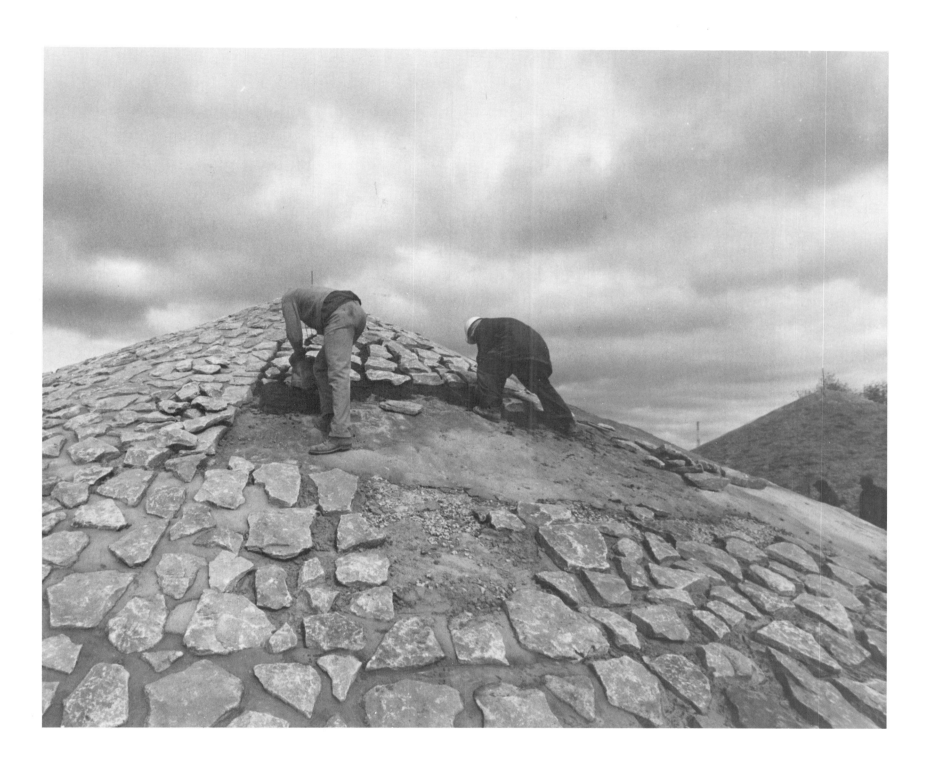

Dale Eldred: Cypress and Thirtieth Street
Park. Detail of western cavity. "Here you see
the transit's influence." *Dale Eldred.*

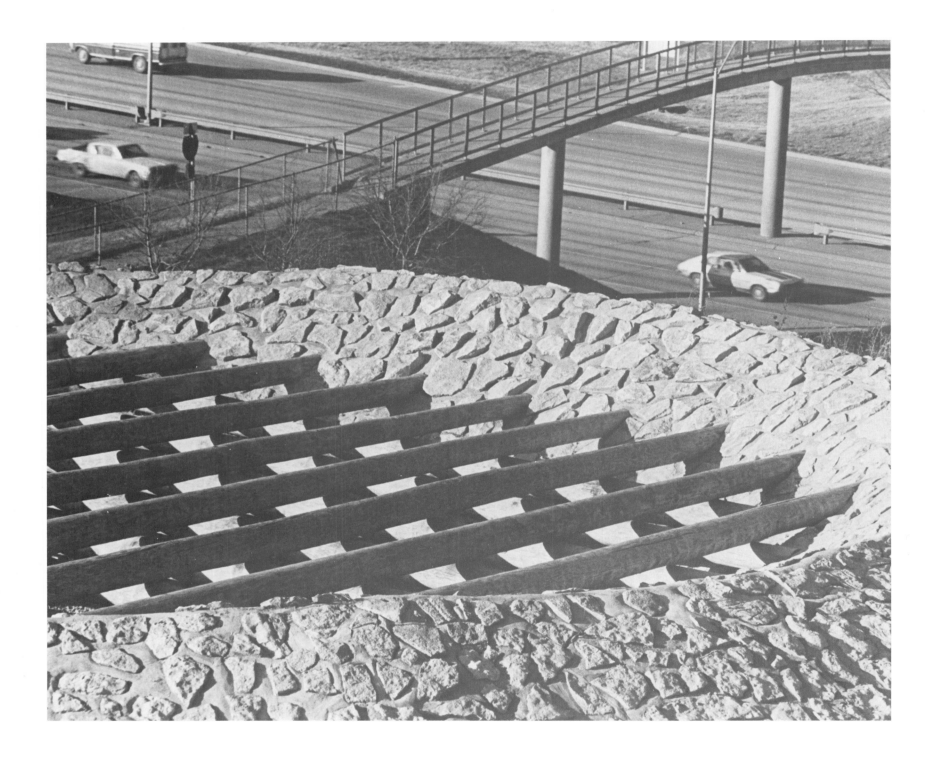

Dale Eldred: Cypress and Thirtieth Street Park. Finished stone wall, western cavity. Maybe it ought to be a log tomb, like a Siberian Kurgan. "Why not," comments Eldred. I've never encountered one, but often happen on things which could have or might have influenced or related to my work. *Dale Eldred.*

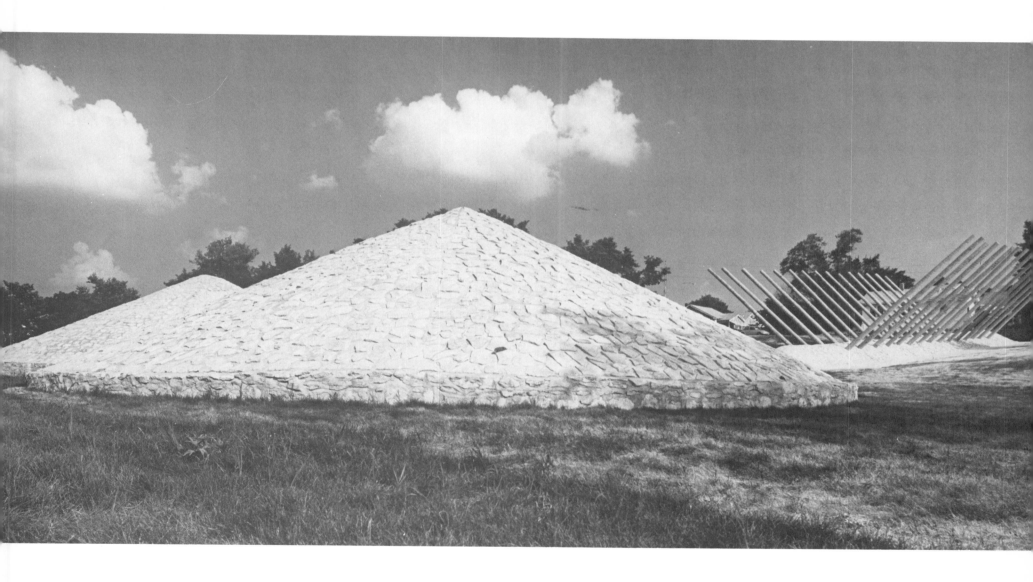

Dale Eldred: Cypress and Thirtieth
Street Park. East cavity filled with sand
and poles in place. The poles recall
those placed atop the stone-clad mound
in Penn Valley Park. "They're gone
but I've not forgotten." *Dale Eldred.*

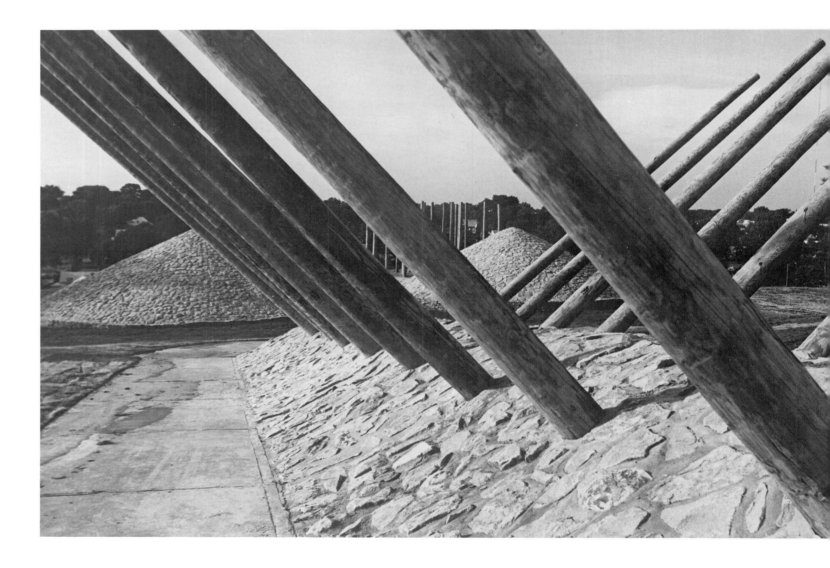

Dale Eldred: Cypress and Thirtieth Street Park.
The finished entrance area. "There're better than six
square yards of concrete to hold each pole in
place." *Dale Eldred.*

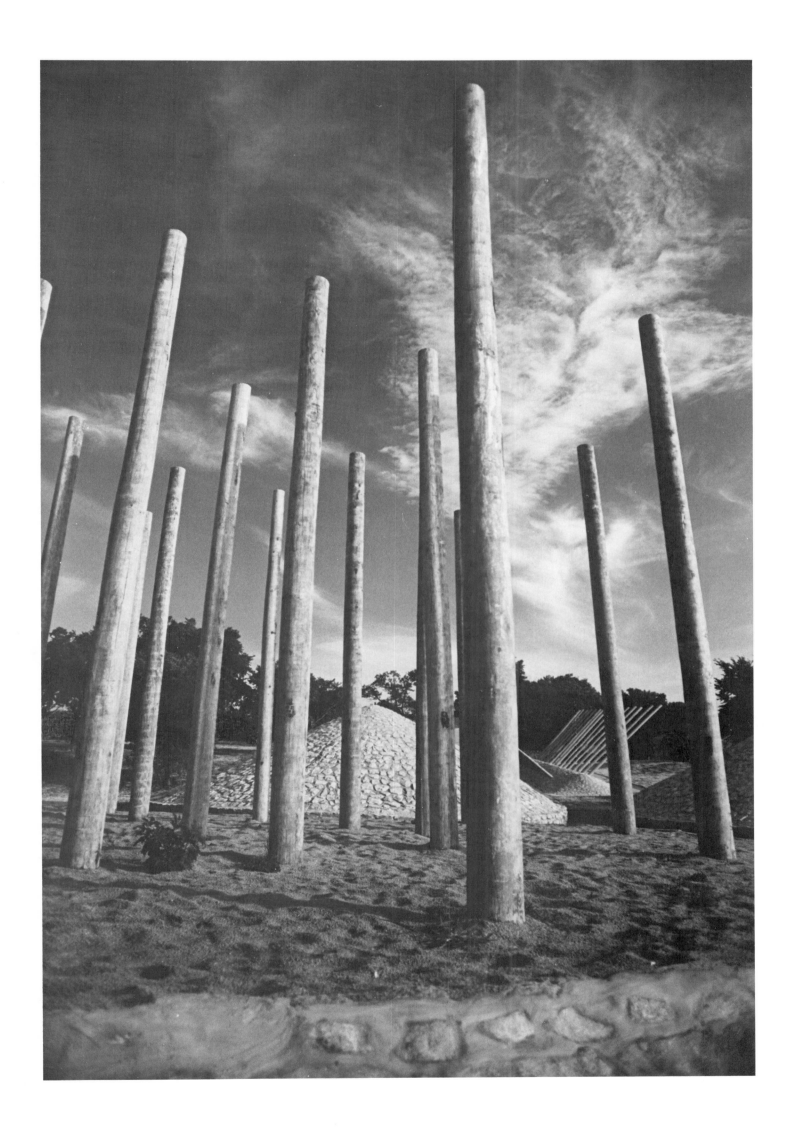

Dale Eldred: Cypress and Thirtieth Street Park.
View from between the two mounds looking
at the eastern cavity. Eldred's concepts
of "sites" and "landmarks" are both embodied
here. *Dale Eldred.*

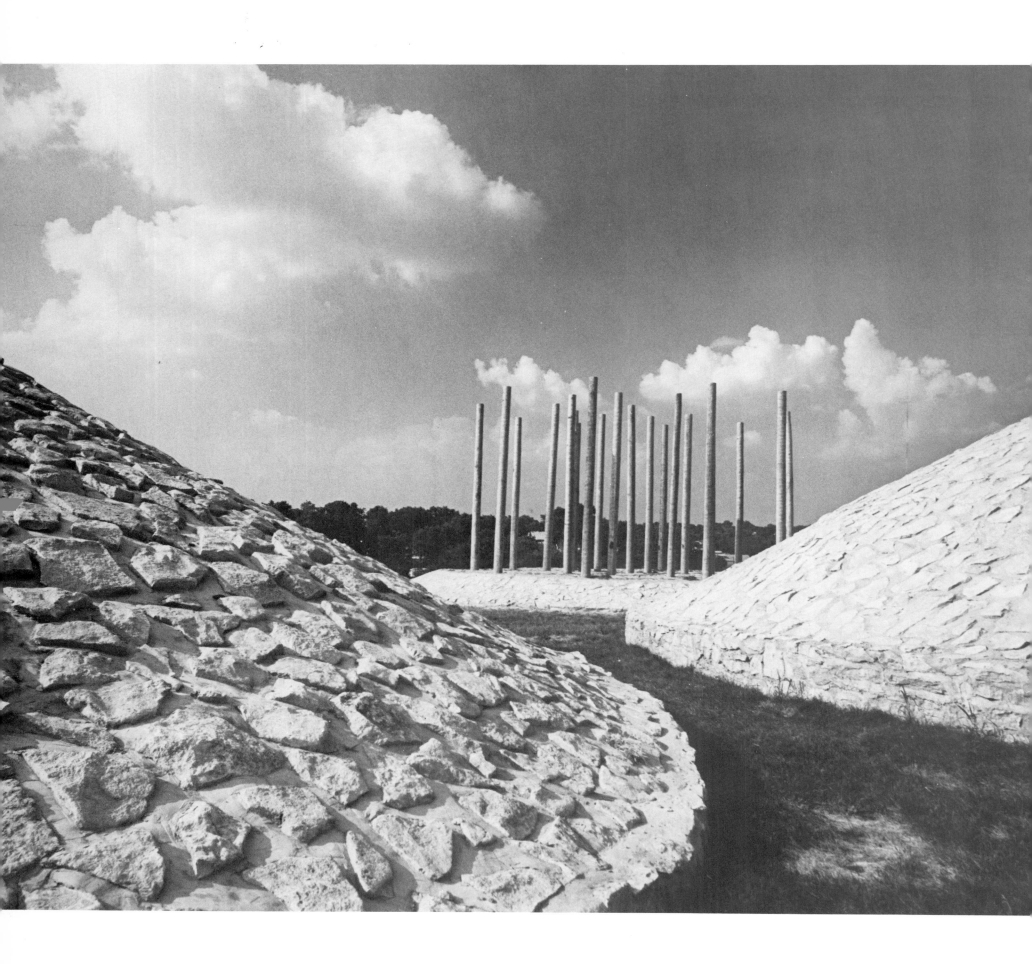

Dale Eldred: Washington Square Project,
Kansas City, Missouri, 1973– .
Presentation plan executed by the artist
and Park Department draftsmen. One of
four plans, showing pedestrian
walkways and tree planting. *Dale Eldred.*

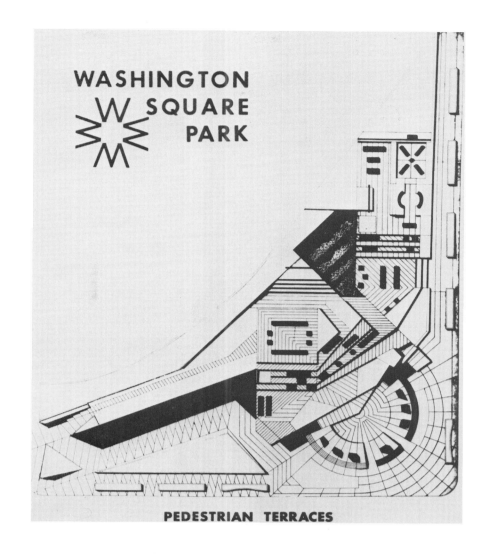

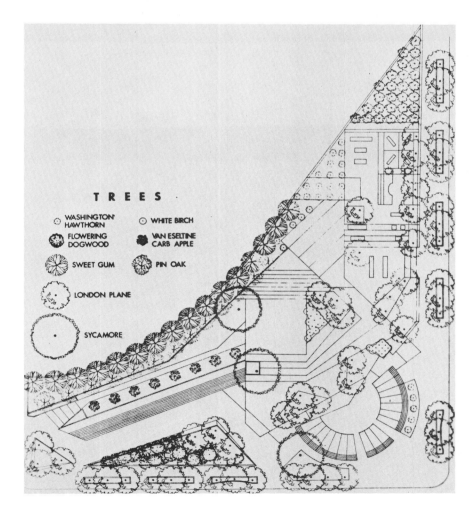

Dale Eldred showing his overall
model of Washington Square Project
to (left to right) Nathan Stark,
of Crown Center Development; Frank
Vaydik, director Kansas City
Department of Parks and Recreation;
John V. See, staff architect, Parks
and Recreation Department;
and Carl Migliazzo, Park
Commissioner. *Dale Eldred*.

Dale Eldred: Washington Square Project.
Close-up of overall model. "Wouldn't
the projection of a folk art museum in this park
be a magnificent symbol of the solidarity
of people's creativity throughout the world?"
Dale Eldred.

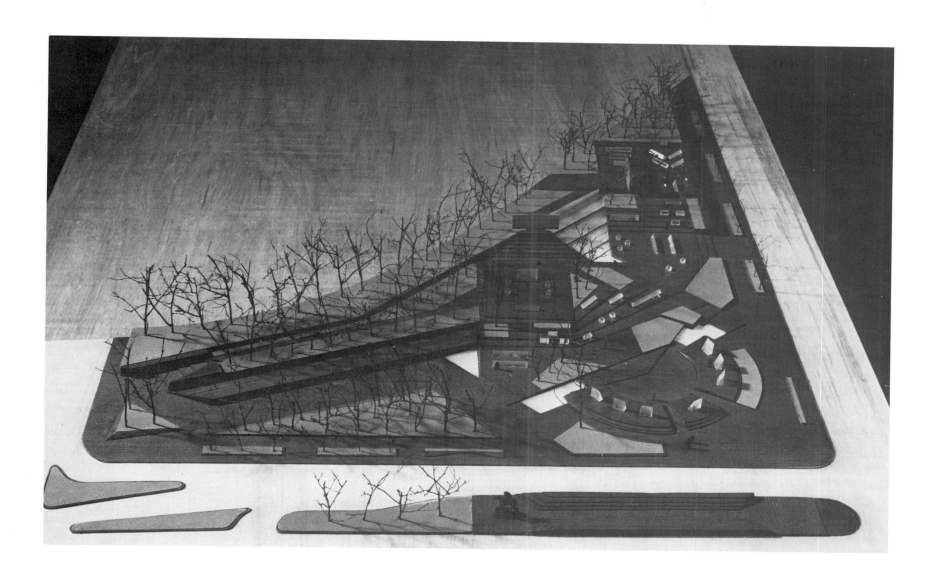

Dale Eldred: Washington Square Park. Detail of model
showing entrance plaza and permanent display
encasements. Photo extracted from artists's slide
presentation. *Dale Eldred.*

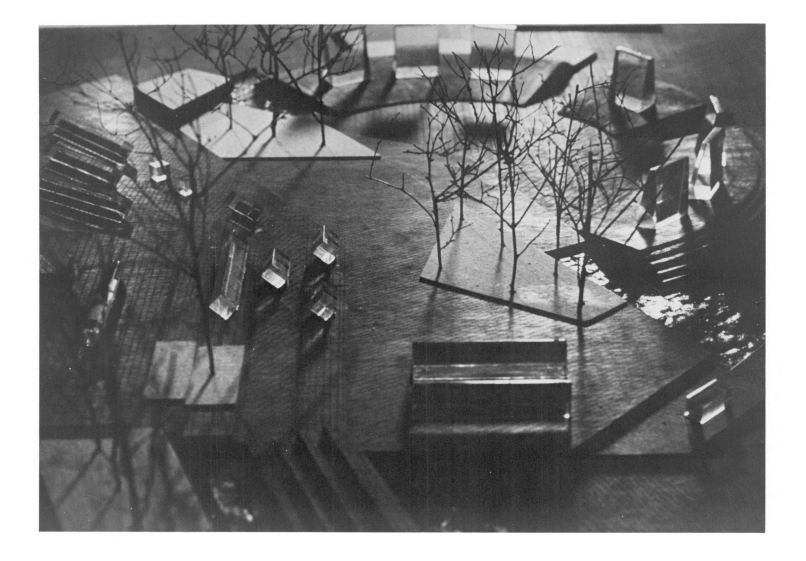

Dale Eldred: Washington Square Project.
Detail of model from the east (Grand Avenue)
showing projection on screen above retaining
wall. Photo extracted from artist's slide
presentation. *Dale Eldred.*

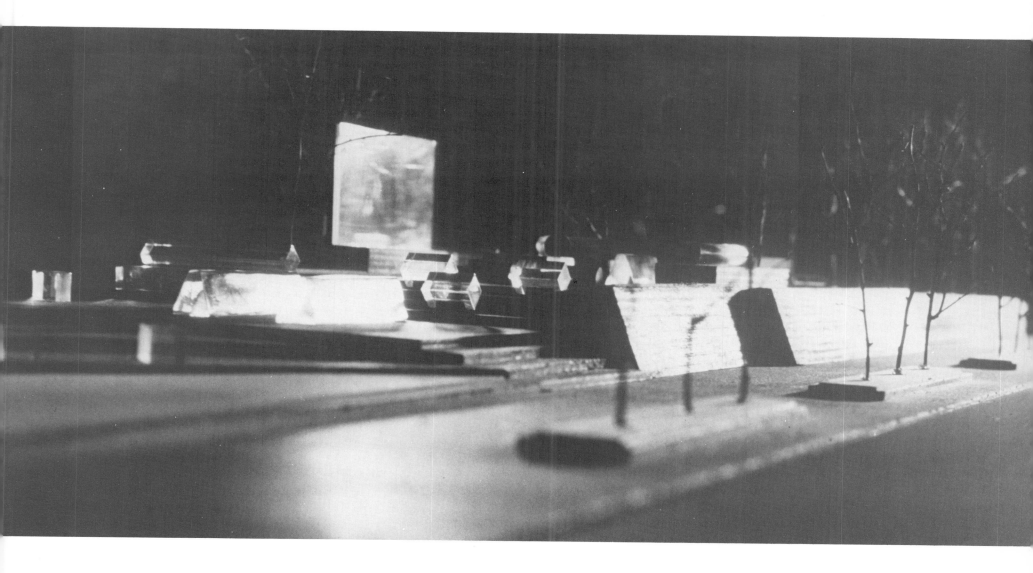

8

THREE LANDMARKS

Three landmarks, so vastly different in concept that one might think them at first to be by different artists, were in progress or completed in 1973. One fits transparently the entrance to an office-building lobby in Olathe, Kansas; another adds a dimension of time to an architecturally defined outdoor corridor between two tall buildings in downtown Grand Rapids, Michigan; and the third deals boldly with vast, open airport space. There is something here of the shotgun approach, and yet all are constructively tied together as outsized landmark "packages" growing out of previous encounters.

Gone is the containing of earth and grass with concrete. The evocation of the carpenter or builder as an individual has departed for good. The technologist comes forward. There is much less recollection of America's past; each solution meshes closely with a particular environmental situation. The interval between the finite and illusion Eldred exploits ever closer with sharpened focus. Shapes employed have become columnar or spheroid or dissolve before the eye, hinting at continuations existing beyond factualism, even though born from it.

"The eye stops at flat, blatant surfaces. They can become barriers," Eldred says. One hardly believes at first that the sculptor of *Sisu* or *Salina Piece* is talking. However, Eldred's interest in reflectivity dates back to Minnesota Avenue and to an ill-fated mirror project for Iowa State University. Yet these recent landmarks are also "built" and relate to building art. "But now I want duality, to really get beyond single-mindedness, to try with the mind, not just present a surface." This idea bridges beyond the builder's aesthetic. "The more facets I see, the more I arrive at where it's always been." The singleness of purpose had not veered an inch off course, nor changed an iota—only sharpened in focus.

Vision, not only aesthetic but actual, produced the mirror wall commissioned for the lobby of the Johnson County Municipal Building at town square, Olathe, Kansas. "That's exactly what it is, a unit of mirror panels six rows high by six wide, ninety panels in all," Eldred says. They are stepped forward as they rise one above the other. They are mounted on an insert metal track system; each panel is loose and can expand or even be disassembled. Each row is set behind its predecessor, but projects forward

115

beyond its predecessor, hanging out farther as the eye looks upward, and all held together by a complicated wooden framework totally concealed behind the tracking system. When seen from below each row springs from an undetermined point, effecting a slight shift in reflective distortion. As the mirrors also point downward they include the viewer and the signs and street life behind the entrance glass doors, yet the modular design appears to be flat as well as stepped. "It's a very subtle distinction, but one I've wanted to make for some time."

The extreme simplicity of Eldred's mirror bank is misleading, for its angles were agonizingly scrutinized. They exploit with extreme care the duality of mirror-smooth conformity on one hand as opposed to the concealed complexity of framing on the other. Each mirror of Plexiglas is one-fourth inch thick, three feet high, and two feet wide. The overall dimension of the installed mirror back is forty-five feet high by forty feet wide. Glass mirror is used for the horizontal insert panels between each step. These inserts cannot be seen from below but keep reflective continuity as they cast light upward upon the succeeding row of vertical mirrors. Two expanses of mirror are fitted with tinted Plexiglas to make another slight reflective variation without disrupting overall continuity.

This commission was awarded by the Johnson County, Kansas, government through the architects of the Johnson County Municipal Building, Hollis and Miller. "They didn't think I'd be interested, but why not? It is the county seat, where I pay my taxes. I also like the idea of having a sculpture in Olathe. It's a surprise since the office building is undistinguished 1950s, modern with a few 1970s touches." Coming upon Eldred's mirrors today parallels stumbling across a Louis Sullivan bank in a small Midwestern town fifty years ago—a gem amidst humdrum mediocrity.

Before stepping through the glass curtain-wall entrance of the municipal building, one becomes conscious of Eldred's mirror wall facing directly behind. As one walks toward and into the lobby, there is a gradual awareness that something mysterious must be suspending all those steps of mirror panels in space. Little by little the sense of ambiguity enlarges. The mirror detaches from its for-

116

tuitous role as lobby decor and becomes a serious entity, gazing upon one point-blank from above, distilling visual experience like a prism, with no comment. It basks in its own precision. The mirrors confront flat-on, in straight, canted alignment. They are before you, then above you as you cross the narrow lobby wall, then beneath you as you pass into the low elevator passage, then gone. "It's a passageway experience—to peace," Eldred observes.

He insists that he has not looked at other artists who have worked with mirrors, though he was undoubtedly aware of the transcendental aspects of the *Magic Theater* exhibition mounted at the Nelson Gallery of Art in May 1968, during which mirrors were used, most notably in a mirrored chamber by Stanley Landsman. "I replaced mirror trickery by study of angles. It's a surveying piece. There is no identifiable structure, yet it is tightly built. The mirrors mediate between you and the structure, putting your mind to work. The modular framework for the mirror panels is adapted from a support system for exterior building sidings right out of Sweet's catalogue."

To conceal the track, a rectangular sliver of mirror rides as an insert between each panel, so that the surface is as uniform as possible. The result is so cool, so pristine that "it's almost a shadow or ghost image—even when there's a lot of traffic outside, the distortion is still very slight, but the cars and trucks are thrown across it at various speeds. While it's an inside piece, it gains from what is going on outside: signs, passers-by, automobiles. What is behind you is visually in front of you. It's an area, a situation, and things in it can be traced." If a prize jury were to ponder Eldred's drawn layout for this piece, they would be forced to admit to themselves: "We don't know what we are dealing with." It is an inscrutable construction, all the more so for being so clear and simple, so articulate a grid. The Olathe mirror bank is a dissolution of *Salina Piece's* waffle-grid slab, or even the roof system of Eldred's house —dematerialized. The clear Lexan exhibition cases of the Washington Square project have had their effect; yet it is as fixed and immobile as any of the fabricated pieces.

The carpenter charged with building its wooden supportive frame did not at first follow Eldred's

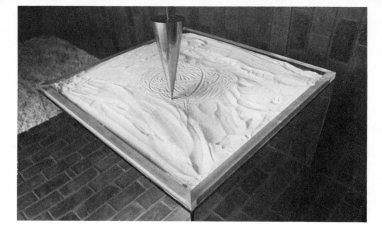

Dale Eldred, model, pendulum sculpture. Collection: H & R Block, Inc., Kansas City, Missouri. *Dale Eldred.*

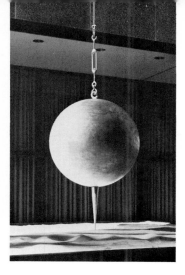

Dale Eldred, *Grand Rapids Pendulum,* Grand Rapids Plaza, Grand Rapids, Michigan, 1973. *Earl Woods Photo, Grand Rapids.*

plan. The metal tracks would not fit. It all had to be torn out, amidst flaring tempers. When it was rebuilt, Eldred and one assistant mounted a scaffold, dropped in the mirrors and insert panels, 186 pieces of mirror in all. "The glazing union was on our tail, even though I explained we were building a sculpture, not installing bathroom mirrors. On the other hand, the local carpenter's union was great—gave me a card for the Olathe piece."

He spent more time ordering parts and sitting at the drafting table than on the site. The metal tracking was assembled in eight-foot sections in Eldred's workshop and trucked to the site. The installation was dovetailed into the architect's building schedule. "We had to keep paper facing on the mirrors until the air was dust free. When we finally tore off the paper tape and exposed the mirrors last October, it was like unwrapping a jeweled Christmas package. You don't do much sculpture unveiling these days!"

The Olathe mirror bank unites what Eldred calls "the mysteries" with structuralism to the point where they become indivisible, one from the other. Is it really a piece of sculpture? Or a landmark? The answer to these questions is contained in its artistic precedents. "There are a lot of people who have worked with mirrors now, but I've been looking instead at the suspended glass walls at Dulles Airport or the mirrored, tinted curtain walls of recent office buildings, like that one in downtown St. Louis or its little cube cousin here in Kansas City." The sources remain constructional, however transcendentally used. They are part of a tradition that leads from Bogardus and Paxton straight to our own day.

The idea of Eldred's *Grand Rapids Pendulum* began in 1968. During that year he built two experimental models, the first a heavily proportioned, three-dimensional triangle ten inches on a side, suspended over a waist-high, solid wood base. The surface of the base was in effect a sand trap. Airplane cable attached the pendulum to the room ceiling. Against the base a ramp was placed with miniature "people" looking up toward the pendulum tracing drawings in the sand with its point (Harrison Jedel collection, Shawnee Mission, Kansas). What would happen if the pendulum could be made large enough so that people could gaze up at it in space?

The opportunity came with the exhibition *Sculpture Off the Pedestal* with pieces commissioned by the Grand Rapids Art Center using the outdoor spaces at the center of the city as frame of reference. "Pedestals are devices for supporting sculpture. In performing that function, however, they inevitably separate sculpture from the everyday world. They enshrine and encourage a worshipful approach. Sculpture that is off the pedestal occupies the same ground that we do. . . . The idea is to break down, as much as is appropriate and possible, unnecessary distinctions between art and life."*

Eldred's giant pendulum is not based on earth rotation, but rather on the two point suspension principles used in physics demonstrations of what occurs when cables are divided: "I saw one working at the Chicago Museum of Science and Industry."

Eldred visited Grand Rapids and asked the organizers of the exhibition for: (1) a registered engineer to test his cantilever and calculate safety factors; (2) the help of a steel fabricating company to build the cantilever and sand table; (3) two blacksmiths for assembly; (4) complete plans of the civic center area. "I left by airplane after two hours, with my idea of a spherical pendulum floating out over the plaza, stretching from a cable going from roof to roof, a forty-five foot span. That locale proved too near the Calder for them—not for me!" Also, both the federal and county governments, proprietors of the buildings, would have to be dealt with, "though they couldn't have been nicer." The federal building also lacked a roof attachment from which to anchor the cantilevered suspension system.

The county building, however, had a concealed roof-top I-beam (a terminal for the window-washing scaffolds), perfect for cantilever attachment. "We couldn't weld because the installation was to be temporary, so I devised a clamping system. We had to be very careful with regard to wind reaction, support capacity: liability protection in a highly public space."

* *Sculpture Off the Pedestal,* Grand Rapids Art Museum, 1973, introduction by Fred A. Myers.

The cantilever projects outward forty feet, with another fifteen feet functioning as a concealed lead-in to the I-beam roof-top anchor. A heavy crane couldn't be used on the paved plaza, so the cantilever was carried aloft in sections by means of the window-washing scaffold: "The cantilever weighed exactly five hundred pounds, no more, to meet the code."

The sphere measures fifty-three inches in diameter and is welded from two hydraulically pressed hemispheres. It is made of stainless steel and, together with the lathe-turned, stainless-steel drawing point, was made by Kuhar Metallizing Company, who also had made the metal objects for the laminated models. Richard Hunt, a Chicago sculptor, let Eldred use his studio as a half-way house. "There I polished the sphere, and Paul Slepak, who now works for Hunt, helped."

The sand table was originally designed by Eldred to be fifteen feet square. "The moment its assembly began I could see that it was too small. At my request the table was entirely rebuilt to measure twenty-four feet square. They didn't bat an eyelash! What people!" The table is built of tubular steel and rests on an inner waffle-slab grid box support. Thus the five tons of sand are distributed safely over the plaza. The turnbuckle Eldred used to tie the table was Air Force surplus: "It's been kicking around my studio ever since I found it four years ago in Chicago." The table was built by Bush-Havens Steel Company and assembled on site by a scaffold system to eliminate use of a crane.

Mrs. M. S. Keeler, patroness of the exhibition, arranged to have the silica sand donated. She asked one businessman, "Would you donate the sand if you had it?"

"Certainly," he replied.

"Well, your competition has it, so we'll obtain it from him and send you the bill."

"That lady really has guts," observes Eldred admiringly.

The pendulum is suspended from a cable atop a ten-story building. A restrictor had had to be attached at night (when there is no guard or supervision) in order to prevent chance manhandling: "Five kids rode on the ball, and it swung into the

building—crash. I had to go back and adjust. Oh, in a hurricane you'd have to tie it to the table."

Under normal conditions (the spherical ball has sufficient wind slippage capability to resist even unusual velocity), one push of the pendulum is good for five or six hours of movement, and the wind helps. "It's never really still, no matter what, except in the dead of winter when the sand box freezes." The point begins to draw, scoring the sand in close parallel movements, depending upon its release point. Gradually the arc widens, and in time there are complex patterns in the sand, drawn not by the artist, but by force of natural law.

"You stand looking at it, first at the object itself, then at what it does, as it makes the drawing and erases, recreates, and swings through with a quiet shooshing sound. It takes thirty or forty swings for the drawing to be apparent. First there's an X pattern, then the drawing fills in; if a breeze comes up, it starts redrawing. Over a lengthy period of time the sand will dish out. I have nothing to do with the beautiful drawing; the earth does."

As gravity, inertia, and rotation interfere with the two points of the cable terminal far overhead, alteration in movement occurs. "But even when you alter them, the paths find their way back eventually to the two terminal points of reference, even if you push the pendulum in a circular movement." Eldred's pendulum is an enigmatic object. People stand and watch it as it makes its pass, swinging out beyond the table, missing the outer edge by half an inch. A half hour later the same people are there still watching. "I've set up an action stimulated by an outside, not an inner, source—things we cannot see or reach out and touch, but knowing that they're mentally there and have everything to do with our existence induces a fourth-dimensional response." As a physical enactment of a nonphysical force, the Eldred pendulum derives an aesthetic tension from intermediation between its polarities. It combines sculpture with drawing and arrives through physics at metaphysics without departing from fact. The early De Chirico painted illusory metaphysics that are impossible to capture and isolate. Eldred aims to capture physically and isolate. He produces a possible metaphysics, concrete and practical to both reason and eye. "Those people in Grand Rapids only

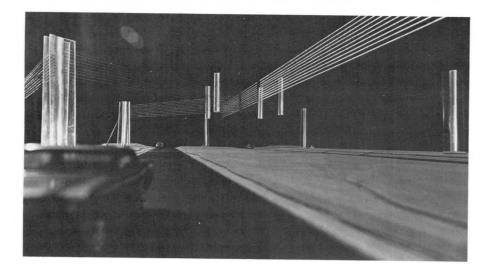

Dale Eldred, Kansas City International Airport sculpture project (model), 1974. *Dale Eldred.*

knew me from my work of five or six years ago. They were shocked at what I produced for them." *Grand Rapids Pendulum* has taught Eldred that a complex piece when set up full scale can work even better than with model scale, if it is done right under optimum conditions. Pristine and jewel-like in its fully contemporary architectural setting, his pendulum does help to erase "unnecessary distinctions between art and life."

One of Eldred's tenets is that "while we have done a pretty good job with interior spaces in this country, we have jumbled up our rich exterior spaces. In fact, we've often ruined them." He has awaited the chance to address himself to this problem—definitive exterior space—hoping for the ideal set of circumstances and appropriate commission. What may be one of the ultimate solutions to the defining of vast outside space sculpturally in our time is Eldred's Kansas City International Airport project, if it is ever built. In the model all his previous building art meets the spatial sublimation of miles of open vista, in devising a sculptural experience that could stand comparison with its distinguished forebears: the Brooklyn Bridge, the Eiffel Tower, and Saarinen's St. Louis arch, the model for which Eldred used to sit under in Saarinen's office long ago. Like them, the airport project derives its effect from the pure aspects of structure; but unlike them, it has no use. It does not carry traffic either horizontally or vertically in elevators as do these predecessors; it is not a viewing station; it is not for climbing upon. Eldred feels that this differentiation is crucial to the understanding of what he is creating: a ceremonial gateway to a large city which is at the same time an exit, envisaged as total structural abstraction. It is not only smaller but far cheaper to build than these other monuments, far more feasible all around. "We could build it in six months," says Eldred. It fits, more than any other work of his career, his criterion that art should simply exist and find justification in its own existential relationship to its surroundings, undefined by the artist, defined only by "the thing itself." At last the gigantism is commensurate with the size of the sculptor's vision. It not only "feels" big, it is big. Despite its hugeness, however, it implies more through the experience it will offer than by size.

In length the airport project spans five hundred feet; the overhead cable system is suspended from spreader towers forty feet high. "I'm not trying to create a shelter, but an observatory to angles and cable connection, to aerial linkings." You are inside the sculpture area of projection as you speed by: not by it, but within it, for five hundred feet. Cars provide the means of visual comprehension.

If the making of good connections is what Eldred's constructive art is all about, all else has been removed but the connections, interacting cables meeting overhead, suspended cylindrical metal objects hung out in space overhead like high tension insulators, taut rows of cables passing through the tower cylinders and threading into the ground. Sculpture has become a spatial network, connected to the ground only at certain points.

Sculpture is not only off the pedestal; it is above the land, conditioned by it, to be sure, but detached from it. Since his earliest fabricated pieces, Eldred has been preoccupied with the problem of lift, of expressively releasing his sculptures from terrestrial imprisonment. In the past he accomplished this by canting slabs so that only an edge would touch the ground, then by tilting them so that only points meet the earth. Early on, rods or chains were used as balancing agents, the precursors of suspension.

Another predecessor of the airport idea was the Ozalid print of a cable system suspended over a chasm; here the idea of lift reached beyond the ground line. But the idea had to await the airport commission. "What is great to me is the possibility to mount this huge structure out over the prairie-scape. One of man's emotional urges concerns the inner desire to interconnect mentally and physically with another being, or to pinpoint our psychic direction toward a center, like settling peacefully into the calm eye of a storm. I'm doing this through sculpture," Eldred says.

The dual airport highway, with cars passing in both directions, is the trajectory for experience of this hovering sculpture. "It defines what you are in terms of movement; I don't care if you get out of the car and walk around, anymore than a man who builds a door cares if you look at it rather than using it to go in and out. One aspect enfolds the other, but a door is a door." Eldred has been preoccupied suf-

ficiently by the concept of entrances—both symbolic and practical—that he has made a slide show of entrances that he has photographed all over the world. Out of entranceways to Buddhist temples or a doorway in Yucatan came the germ for this idea: a modern gate facing in all directions.

The Kansas City International Airport is reached by a dual boulevard with a wide median strip, cutting across rolling, open land nineteen miles north of Kansas City's downtown. This Eldred saw as a pretext for a grand exit on leaving the city, or entrance to the city on arrival. If his plan is executed, Eldred's airport cable project will straddle this entry boulevard. The cables will stretch from six towers, cylindrical in shape, forty feet high, each fitted with solar glass shields to add an element of reflectivity to the stainless-steel jackets. The ten-strand cable networks of five-eighths inch cable will be anchored behind each tower, on heavy concrete footings extending perhaps twenty feet into the ground. "Excavating for these footings will be one of the most expensive items in working out costs. I can bring it in for not too much over a hundred thousand, and when you compare it with the cost of the new airport [$170 million], that's not much, considering the monumental spanning you'll get."

The cables will intersect overhead, using tie rods for floating support. They will suspend a group of metal cylinders high overhead, above the median strip. At night these floating cylinders will gleam like disembodied spirits. Special lighting is planned to bring out this effect. By daylight the piece will serve as a support for its angles and connections, which do recall flight patterns and diagrams. "It will be stunning to see planes landing and taking off against the cable patterns," Eldred avers.

Two spreader towers will be located five hundred feet apart along the length of the entryway, with the four flanking towers well away from the pavement to either side. The six towers will create "a portal that has as much to do with the city as the airport and mediates between the two, even if its setting is far away from the city center." Eldred's art embraces gigantism as aim and the making of good connections as method, and the Kansas City airport project will mark an ideal combination of intent and method.

Previous ideas, flotation tanks, the cable system print, fabrication, lift mechanisms, earth spanning, all are imbedded in the project. "You could go right through it at fifty miles per hour; in concept and design it's the most consistent thing I've worked out." There it will sit, out in the landscape, on the vast Midwestern steppe, directional to the extent of extending its sphere of influence far beyond the limits of the border towers, visible from a great distance, marking out the landscape in an eternity of time. From the air it would look like the imaginary landmarks that inhabit Eldred's graphics.

The Kansas City airport project is a product of the idea of permanence of art. Architecture is of limited life expectancy because of its practicality. It can become outmoded and, once obsolete, can be destroyed. But a monument with no practical purpose can survive into succeeding periods precisely because its use never becomes dated. Architecture is transitory, but ritual survives. "What will last in St. Louis?" asks Eldred. "Saarinen's arch may outlast Louis Sullivan's Wainwright Building, for it is truly conceptual, not an office building built for one purpose only." Eldred aims to accomplish truly lasting monuments, landmarks for all time. "Maybe we are at the edge of understanding what artistic permanence is all about in this country, in spite of all our jerry-building, misuse of space, and profligate waste of technics."

Thus far, Eldred's airport sculpture remains a project that may never be realized, though in the summer of 1976 Eldred was able to build, with a National Endowment for the Arts grant, a smaller, similar version of the suspended cable sculpture "hung out" over the quadrangle of St. Lawrence University at Canton, New York. At least the general concept is saved in this embodiment, even if the scale and solution differ. One member of the Kansas City Art Commission, a concerned and conscientious member, seriously doubts that the airport project would be appropriate to the surroundings. "We worked so hard to build a prairie airport, blending it in with the grasses and terrain. Then why, fairly nearby it, this disruptive intrusion—why?"

Kivett and Myers, architects for the airport, designers of distinctive environmental tracts, em-

ployed Eldred as one of their consultants in the early planning stages of the airport complex. In fact the airport, with its bunkerlike terminals integrated with the bulldozed landscape forms, does recall Minnesota Avenue, Eldred's house, and his park concepts in general. From the beginning these architects thought of a sculpture to accompany their design. Eldred once devised a bridge-way gate into the Minnesota Avenue project: "It was scrapped, but remember I never throw away an idea." It is regard for the land, not ignorance of it, that accounts for his airport sculpture idea. It embodies Eldred's recognition of the reciprocity between site and landmark necessary for the unity of environmental art. With regard to environmental conservation, Eldred's project barely touches the land itself. The cables cut only air. The airport itself is an appreciable distance away. The site is preserved. Will as much be said of the disruptive clusters of motels, gas stations, signs, and warehouses that may clog the area of this vast and open airport park, if action is not taken to protect the area? Seen against this threat, Eldred's project strikes pure and clean: it returns us to primordial essentials.

Dale Eldred: mirror embankment, Johnson
County Building, Olathe, Kansas, 1974.
This photograph shows the wooden
frame complete before insertion of the
mirror panels. *Dale Eldred.*

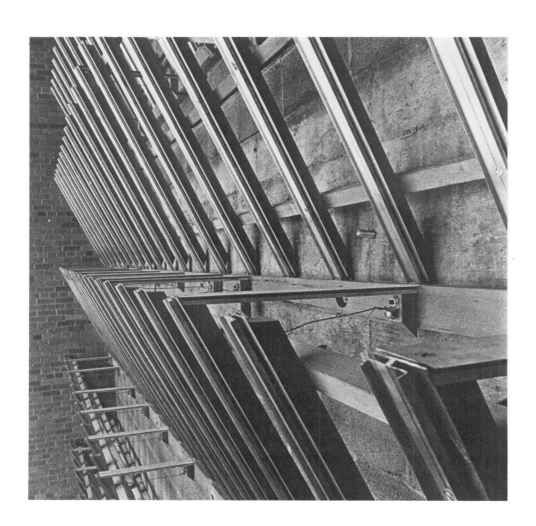

Dale Eldred: mirror embankment, Johnson County
Building. As complete, looking toward the lobby ceiling.
"It does something beyond viewing but it is not
kinetic. What it does exists between performance and
movement because it is neither. I sought a pulsing surface
beyond the waffle grid of the *Salina Piece* without
contradicting the static qualities of building."
James Enyeart.

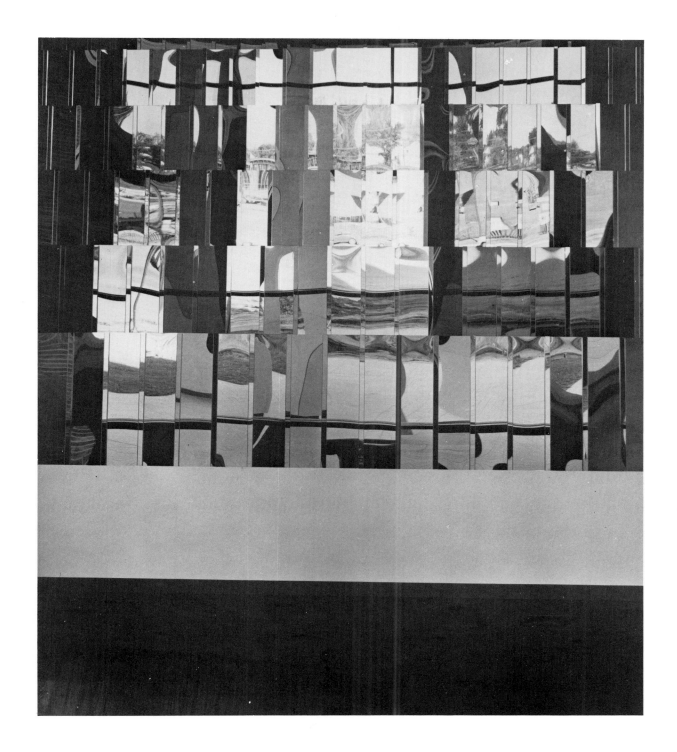

Dale Eldred: *Grand Rapids Pendulum,* City
Plaza, Grand Rapids, Michigan, 1973.
The cantilever extends 30 feet outward from the
City Hall. Since the late spring of 1974
this piece has been bought and permanently
installed by the artist at nearby Grand Valley
State College inside the glassed-in lobby
of the student center. "Now you see it from
balconies, an unforeseen but beautiful situation."
Dale Eldred.

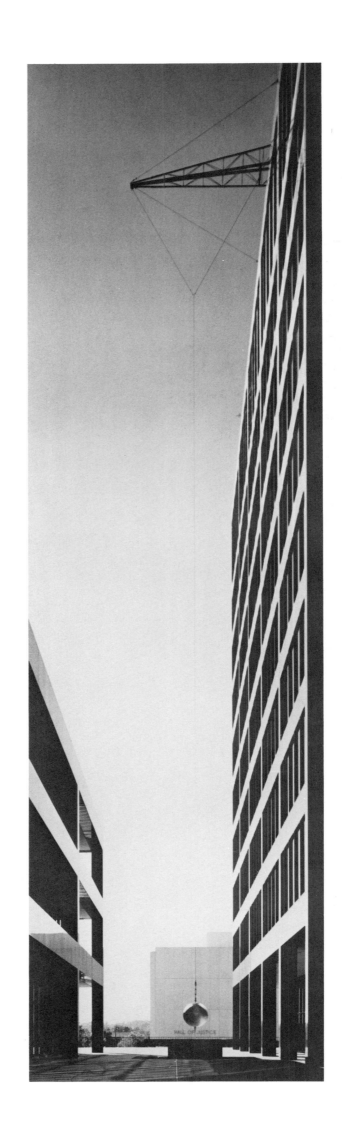

Dale Eldred: *Grand Rapids Pendulum,* City Plaza, Grand
Rapids, Michigan, 1973. One of the countless sand
"drawings" the pendulum can produce, including tightly
controlled patterns reminiscent of land contour elevations.
"There is no way this pendulum can make a random,
nondisciplined drawing, but the combinations
are infinite." *Dale Eldred.*

Dale Eldred: Kansas City International Airport
Project, 1974. Drawing showing elevation of sculpture
along east-west access dual lane highway. From
tower to tower the expanse is 700 feet. The
cross axis is 450 feet. *Dale Eldred.*

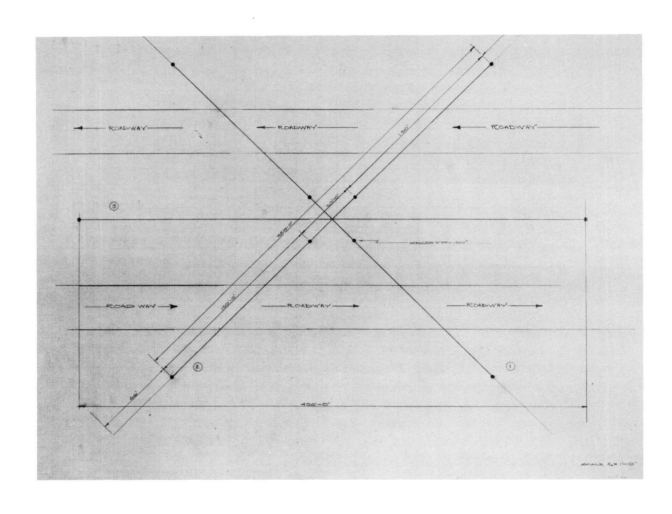

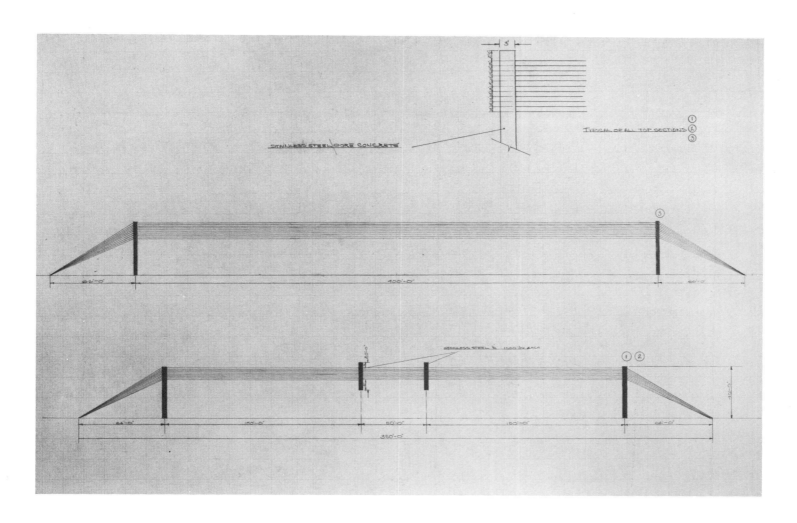

$$\text{Tension} = H \sec \alpha = H \sqrt{1 + \frac{16d^2}{s}}$$

$$\text{and} = H = \frac{(wl + P)\, l}{2d}$$

$$\therefore \quad \text{Tension} = \left[\frac{(wl + P)\, l}{2d}\right] \left[\sqrt{1 + \frac{16d^2}{s}}\right]$$

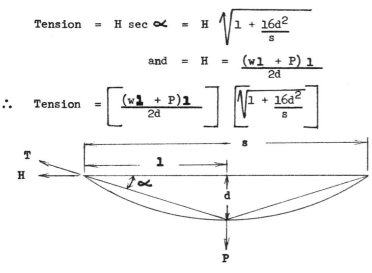

T = Tension
w = .517 lb./ft. = weight of 1/2" strand/ft.
P = 173 lbs.
l = 200'
s = 400'
d = Sag (ft.)

Dale Eldred: Kansas City International Airport Project. Drawing of cable system; and engineering calculations determining cable loads, cable sag, and oscillations. "Until I could prove its physical characteristics of wind stability, weathering, and fatigue, and the precise metallurgic qualities involved, it remained a vision without a chance of becoming a physical reality. I submitted my calculations to three different cable handling firms. They sent me back the necessary cable specs." *Dale Eldred.*

Dale Eldred: Kansas City International Airport Project. Photographs
of model from automobile driver's point of view approaching or
leaving the cable system, with all six suspension towers
visible. *Dale Eldred.*

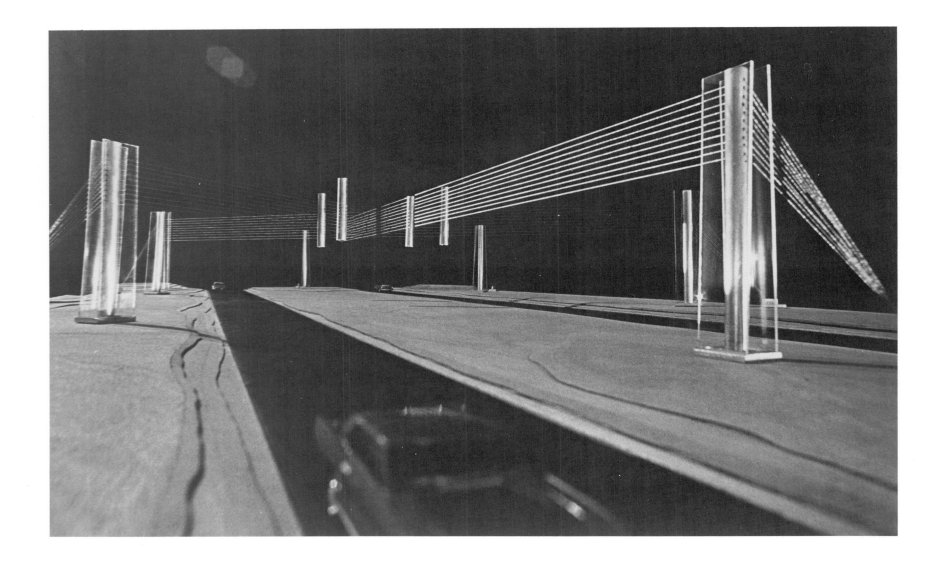

Dale Eldred: Kansas City International Airport Project. Another
view of the model, with five suspension towers visible. *Dale Eldred.*

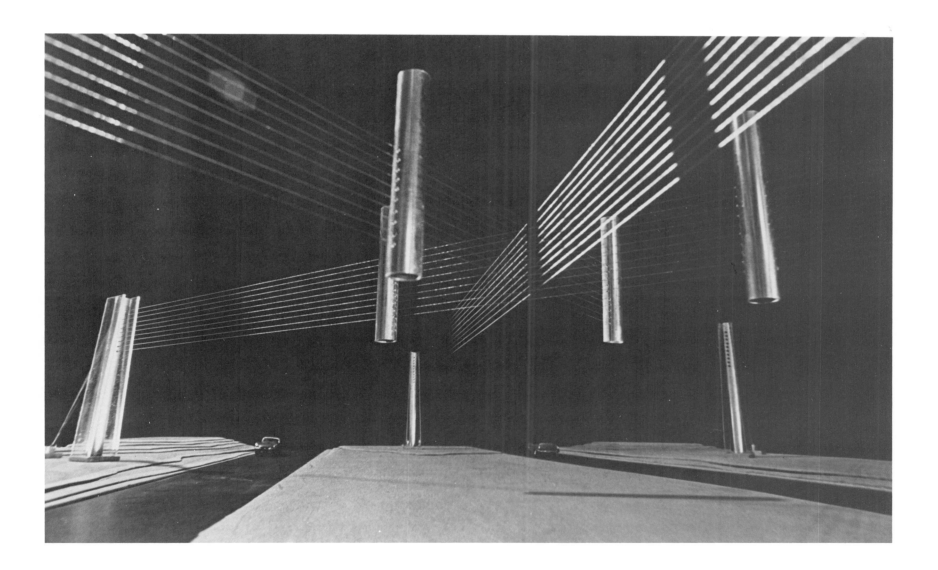

Dale Eldred: Kansas City International Airport Project. Now the driver nears the conjunction of the space-defining cables at the center of the sculpture, with the overhead cylinders looming in suspension above the car roof. "I've bridged out of the single sculpture limitation, so that I thought here from a multiple point of view it is both six independent elements cross-connected and an interconnection bordered by towers of lesser importance. You can pick your own relationships." *Dale Eldred.*

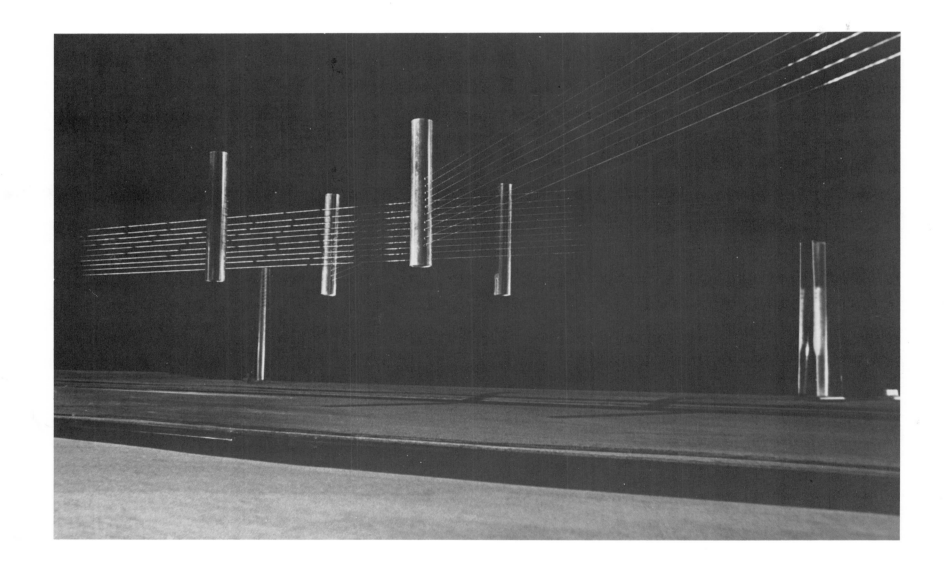

9
SCULPTURE INTO ENVIRONMENT

"Now I'm dealing with transport—all in scale with my large constitution," says Eldred with a smile. It has taken him over a decade to get there. "I could work in any one of several roles," he goes on. "I'm not going to back away from working in any position. Minnesota taught me to be in the middle. If they string cable, I'll be there; if they're erecting the towers I'll be there. That's what an artist has to be today."

Eldred's varied experience, embracing athletics, the out-of-doors, and the active life, what might be called his Northern hardness, in combination with his experience in architecture, engineering, and construction work, as well as sculpting, has uniquely fitted him for his role as an environmental artist. In comparison to the breadth and scope of these career facets, the training of the art school artist, particularly the painter, pales. The emergent artist of today is not in fact a painter, for turning a paintbrush does not equip an artist to handle all those technical problems out in the environment—away from the art gallery or the cloistered studio. That is where the important battleground is today. The bishop, the statesman, and the merchant prince used to determine when a work of art was to be made and where it was put, in a chapel or a private study. Now the artist puts together the factors of design, assembly, and supervision and says: "It will be here, with sky and earth for space dividers."

Despite technology, art even today has retained many anachronisms of the pretechnological age. This Eldred deplores. "I don't like art to look like a well-designed suit of clothes. When it's all in 'good taste,' then it's only well done; the inner core of perception, the real guts are missing. How tired I get of the cosmetic touch. Then the life is gone, and only the empty package remains to become more and more sterile as time gives perspective."

Eldred believes that artists must work in the environmental dimension to save the future of art from such a fate: to work in view of and with regard to all those external circumstances that affect our life on earth. We relate as humans to natural resources and to the products made from them, not to abstract concepts. We have moved too far from these beginnings. Harmony in these matters needs to be restored. The first character is essential, no

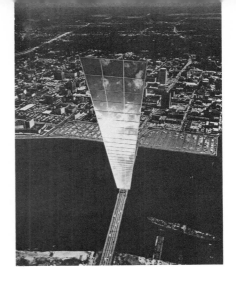

Dale Eldred, photo composite print on Mylar, 60 inches by 40 inches, *Homage to the Ancients*, commissioned by the Friends of Art, Kansas, City, Missouri. *Dale Eldred.*

matter how polished the result. This character still remains intact in nonintellectual arts such as folk crafts and the building arts. The idea is to embrace, extend, surround, or encompass space by using the direct assault of craft or construction. It is enough to keep an artist very busy and away from the studio a lot: "Don't let your mind become an attic." Sometimes he feels that today's art is more atticlike than any museum he knows. "They [the museums] at least offer adventure for any who care. But why paint stagnant pictures today?" he asks.

Eldred now maintains, thanks to the Kansas City Art Institute, a very minimal teaching schedule. He has one senior class and for two years has been artist-in-residence, with great freedom to organize his own activities: "They have been very good to me. I'm no longer an on-the-spot technician, but develop individuals. I know what everyone is doing over there: I've never been bored by students and always enjoy seeing what they do." Environmental artists do not survive without cross-fertilization of ideas—the exchange of technics. He's always happy to talk to anyone who shares his feelings for products and ways of doing things, student or professional. "I think my school relationship makes me happier than running any office."

The wonder is that Eldred, despite all his projects and collecting activities, is a very balanced and wholesome personality. With undiminished appetite for life, he looks forward to the next experience more than the one before. He absolutely refuses to accept defeat, an attitude that enables him to work with so many civic forces, so many combative committees, and respect those who know little or nothing about art. "I'd really rather talk with a grain or steel importer than many an artist. They know their commodity." Or how about a sensitive photographer more in touch with life than many a painter? Or best of all, an old craftsman.

There is in Eldred's work an essentially Midwestern concern for the conserving forces of nature and life. He is interested in an individualism that may appear somewhat old-fashioned amidst the anonymity of think-tank technology. He believes that art has been minimized by the studio technics which have slowly decreased an artist's intake of courage and individuality. The building of a robust

and vital approach to art is an important activity for what remains of this century. He does not care one whit whether he is ahead or behind someone else's technology. He uses a product when it fits his needs —and only then. He is not afraid to be behind in some things or ahead in others: "I just couldn't care less. It's all there anyway." Where would he like to build a piece? Most of all in Chicago. "That's a very factual town. I like it a lot, for everything there smacks of construction. It's really built. It's basic. I'd love to do a piece there, right amidst all that factuality."

Who will commission this piece? Eldred recently turned down an invitation to stay at the Berlin Academy and do a sculpture there: "It's fine for Rickey, but it just isn't me." More interesting to him is the possibility of a sculptural commission in Portland, Oregon. It would be fitting for his chain of residuary monuments to reach the West Coast. "Now that would be something. Mount Hood and the Columbia River gorges!"

In the meantime the Print Collectors of the Friends of Art (the service organization for the Nelson Gallery of Art) has received from Eldred one of his largest prints. This is the first print commissioned locally by the group, the previous commissions having gone to such artists as Rauschenberg, Lichtenstein, Wesselmann, Trova, Landsman, and Sam Francis. For this occasion Eldred summoned his resources to produce a print so large and so salient in imagery that it ranks with his best efforts. It is both a refining and expanding of the previous imaginary graphic mode. In it the enigmatic qualities of these other prints are carried abruptly to full thrust. The actual scene is Kingston, Ontario, along the St. Lawrence River; the knife-edged, wedge-shaped structure in strong vertical climb lunges in such a way as to confound the original source: it was collaged from an industrial window-glazing ad. He could only have done this with the Olathe mirrored piece behind him. After the collage stage, a small negative and then a thirty-two by twenty-four inch negative was developed, then printed out experimentally, along with several other similarly collaged print ideas. The present image was selected for further expansion by the artist. A computerized camera was employed to program and produce a

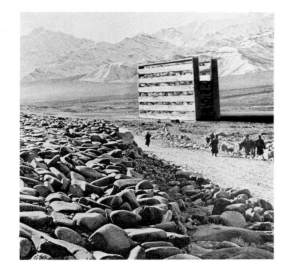

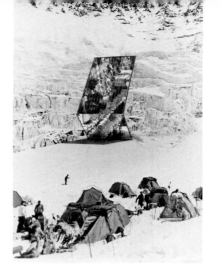

Dale Eldred, photo composite, based on Tarkio College model (1966), 1974. *Dale Eldred.*

Dale Eldred, photo composite, 1975, *Mirror in the Himalayas. Dale Eldred.*

negative sixty by forty inches which was then carefully air-brushed to enrich the background and more convincingly suspend the bottom edge of the glass wedge against the bridge. Imagine what kind of a crane it took to lodge this structure in place! Then the negative was commercially printed out on a heavier Mylar than Eldred had used before, affording greater depth of tone—altogether a huge production. No home printing this time.

"I'll bet the production manager at New Blueprinting is ready to kill me," says Eldred. "I made him throw away so many defective prints, and that is money. He even had to replace the rollers at my insistence."

A number of Friends of Art subscribers have expressed dissatisfaction at possessing such an outsized print, like having the Empire State Building in your living room—it dominates. Where is it going to be put? "Where would you ever get so much print for so little?" Eldred replies. Does the consumer attitude indicate that Eldred's gigantism—graphically speaking—may have reached an apogee for the time being? Not at all. "I'd like to do some other prints even larger. In fact, I'm going to do twenty-eight prints and pull four proofs of each print and dispose of the four sets. They'll move." In one of his photo composites, a mirror grid is intruded into a Himalayan snow scene complete with expedition tents! In another, a cone stands at the verge of the Sahara.

When Claes Oldenburg saw the trial print hanging in the curator's office at the Nelson Gallery, he said, not without admiration: "That's the sort of thing nowadays that indicates a knowledge of my work." "That's nonsense," Eldred said flatly on being told the comment. "That developed entirely out of my own thinking and intrinsically out of my own work." Be that as it may, that is the sort of price that will be paid by an artist working in a part of the country where artistic roles have been more reactive than leading. "If Oldenburg and others wish to live in the head of the country, let them; that's fine. I prefer to live in the body—that's where the viscera are."

In 1973 Eldred was in central and southern Asia putting together a body ornament for-sale exhibition for the Sales and Rental area of the Nelson Gallery of Art and another for the Grand Rapids Art Museum. Since then he has been curator of another exhibition plan for the Kansas City Art Institute, "flat weavers of the world." There has been another Turkish traditional textile exhibition in Houston. At times the rugs pile up in his studio, making it look like a bazaar. In his studio repose the models and drawings for an ill-fated, tall office-building project by Louis Kahn: "We ought to exhibit the material as a sort of memorial to the intimacy of Louis Kahn's architecture," says Eldred. Of late he has been very active in buying from Jessie Howard, an eighty-nine-year-old Fulton, Missouri, grass-roots artist, the signs and drawings he has made for many years and placed on his property: "It was a plain question of saving the material from crude destruction."

Reviving an old idea, he finished on time for the Nelson Gallery's fortieth anniversary (December 6, 1973) one of three special sets of eight of the imaginary graphics executed on aluminum plates, a sort of putting his house in order. It was a reflective thing to do. It solidified a whole area of thinking for me."

The Washington Square project stands in abeyance, "though I still have great hopes." The new Pershing Square development around the old railroad station "ought to spur things." While the airport project may or may not be built, he has worked out with the engineers the solutions to problems attendant on the freezing of the cables in winter and the weight of snow added to the suspended cylinders. Wind dynamics have been carefully studied. "It's all totally concluded and ready to construct," affirms the artist. "Let us hope cars will be driving under it before too long," said an interested citizen. "It will be our loss if it isn't built. What a shame for it to lag along. But that's politics, I guess. If a sculptor of Dale's stature is willing to stay here, why not encourage him? Why kick him in the shins?"

Time has not been kind to the Minnesota Avenue mall. Many of the shops have become empty. At times litter is scattered about, and trash accumulates at the base of the steel towers in the water basin. The whole area has the sad air of a contemporary ruin. The quality of commercial control has deteriorated. One shop owner put a sign in his window: "Welcome to the broken glass empty

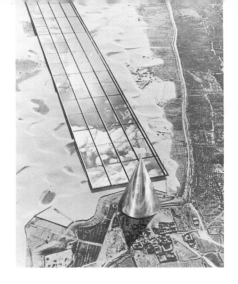

Dale Eldred, photo composite, 1975, *Cone and Mirror at the Beginnings of the Sahara Desert. Dale Eldred.*

building city center mall." An admirable lady was arrested for attempting to black out the sign. She ended in jail, but her protest carried. The sign was effaced. Elpidio Rocha has left town and is now teaching in San Luis Obispo, California.* The mayor of Kansas City, Kansas, heaps abuse on the project. A suit to have the pylons removed was defeated in court. Eldred still has hopes.

If only the mall had been built with its features as Eldred first envisaged them. If only retail planning could make the mall a first-class shopping area, like Hallmark's Crown Center across the bottoms in Kansas City, Missouri. "Does anyone shop in Kansas City, Kansas?" someone asked recently. "What for? What horrible merchandising techniques!" One feels here the tragedy of a concept too sophisticated to be understood or capitalized upon, given the immediate situation. One must admire Chris Vedros and his associates for believing in the project. No one had defended them the way ordinary citizens arose to defend Eldred's sculpture in Mankato. Another concerted effort is in process to remove the offending steel towers. "Considering the entire scheme, that will accomplish absolutely nothing," states Eldred. "It would only make the situation worse. Nobody's thinking beyond negativism. Where's the smart advertising campaign to go with attractive merchandising techniques? They're years behind." That is where the blame lies. A newspaper editor put it bluntly: "Perhaps that was the last place in which to have staged an attempt of this kind. Just across the way in Missouri it seems possible . . . who knows?" By way of total irony, the mall has received a National Urban Design Award. "Perhaps they'll all be kissing cousins again now," observes Eldred. "Maybe they'll take another look, see what they've got, and start realizing potential. Have you seen it since the signs and graphics were put in? It looks beautiful." There are signs that a modicum of civic pride is beginning to be taken in the mall, though it

still is not functioning as its sculptor-designer intended.

The Cypress and Thirtieth Street Park has been completed. To develop his art, Eldred has to ponder ways to bring into closer unity the visionary quality of the more recent graphic "monuments" and the reality of his actual ones. Construction of the airport project would do much to close any gap. This shift between visionary documentation in art and realistic documentation was a recurrent preoccupation of the early 1970s with Eldred as much as anyone else. Somehow "visionary" reality and "realistic" reality must fuse in his work. The fission should make quite an explosion.

In 1974 Eldred was buying body jewelry in Katmandu and Tantric art in Jaipur, and absorbing inspiration for another project: "The possibilities are rising. I can stand wherever I like and not think a provincial thought. My compatriots built Giza [he has visited there six times now], Sanchi [five times], and the stupas of Nepal [four times]. It's a different way of looking. That's what unlocks me. I've got to be on site. That's the only way I can become my own learned man."

The Atlanta project materialized in August 1976. Eldred describes it as a two-in-one piece: (1) three large stainless steel tubes forty-two inches in diameter and twenty-five feet long, suspended by steel aircraft cable from overhead axis point; (2) a floor-mounted forty-five degree pitched, eight feet high by forty-five feet long, solar glass mirror with a Freon-compressing unit enframed in back; this will develop alternating frosty and dry reflective surfaces—to distort imagery, "like an animated Olathe mirror"; (3) a pendulum. These three units are thirty feet apart; you walk under the tubes and filter around the corrugated mirror; sixty thousand people a day will walk by at high peak shopping periods. It's a slower action piece because I'm dealing with pedestrians, not cars." The location is the new Southgate Mall Shopping Center in Atlanta. "My three elements are placed where the pedestrian walks meet, enclosed in a huge space frame support." In combination are fragments and lessons learned from the airport project (cable-suspended tubes), the Kansas City mall (the abandoned mirrors by the library), and the Olathe mirror bank. He

* For Elpidio Rocha's recapitulation of the Minnesota Avenue mall see *Entrelineas*, Penn Valley Community College, Kansas City, Missouri, volume 2, number 1–2, 1972. This reprinted Reynolds's report but makes no mention of Dale Eldred's contribution as designer.

134

has complete control of the environment, since "I designed the walkways, nearby water pool, and elevations in conjunction with Thompson, Ventulett, and Stainback, project architects. None of the Kansas City, Kansas, mall trouble here," adds Eldred. "The architects and engineers provided maximum cooperation with an efficient 'can-do' attitude." Here are all the sophistication of finish and perfection of detail that was missing in the Minnesota Mall project, proof that collaboration of a complex sort can be successful.

In the Southgate complex of sculptures, the tubes are mounted on a bar that penetrates through each one just above dead center. Bearings at each end of these bars attach to cable supports that spread outwards as they rise toward the ceiling support truss—like three giant trapezes. There can be no sudden movement of the tubes, because they are so heavy: everything is deliberate as always. The contrast—heaviness versus weightlessness—is what fascinated Eldred. "The visual effect works both ways."

The pendulum element is more intricate than the Grand Rapids prototype because suspension is achieved by ball bearings rather than by a friction point. With less friction, movement of the pendulum is smoother—inexorable. Now the floor itself seems to cantilever upwards to form the sand-box drawing pad for the pendulum's point, a neater solution than the rather awkward Grand Rapids table-like base. The sand trap is set above water.

The water-filled base of the third element, the giant zigzag (eight panels) mirror, is lined also with black; the black water functions as another mirror for the solar glass mirror set at right angles above it. "Originally the mirror was plain (too weak in reflective power); then we went to gray glass (not enough mirror effect); and then to a coated solar glass for intensity. But they inadvertently dropped the pool level in construction, and now the mirror is set too low for proper reflectivity; so we're working to get it raised. Then it will be perfect." The playing off of these three dissimilar sculptural programs against one another in a single space is a development of the disparate elements that compose the outdoor programs of *Mankato Piece*. Only design and execution are both more technologically refined and far more polished in concept—as if Paul Bunyan had gone to

an engineering congress in order to refine his approach.

A road sculpture project submitted by Eldred to the Interstate-80 project in Nebraska was initially approved by the jury but was rejected by the U.S. Highway Commission. The competition involved twelve sculptural works to be built for the American Bicentennial across the state of Nebraska on Route I-80. Eldred was one of the invitees. "They gave me several sites to choose from, but I proposed my own, using the highway expanse rather than a rest stop. Rest stops are pedestals! Pure corn!" Eldred designed a huge pipelike X that appears to extend below the dual highway surface, showing wherever the elevations drop to expose its elements. He suggested huge concrete tubes, half buried, gigantic, recalling the concrete piping at one section of the Kansas City, Kansas, mall. The terminals of the X were to rise at either side of the highway twenty-five feet.

"The concept is a reverse of the airport project," as if it had gone underground. "I want to create a situation in which people traveling down a stretch of highway encounter the earth-tied sculpture. It is necessary for the idea to feel as if it has been present before the highway and will be there long after. The illusion of this is penetration of form rising on each side of the highway, showing itself in the center area. Hopefully the site area decided upon would be a geographical area with surface rock nearby so no distant hauling would be necessary," wrote Eldred to the Interstate-80 project director on December 24, 1974. I bring with me experience in supervision of construction, actual construction, knowhow in equipment operation, and good common sense." And at a very reasonable price; only the exposed sections of piping need be built to secure the contiguous effect.

If the Kansas City airport project had been built (after boldly commissioning the studies for it, the Kansas City Art Commission has tabled it for the present), and if the Nebraska I-80 project had been realized, all the promise of timeless gigantic projection worked out on a sketch pad in Greece years ago would not have been random conjecture but the inception of extravagant action, hinged not

to flight of fancy but to learned facts gleaned from earth, water, and sky.

These elements, in their transcendental aspect, have become the ultimate subject of Eldred's latest giant-print series in sepia Mylar. It features acres of hinged mirrors set in exotic geography, punctuated by photo-negative images of the miniature metal cones used in the table models. "The sepia color accords smoothly with my present interest in metallic reflectivity." By photo alchemy those applied miniature cut-outs become gigantic reflective space constructions. They become alternatively radar sets or solar mirrors. "It's a sort of lift-off from the old print constructions, collaged and Ozalided to transparency and pinned by a ball bearing or cone. After all, a ball bearing is perhaps the most perfect description of the twentieth century."

This growing preoccupation with reflective surfaces has added a transcendental fillip to Eldred's fabricating bent, almost a contradiction in constructive terms, turning reflective judgment upon his sculpture ideas out into the environment, away from the critic, creating a sort of music of the spheres. It is as if the trylon and perisphere of the World's Fair of 1940 had landed on Mars. One thinks of the automatic drawings in the sand made by the Grand Rapids pointed sphere, drawings that no man could possibly make on his own. One has the hope that Eldred is going on to make a lot of connections that have not been made before.

He *has* become his own learned man. He has hit his stride. His technology is more sophisticated. His engineering sources are more diversified. What awaits is more major implementation of his vision. It will be expensive to build these huge environmental projections, but worth it as an affirmation of man's spirituality as builder and of the poetics, even mystery, of the technological age. Why shouldn't this age build its own Colossus of Rhodes at which some future age might gape and wonder? Eldred would like to do it: "My passion is my work. I get my reward more and more from the possibility of realizing it. Anything else is nothing with me."

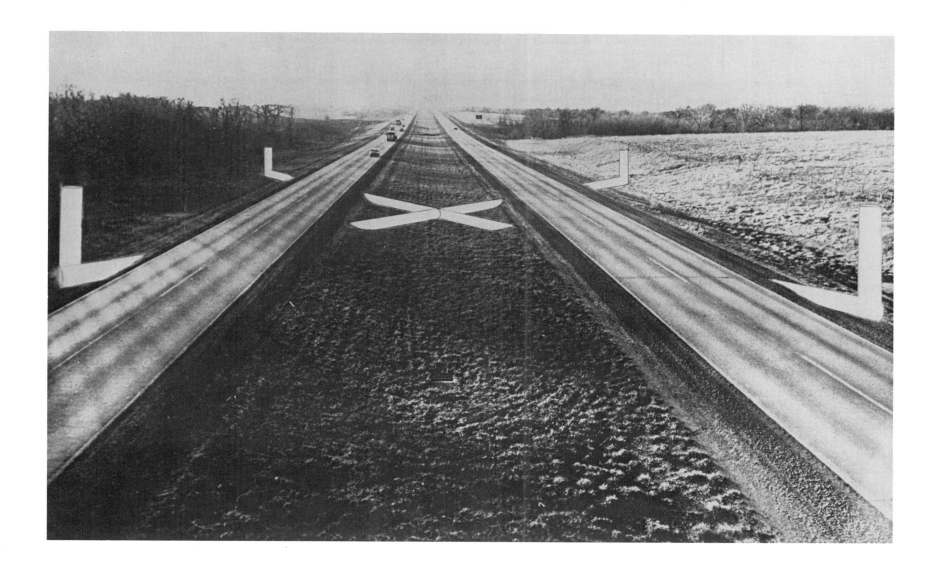

Dale Eldred: Nebraska I-80 Project. Schematic of project
for presentation to Nebraska Interstate-80 Bicentennial
Sculpture Corporation. Collage and photo on sepia paper.
Here the print conceptions of the artist join the
possibility of reality, exposing the give and take between
the possible and the impossible, which Eldred's
constructionism bridges with ease. *Dale Eldred*.

Dale Eldred: model for Southgate Mall Shopping Center
sculpture, Atlanta, Georgia. General view of the triple units.
This model was prepared while final decisions on placement were
being settled between the artist and the shopping center
architects, even while components were being fabricated in the
artist's studio. For views of the finished sculpture complex
see color plate. *Dale Eldred.*

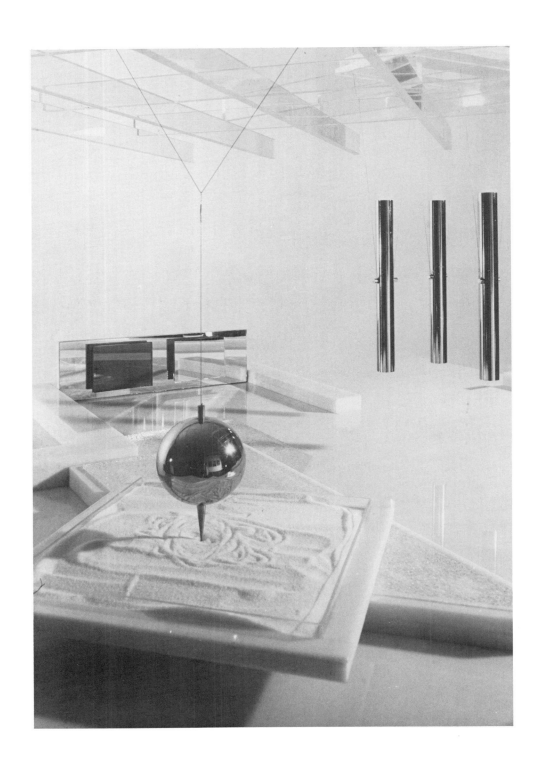

Dale Eldred (Thompson, Ventulett, and Stainback, architects):
Southgate, Atlanta. View of the finished sculpture complex,
August 1976: Foreground, pendulum and sand trap;
left, zigzag Freon wall; above center, the triad of suspended
stainless steel tubes. The pendulum sand trap has a narrow glass
band around the inner borders to help contain the sand.
The beveled edge is finished with quarry tile. The trap is
cantilevered over a pool of black water which connects under the
floor with the mirror pool to the left. These features give
an idea of what the terrace elevations of the outdoor Washington
Square project would look like. *Dale Eldred.*

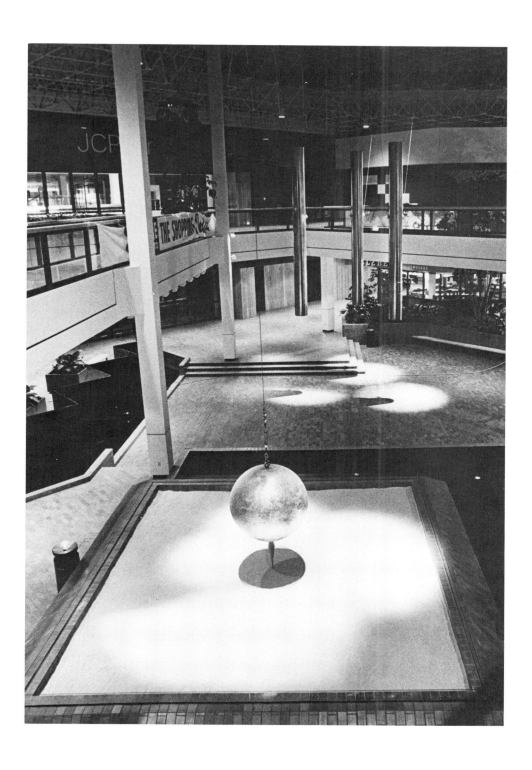

Dale Eldred: St. Lawrence University quadrangle, Canton, New York. Four views of completed sculpture, 1976: (1) one of the three seamless steel supporting towers, each 40 feet high, made of half-inch pipe and placed 180 feet apart; (2), (3), and (4) three views of the stainless steel tubes in their gimbal mounts. In counter distinction to his earthbound stance, Eldred explores here the uneasy relationship between the ground line (not seen) and heavy objects suspended in space with great deliberation—a liberated outcome of the dragging attempt at a space leap made by an end slab of the multipaneled *Kansas City Art Institute Piece* in 1967. While the airport project's cylinders would have moved in slow ascent and descent patterns held taut against the wind, this executed variant features cylinders mounted in gimbals so that they swing individually off-axis in their ring mounts, like a compass partially adrift in the sky. The anchor systems are heavy-duty compensating elements.

1

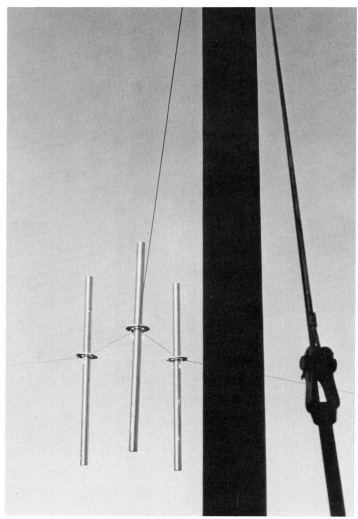

2

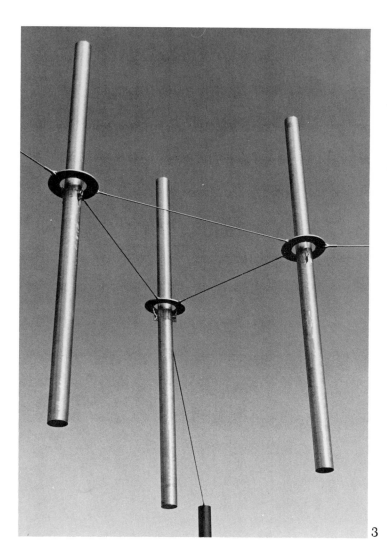

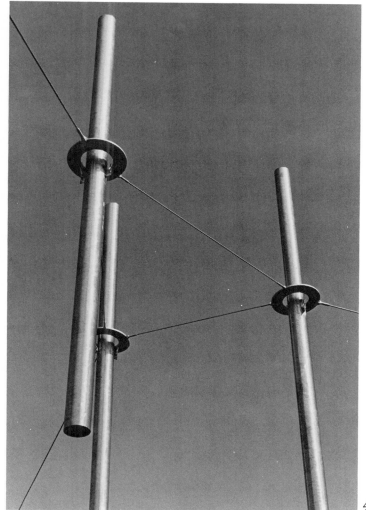

3

4

10
ANTI-COLOR NOTES

Lowest on the totem pole in Eldred's estimation is the figure painter working today in the painting studio as in a cloister, going back to Methuselah with dull-as-dust academicism. Next is the artist painting nice, polite color abstracts, painting by the rule (or should we say tape), but not engagé, not fighting new battles but rather warming up old style in new bottles. Such artists often fail signally to come to grips with environment in the Eldred sense. Fiddling with color is self-limiting. This work is consciously done for a market, and the market passes judgment. Eldred asks, "Why be strictured before you even start?" There is no expression of large ideas, only large coverage of canvas. "Sure, Stella has a real thing, and Noland, but where do you go from there?" There is no confrontation of a site or a landmark. Moreover, ideas fly away quickly from media nowadays, lodging elsewhere far and wide. It no longer makes much difference where one is an artist. Rather, the question is where the work is sited. That explains what a work of art does. If it isn't constructed, a work of art cannot be "sited." It can project, outgo, attack a problem only when centered by action.

What would happen to Eldred's work if it were denied that element of action, conveyed through the building process? Though its quality is heavy, even lumbering, it is not static, due to the fact that the manufacturing process is implied in finished work—an after impact. That readability is what separates an Eldred work from a simple builder's object. That explains why he is so preoccupied with what he calls the drama or battle of assembly. Imagination, Eldred declares, is a fact, a positive fact. And to be noteworthy in his concept of things a fact has to be large, emphatic, possess "dimension": flat-out, dead-on, straightaway, without a curlicue. Everywhere in his work to date there is regard for planeness, for planar surfaces. As Siegfried Giedion has remarked, this regard for naked and clean surfaces is a leading characteristic of the American feeling for form, especially when left to its own devices, whenever it is unhampered by the need to be self-consciously decorative. No matter how primitivistic the geometric forms of some European sculptor may appear, Eldred's are ruder; one is tempted to say, more basic. There is less synthesis, more nakedness.

143

If subtlety in the manipulation of forms is not his forte, why would he want to color structural members like a coloring book? Americans have lately produced a David Smith and a Tony Smith, not a new arabesque. Sculpture has to be self-contained: it cannot be superimposed with color that would confuse end with effect. What we are speaking of may separate sculpture from painting and other media today, but it is more basic than that. "Let others be bothered by our culture," says Eldred. "I want to come to terms with it, just look at the sky and earth and put something between."

That something can't be puny if it is going to communicate outwardly across natural space. Steel, concrete, industrial mirror, these media stand up. But color: is this not the most dangerous of media for the structuralist? It is by definition evanescent, capable of nuance, expressive of all that is breathtakingly delicate. Impressionism was rooted in that color of sense. Eldred says, "I want to stay as far away as possible from that kind of thing. Paint doesn't have staying power for me unless it is a manufactured product. Those blue enameled silos now being put out in the northern plains landscape —now they mean something from the landmark identification point of view."

When Calder has a stabile painted, he specifies "Japanese flat black." When Eldred specifies, as for example for his only loudly colored piece, *Big Orange,* it is a matter of "bridge finish paint" for industrial outdoor use. "I just want to identify that piece the way you do a bridge, and that is that. There's a reason for that paint being there: it's a preservative. That's the powerful factor."

Sealants for woods, zinc primers, industrial preservatives for metal, black industrial finishes—these are Eldred's colors. They are applied to conserve the piece, not to pretty it up "like a paper cut-out. What I dislike the most about color is that it can make anything pretty. That I'm postitively against." He would never be able to two-tone a piece (as David Smith occasionally has done). He never mixes a color any more than one would "blend" hardened metal. He doesn't like surfaces that look "brushed." David Smith was guilty of that, revealing a relationship to painting. "I carry it an eliminative step farther." Such color as he uses is integral

144

with his aims, not an enhancement of them. Most of his color exists in the environment, ready-made, to be tapped by the sculpture when it is sited—existing beyond the program. Or the natural textures of rock or wood poles are used without alteration. "The sculptures are black and white; the landscape is color. My pieces exist to make the grass greener." That is why he so successfully sets his imaginary sculpture in collage form into *Natural Geographic* landscape photographs and other industrial color plates, noted for the acidity and strength of their reproduction. "Steel is steel; don't lose the feel of it. Just give dimension. Stainless steel is always the same, forever. Weathered tones in stone, concrete, and grass, how can they be improved upon?" Without the surrounding animate colors in nature, Eldred's works would lack needed counter definition. That they do not is due to his regard for the properties of anti-color. Color is used in the negative sense: i.e., it defines not the object as much as identifies surroundings.

For him the concept of patina comes out of painting and is alien to sculpture: "There's nothing of the painter left in me." His industrial finishes have also had their own development since the invention of the foundry. "Someone ought to write that history." It was Henry Ford perhaps who put the choices across: "He sent us to the galvanizing catalogues and to spray finishes. Renoir didn't."

"How would you color a salt flat?" Eldred concludes: "You don't. You just lift a sculpture away from it!" The finishes he applies have one leading and positive idea beyond preservation: identification. One judges a product of industry by its material identification—that's an *aluminum* extrusion; that's an *iron* bolt. One identifies an Eldred sculptural site or landmark by its material finish. Preservatives add strength to classification, sharpening one's compass of sculptural positions between landscape and sky in a totally natural way. Color is material identification, never manipulation. The slight shift of mirror tint in the *Olathe Piece* is not a coloristic exercise, but a means of sharpening the reflective process for the viewer. When that process of identification is completed, Eldred has no more concern with color, any more than does a contractor

turning over the key to a completed building. It's over and done with. The finish of his work, as with every other aspect of it, is determined by the facts of building, and that alone. The Atlanta suite of sculptures shows that those facts are becoming refined and polished—formal. This overwhelming concern provides the *raison d'être* for sculpture of material structuralism, invested with the factualism of anti-colorism and identified by multidimensional projection into the environment.